Story and Simulations for Serious Games:
Tales from the Trenches

Story and Simulations for Serious Games:
Tales from the Trenches

Nick Iuppa & Terry Borst

Focal Press
Taylor & Francis Group

NEW YORK AND LONDON

First published 2007

This edition published 2013
by Focal Press
70 Blanchard Road, Suite 402, Burlington, MA 01803

Simultaneously published in the UK
by Focal Press
2 Park Square, Milton Park, Abingdon, Oxon OX14 4RN

Focal Press is an imprint of the Taylor & Francis Group, an informa business

Library of Congress Cataloging-in-Publication Data
Iuppa, Nicholas V.
 Story and simulations for serious games : tales from the trenches / Nick Iuppa & Terry Borst.
 p. cm.
 Includes bibliographical references and index.
 ISBN 0-240-80788-X (alk. paper)
 1. Digital computer simulation. 2. Computer games—Programming. I. Borst, Terry. II. Title.
III. Title: Story and simulations for serious games.
QA76.9.C65I86 2006
794.8'1526—dc22

 2006024346

British Library Cataloguing-in-Publication Data
A catalogue record for this book is available from the British Library.

ISBN 13: 978-0-240-80788-1 (pbk)

The play's the thing wherein I'll catch the conscience of the king.

Hamlet, act 2 scene 2

To Ginny and Carolyn

Acknowledgments

The authors gratefully wish to acknowledge the following contributors to the development of the three projects that form the core content of this book.

Department of Defense
Dr. Anita Jones
Dr. Judith Dahmann
Del Lunceford

United States Army
Dr. Michael Andrews
Dr. Michael Macedonia
Dr. James T. Blake, Ph.D.
Dr. Kent Pickett
Dr. Stanley M. Halpin
Dr. Stephen L. Goldberg
James (Pat) O'Neal, Brigadier General, U.S. Army (Retired)
Forrest Crane (Retired)
Susan Harkrider
LTC Donna Brazil

Industrial College of the Armed Forces
Dr. Alan Whittaker

Mitre Corporation
Marnie Salisbury

Paramount Simulation Group
Dr. Gershon Weltman
Janet Herrington
Larry Tuch

Nathaniel Fast
Alex Singer
Harry Dorsey
Roland Lesterlin
Florence Maggio
Judith Singer

Paramount Television
Kerry McCluggage
Steve Goldman
Bob Sheehan
Bruce Pottash
Kim Fitzgerald
Stephen Sacks
Carolyn Petty

Paramount Pictures
Tom McGrath
Bruce Toby

Paramount Digital Entertainment
David Wertheimer
Leonard Washington
Marc Wade
Mark Tapio Kines
Erin Powers
Mark Goffman

Institute for Creative Technologies—University of Southern California
Richard Lindheim
David Wertheimer
Dr. Andrew Gordon
Dr. William R. Swartout
Dr. Randy Hill
Dr. Michael van Lent
Martin van Velsen
Kurosh ValaNejad
David Hendrie
Paul Carpenter
David Miraglia
Travis Castillo
Ian Mankowski
Yuki Miyaki

Richard Almodovar
Hafid Roserie
Alan Lee
Laurie Swanson
Regina Cabrera

University of Southern California
Dr. Paul Rosenbloom
Dr. Patricia Riley
Dr. W. Louis Johnson

ICT Research Assistants
Arnav Jhala
Brian Magerko
Keith Miron
Tim Smith

United States Army Research Development and Engineering Command (RDECOM)
United States Army Simulation and Technology Training Center (STTC)

The authors also wish to acknowledge the Wikipedia website (http://www.wikipedia.org) and the online archives of *Game Developer* magazine as significant aids in researching and verifying information; along with Greg Roach's generous sharing of his ideas regarding media costs and benefits while teaching alongside him at USC's School of Cinema-Television.

All images and graphics from the *Leaders*, ALTSIM and Final Flurry projects are used by permission of Paramount Pictures.

Table of Contents

Introduction:
The Road to StoryDrive

Northeastern Bosnia, 1998. The refugees of ethnic conflict are returning. But they aren't welcome. Paramilitary thugs are determined to drive them out and drag their NATO protectors into a mire of guerrilla attacks and urban combat.

In the town of Celic, a platoon of U.S. peacekeeping troops inspects a Weapons Storage Site. Weapons are missing and a hostile crowd has surrounded the site. The Platoon Leader radios for assistance.

At the Brigade Tactical Operation Center . . .

The BATTLE CAPTAIN picks up the call—and the job of launching a rescue mission. His Commander instructs him to "Deliver the force with speed and surprise." The Battle Captain's response: Operation Cobra Strike. Mission: secure the town of Celic and neutralize the threat. Action: An air assault force will establish a cordon and seal the town. Mechanized infantry will roll in, rescue the weapons inspection team and protect the residents and refugees.

The Battle Captain broadcasts the order to all units: load up and get ready to roll.

At that moment a call from the Platoon Leader at the Weapons Storage Site reports that the crowd has grown larger and that shots have been fired at his troops.

So reads the description of a new kind of military simulation: one that attempts to engage users in a collaborative exercise in which they take on the roles of the Battle Captain and his staff and attempt to engineer the rescue of the endangered platoon. It is a simulation driven by a story that was designed, written and created by a Hollywood motion picture studio.

The exercise represents one of the first and most important efforts in the difficult struggle to bring the full power and effect of storytelling into the realm

of simulation. The benefits of story in simulation training have been quite apparent to the US military and to trainers and game designers alike. Stories can engage participants, make their experience more memorable, help them learn, and help them transfer that learning to the real world. Stories can portray the full complexity of a difficult situation; they can induce the kind of tension and stress that learners must become familiar with when it becomes a major part of their jobs.

These are all things that a good Hollywood movie can achieve through cinematic storytelling. But the mechanics of combining the structure of a good story with the sense of free will needed to have a believable simulation have always seemed difficult or impossible to achieve.

The book you're holding in your hands addresses this challenge. And to see how this can benefit you, read on.

Who This Book is For

You could be working for an oil company, involved with training workers to operate on offshore oil platforms, and concerned about new security issues in this environment. You could be working for a financial services company, involved with training employees to move into management responsibilities. You could be working for a nongovernmental organization that must train its field workers to contend with broad cultural differences in order to provide relief services and aid to overseas populations. You could be working for a state or county entity that needs to prepare first responders for potential new disaster situations.

In short, you may be involved in some form or manner (however tenuously) with the transfer of training, educational, or pedagogical material to employees or volunteers. In today's rapidly changing world, these employees and volunteers frequently need new skills, knowledge, and experiences to better compete in the global marketplace, and to respond to new challenges and job demands.

In the past, that transfer might have been handled by more experienced workers conducting walkthroughs for less experienced workers. Or, a workbook or other training materials may have been devised to teach employees new skills. A video illustrating new principles and concepts may have been produced as well.

But in the 21st century, these methodologies have become less effective. For starters, today's employees have grown up bombarded with media stimuli, and they're very practiced in tuning out droning lectures, boring print material, and "educational videos." In addition, the transferable pedagogy has become increasingly complex and nuanced, lending itself less well to traditional learning methods such as rote memorization, multiple choice testing, and watch-the-film-strip-and-get-it. Finally, in the era of mergers and acquisitions, budgets for one-on-one training and workshops with no clear-cut ROI (return on investment) are often slashed or eliminated.

Today's employees have grown up with fast-paced, immersive, interactive media. Today's technologies have enabled the relatively inexpensive construction of computer environments offering varying degrees of user immersion, user participation, and "virtual reality." In short: simulations.

Videogames like *Grand Theft Auto* and *Halo* are simulation environments. Very recently, these environments have become a partial basis for the Serious Games movement: videogames designed with serious teaching and training purposes.

You, or your boss, may have heard of these simulations or serious games. Perhaps the competition is already using or creating one. Perhaps budget money is available to build one. Perhaps you'd just like to see if you can reach your employees in more effective ways, and maybe the building of a simulation is the right step for this.

But you've never built a simulation or serious game. You do a little research and you find out that when Rockstar Games or Microsoft produces a game, they spend millions and millions of dollars.

And if the task isn't daunting enough, suddenly your boss says, "Oh yeah, and it should have a story." Or, perhaps you begin going out to professionals about your nascent simulation project, and sooner or later one of them asks, "What's the narrative that holds this thing together?"

Now what?

This book is about confronting this challenge, and showing that designing an interactive, story-driven, pedagogical simulation is not as impossible as it might seem.

The origin of this book rests in a remarkable collaboration that took place between Paramount Pictures, USC's Institute for Creative Technology, and the United States Army. Their intent was to build serious games: interactive, story-driven simulations that would train officers and commanders to handle various crisis situations.

However, the lessons and observations from this collaboration are applicable to the building of serious games in any professional, educational, vocational, or volunteer arena. Given the ubiquity and inexpensiveness of technology and distribution, an organization of almost any size can contemplate the building of a serious game to address training and educational needs.

The first half of this book begins by outlining three major projects that Hollywood created for the United States Military. These projects were expressly designed to place storytelling at the heart of the simulation. This first half will then take a broader look at what constitutes story and character, and how these components can be successfully integrated into a teaching experience, while reviewing the design principles and the paradigms developed in the Hollywood/military collaboration. We'll move on to how the instructor is incorporated into a training simulation, and how automated story generation may assist in the replayability of simulation scenarios.

The second half of this book examines the design and building of these projects: how scripts are created; how gameplay is selected; how pedagogical design and assessment fits in; and how media, gameplay, and story will drive the selection of media and platforms. The book will look at different types of simulations and offer techniques on how to maximize user immersion and interactivity, even when a budget is small and personnel scarce. Returning to how story fits into simulation environments, we'll examine the uses of story narrative in commercial games and serious games, and gaze into the crystal ball on how story will fit into different platforms and environments in the future. The hope is that the lessons learned will benefit all training designs, and encourage instructional designers, game companies, and developers of entertainment software to begin exploring this new convergence of story and simulation and its enormous potential.

You may be a project manager, an executive, a training leader, a subject matter expert, a personnel director, a professor, a fundraiser, a military officer, a government official, a regional office manager, a researcher, a textbook writer, or just someone who would like to know how to move beyond exam blue books and PowerPoint slideshows. In the following pages, we'll suggest ways that you can.

PART ONE

CASE STUDIES

2

The StoryDrive Engine

In 1995, The National Science Foundation, under the direction of the Department of Defense, sponsored a conference on the potential impact of computer games and entertainment on military strategic planning. One of their missions was to explore the use of story within computer games: specifically, the way story structure is used to present ideas within the game context.

TV and film director Alex Singer (*Star Trek*, *Lou Grant*, *Cagney and Lacy*) represented the Hollywood creative community at the conference. Alex brought along several Hollywood colleagues, including Richard Lindheim, then Executive Vice President in the Television Group at Paramount Pictures. The conference led to a discovery of common interests and a series of subsequent meetings between Paramount and the DoD.

Impressed by how engaging and memorable good Hollywood films could be, Dr. Anita Jones, then head of R & D at the Department of Defense, wanted to learn if movie-making techniques could be applied to the building of soldiering skills and practices. Paramount accepted the challenge. And so, as reported in the *Wall Street Journal* on November 11, 2001, a close collaboration began between the two entities, one that extended over many years.

Paramount and the Department of Defense began their effort with a series of research trips in order to review the kinds of simulation training carried out by the US military. They also wanted to identify an appropriate training program that could serve as a test case for the military application of Hollywood techniques. A select group of military simulation training specialists and a small team of movie, television and Internet creative people chosen by Paramount undertook the effort. Dr. Judith Dahmann, then Chief Scientist for the Defense Modeling and Simulation Office, was in charge of the DoD team. Other members included Dr. Kent Pickett of Ft. Leavenworth's Army Research Center and Dell Lunceford from DARPA. Co-author Nick Iuppa, Vice President and Creative Director of Paramount Digital Entertainment (PDE), headed the Paramount team. Nick worked under the management and direction of Richard Lindheim

and David Wertheimer, President of PDE. Alex Singer continued his involvement in the project and experienced television and interactive media writer Larry Tuch (*Quincy*, *Carmen Sandiego*) and associate producer Erin Powers were brought in to complete the team.

In order to develop an actual training prototype, a new piece of technology had to be hypothesized and defined. To help in this effort Paramount enlisted the added support of members of the Information Sciences Institute at the University of Southern California. Dr. Paul Rosenbloom was the lead USC scientist on the project.

The new piece of artificial intelligence (AI) software defined by scientists and researchers at USC and by Paramount creatives was expected to do nothing less than turn a fairly mechanical military simulation into a "Hollywood Experience." Anyone who knows Hollywood and its workings will tell you that the not-so-secret ingredient in the best movies and television is the story. In terms of simulation training, what Paramount decided was most likely lacking in military training simulations were stories to drive them. So the software concept that was hypothesized was called the StoryDrive Engine.

Armed with a crude idea of how injecting stories into simulations would make them more compelling, memorable, and effective, the research group visited US Army and Navy bases to review the state of their military simulators. Over the past several decades the military had already committed heavily to simulation training of many kinds. At Ft. Knox, Kentucky, enormous tank simulators stand side by side, propped up on hydraulic legs that allow them to buck and gyrate as trainees simulate driving across a terrain in France. As expensive as these simulators appear to be, their cost is remarkably less than the cost of allowing thousands of soldiers to drive hundreds of tanks over vast expanses of real terrain. The savings in fuel and maintenance alone are reported to be staggering. And the transfer of knowledge is considered to be comparable.

As the Paramount/DoD survey progressed from tank, to gunnery, to aircraft, to naval simulations, one thing became very clear. At the moment of combat, when soldiers are face to face with an enemy and it is either kill or be killed, stories and all that they can bring to the experience probably don't matter at all. If enemy soldiers are coming at you with the intent to kill, you're not going to pay attention to their story. Your mode of operation drops immediately to survival.

So the research group began to move away from the concept of story-driven simulations for basic combat training, but at the same time they began to see further evidence of the need for stories in other critical kinds of military training, primarily in leadership, interpersonal skills training, and especially tactical decision making under stress.

In a combat situation, a soldier may have his or her hands full and should not be distracted by the bigger picture, but the leader *has to* consider it.

Leadership decision making must be carried out with a complete understanding of what is going on. The military calls this complete understanding "situational awareness."

And so, after a 3-month review of the many major military simulation-training centers, the Paramount group proposed to focus on those exercises that require a broad awareness of the situation and important decision-making skills. Several such exercises were identified as possible candidates, but in the end, a large simulation called the Crisis Decision Exercise (conducted at the Industrial College of the Armed Forces [ICAF] in Washington, DC) was selected as an excellent venue for such a study.

The Industrial College of the Armed Forces shares a campus with the National Defense University at Fort McNair on the banks of the Potomac River. The student body is composed of soldiers in mid-career who show great promise and are candidates for advanced assignments in any of the branches of the military or in the Federal Government. Students also include members from US Government agencies such as the State Department, FEMA, and the USIA (the United States Information Agency).

The Crisis Decision Exercise is put on annually at the end of the school year at the college, and all graduating students are required to participate. At the time of Paramount's involvement, Dr. Alan Whitaker, Director of Exercises and Simulations for ICAF, managed the entire course implementation.

The Crisis Decision Exercise lasts an entire week and is nicknamed the Final Flurry Exercise because it involves application of all the skills that have been taught throughout the year in one frantic, all-encompassing effort.

Late in 1997 the Final Flurry Exercise took place in university classrooms where students played the role of members of a work group reporting to the National Security Advisor (NSA) on matters of world importance. The students were confronted with a series of hypothetical international crises and were required to make recommendations to the NSA, who in turn passed on his recommendations to the president. In the exercise, the magnitude of each problem was pushed to the maximum so that students were confronted with a world in which every major international hot spot erupted at the same time.

Instructors were give latitude in the problems they chose to emphasize and their manner of presentation to the class. They had a video that highlighted the current state of the world in 1997, mentioned the trouble spots, and then opened the door to a series of classroom work sessions. Use of the tape was optional. But somehow the instructors would have to describe the state of the world, ask for recommendations, and then leave the room for an hour or so, allowing the students to brainstorm solutions. The instructors would then return and hand out note sheets, which offered updates to the evolving world crises. By the end of each day the students would have to create a set of final recommendations to be given to the NSA and then passed on to the president.

Figure 2.1 Artist conception of the workroom where students participated in the Crisis Decision Exercise at the Industrial College of the Armed Forces.

As the days went by, crises worsened and recommendations would have to be modified or changed drastically to fit the new situations that the instructor presented.

The Final Flurry Exercise was put on in 30 separate classrooms to groups of 18 students in each class. Thirty different instructors presented their versions of the exercise. To a large extent, the quality of the learning experience depended on the skill of the instructor. Instructors with a flair for the dramatic, who were able to engage their classes with their own knowledge and inventions, did best in maximizing the effect of the exercise. To put it simply, these instructors employed the elements of dramatic storytelling in their simulations. They were doing what Paramount proposed that the StoryDrive Engine do. Unfortunately, as in all teaching environments, not every instructor possessed the same dramatic skills, and so the outcomes were inconsistent.

There were several reasons for choosing the Final Flurry Exercise as a testbed for the StoryDrive concept. A major reason was that the same exercise was presented to 30 different sets of students at the same time. This provided a great

evaluation opportunity. Control groups of various kinds could be set up within the population of classes to help evaluate the effectiveness of StoryDrive.

In May 1998 representatives of the Paramount/DoD team attended that year's Final Flurry exercise. They observed its presentation in several classes and videotaped parts of the exercise. In the end, the team came away with a strategy for developing a story-driven version. Developing a full story for each scenario, populating it with realistic human characters, creating media that presented elements of the story in short snippets that could be introduced by the instructor at varying times as needed, allowing the media to be delivered to students on individual laptop computers, and building a fictional computer network with all its trappings so that participants felt that they were operating in a realistic and highly secretive environment—all these factors would enable the power of stories to increase student involvement, and engagement, and build skills that could be tested. However, in such a plan the technology itself, the AI software that monitored the participants' progress through the story and recommended story twists and other obstacles that could maximize the participants' engagement and challenge, would be transferred into the hands of the instructors. The military calls this kind of system "Man in the Loop" because it places a human being into the simulation and requires that that person carry out the role that could otherwise be played by technology.

The plan was in some way dangerous because it chose to focus on the underlying concept of StoryDrive rather than its technology. The danger to this approach is that the improvements to the exercise could appear to be the result of better media alone rather than an entire educational strategy with an important new technology behind it. Nevertheless, the time and financial constraints of the situation almost dictated that this approach be taken.

As a result, in 1998 Paramount adopted the most pragmatic solution, which was to test the StoryDrive concept. Working closely with instructors at ICAF, the Paramount team began to flesh out the situations and build the multifaceted characters needed to bring a Hollywood style to the exercise. The arc of each story was plotted, analyzed, and revised for maximum impact. All major characters were defined in character bibles. This is a Hollywood story development tool that requires that the childhood experiences, parents' history, and life achievements of each character be thought through and written down in an extensive document that guides the writers in developing the characters and in understanding their motivation and actions as the story progresses.

Writer Larry Tuch presented the story's events through various media forms, including e-mails, formal military documents, and simulated video newscasts that portrayed the characters and the results of their actions. The Final Flurry scripts and background documents evolved into a novel-length work with an equally imposing set of design documents, including story graphs that resembled flowcharts—except that at critical points there were no branches, but something more like bundles of media elements that the instructor could

draw upon based on his or her assessment of the progress and needs of the participants.

Once the script and design documents were fully fleshed out, reviewed, and approved by the experts at ICAF, media production began. Drawing on Hollywood's exceptional pool of acting talent, Paramount was able to create all the simulated news broadcasts, news anchor commentary, reports from the field, interviews with heads of state, executive speeches, and comments required by the simulation. Director Alex Singer and producer Florence Maggio cast the complex and difficult roles and created all the necessary video. News reports of world events, put together using voiceover narration by professional newscasters, were accompanied by video footage from the military's own archives. In the end, over 600 individual pieces of media were assembled to create the difficult world situation that the participants had to address.

At the same time that the media was being created, Viacom's interactive media group in New York created software that would store, identify, and serve up these media elements to the participants. (Viacom is the parent company of Paramount.)

The software package also provided separate interfaces for students and instructors. These were designed to look like the screens of a top secret Internet system running inside a government agency. Forms within the system allowed the participants to send messages and even formal presentations to the instructor as final products of their deliberations.

The instructor's interface allowed the instructor to preview each media element, select it, and send it to the participants during the course of the exercise. The instructor had the flexibility to submit media elements at any time during the presentation and even to move media between days. For example, an incident slated for day 4 of the exercise could be presented in day 2, if it seemed that the an extra jolt was needed to make a point with the participants.

All media production and software development for a StoryDrive version of the Final Flurry exercise was completed by November 1998 and tested by members of the US military. Concerns were noted and a second revision of the course was created for a complete alpha test, which brought members of the Marines, Air Force, and Army to the Paramount Pictures studio lot in February 1999. Another successful test yielded more modifications, including a complete redo of most of the video elements of the simulation, to include new footage purchased from CNN to expand the news stories, and expanded performances by actors in the lead roles. At this time the whole software architecture was rebuilt by outside contractor Empire Visualization under the direction of super programmer Nat Fast.

In May 1999, the Paramount team descended on the Industrial College of the Armed Forces and, in an intense 2-week session, installed the complete StoryDrive Final Flurry Exercise in three classrooms equipped with 10 laptop computers each as well as separate instructor workstations. They tied in laser

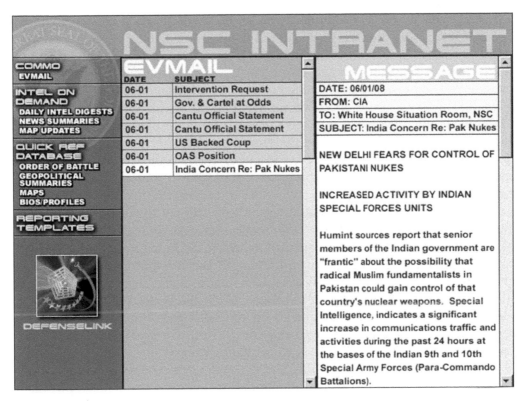

Figure 2.2 Sample participant screen from Final Flurry Exercise.

disc media projection systems to display the daily orientation video that was to be presented at the start and end of each classroom day (all other video elements were sent directly to the individual student computers as digital film clips). Paramount trained three sets of instructors to run the complete program in their classrooms and then provided a general orientation to all the other instructors. In accord with the evaluation strategy imposed by the Department of Defense, an additional 10 classes were given the complete scripts and all printed media elements as supplemental handouts to be used at the instructor's discretion.

How did it work? On the first day in each of the three classes, the students were apprised of their roles as consultants to the National Security Advisor. They were then presented news clips that pointed out a series of international problems. The clips were identified with titles to suggest that they were news stories selected from daily broadcasts by a screening group within the CIA. The stories included reports of one antagonistic regime with a complex and difficult leader in the Middle East. Other trouble spots included a potential conflict in the South China Sea, India and Pakistan, and Latin America, where severe droughts were fomenting a humanitarian crisis.

The class was asked to review a series of background documents that had been provided on their laptops. These included intelligence reports, dossiers, political maps, historic studies, and other deep research. The class then had to discuss the crisis points and to formulate a series of recommendations for the president. The president's own political fortunes were factored into the equation as well. The news stories included information on the upcoming election year. The president's most likely opponent was the governor of a large southwestern state, who was highly critical of the president's inability to deal with international issues. All these stories were laid out on the morning of the first day, and then, gradually, as new information was disclosed in messages and breaking news broadcasts, the situation grew worse and worse and worse.

Two years before 9/11, the threat of international terrorism was a major element in one line of the story. Hypothetical terrorist attacks were detailed in several news reports. Over the course of the week, charming but nefarious adversaries, opportunistic despots, drug lords, and the weather itself conspired to challenge the participants in ways that were made crystal clear to them through daily media reports and urgent messages. If no one noticed the messages the course of the conversation might go on unchallenged, but new events were almost always identified at once and often greeted by surprise and excitement that brought a charge of electricity to the deliberations.

At the end of the business day the NSA (who existed only on video) would come back to critique the class recommendation, and then the fictional president would address the nation concerning the major international issues that the class had been discussing. If the members of the class were on their toes, his speech would echo their recommendations.

The president's speech was actually constructed by the instructor from a large database of prerecorded video clips, each clip offering a different response to a specific crisis. The original content of the clips was based on input from the ICAF advisors who came up with all the possible recommendations they could imagine being given by the class. The database of video statements was stored on laser discs and accessed by the control software that was part of the instructor interface. If the class came up with recommendations that no one had thought of before, the instructor had the ability to create a special text memo from the NSA that would provide very specific feedback explaining why the president did not include that particular recommendation in his speech. But more often than not the predictions of the instructors proved to be accurate and the crisis responses that the students recommended matched, sometimes almost to the word, the prerecorded statements by the fictional president. Students in the class were dumbfounded when they heard the president repeating the words of their recommendations in his prerecorded speech.

After the first day, news of the StoryDrive version of the Final Flurry Exercise spread to the other classrooms. Most students were very interested in the new approach. Many wondered why they were not able to see the same

presentation of the materials. By the end of the full week the interest in the story-driven simulation was so great that ICAF determined to spread that approach to the exercise to the full student body the next time the exercise was presented.

The attitudinal surveys that followed confirmed the fact that the story-driven approach did a better job at engaging the students and allowing them to focus on the difficult issues involved in the simulation.

The project was regarded as a great success at ICAF and in the Department of Defense, and it was generally conceded to have proven that story-driven simulations can be effective in military training. What had not been demonstrated was a working system that used AI to maintain the story and the high level of drama needed to test the ability of the participants to make decisions under stress.

Fortunately, other departments within the US military became interested in carrying that effort forward. All of which lead to the second of the three major projects that Paramount Pictures carried out in pursuit of story-driven simulations.

SUMMARY

The Department of Defense became interested in creating a simulation-training program that used storytelling techniques to make military training simulations more compelling and effective. Paramount Pictures accepted the challenge and with the DoD embarked on a survey to find appropriate subject matter for a study of the concept. Leadership and crisis management simulations were identified as the best candidates and the Final Flurry Exercise at the Industrial College of the Armed Forces became the focus of the effort. Paramount developed a complete media package that brought storytelling techniques to the exercise. The exercise was presented to three of the 30 classes conducting the Final Flurry Exercise and was judged to be so successful that the leaders of the school adapted the approach for use across the board.

3

Collaborative Distance Learning

In 1999, the University of Southern California hired Richard Lindheim away from Paramount Pictures. Lindheim was an Executive Vice President in the Television Group at the time and was the leading force behind the Paramount/DoD collaboration. USC had received a large research grant from the United States Army to set up a university-affiliated research center, and critical to the affiliation was the bringing together of military training researchers, university scientists, and the Hollywood creative community. Lindheim was the perfect man for the job in many ways. His relationship with the DoD had already given him experience with the world of military simulation training. More importantly, he knew many of the most important people in Hollywood, he had access to the inner circles of the creative community, and he was an impresario. He knew how to stage events that could dramatize the power of creative stories in military training. And he could explain things very clearly, clearly enough for the generals who became frequent visitors to USC to understand the concepts and the technology behind the endeavors of his research center, which was officially titled the Institute for Creative Technologies (ICT).

One project on the ICT agenda involved ongoing collaboration with Paramount and its creative group. The project's goal was, in some ways, to continue the StoryDrive effort initiated by the Department of Defense. That is, it sought to create military simulations that used Hollywood storytelling techniques to heighten tension and make them more memorable and effective. Unlike the StoryDrive effort conducted for the DoD, however, the first order of business at the ICT was to construct the technology that would make StoryDrive possible.

The new project was launched in 2001. After considerable analysis and consultation with the Army, Paramount and the ICT proposed that the project focus on leadership skills involved in the running of a tactical operations center in Bosnia. At the time the Bosnian conflict was at its height and tactical operations centers (TOCs) were a key force in the growing success of the operation.

17

The ICT project was named the Advanced Leadership Training Simulation, or simply ALTSIM. Nick Iuppa again headed the Paramount effort, this time under the guidance of Paramount television executives Steve Goldman and Bob Sheehan. Larry Tuch continued as head writer and Dr. Gershon Weltman came on as creative and military consultant. Dr. Weltman was the former president of Perceptronics, the company that had built SimNet, the first major military simulation. Nat Fast of Empire Visualization provided simulation architecture and development, and Janet Herrington served as executive producer of the entire effort. ICT's Dr. Andrew Gordon became the lead researcher on the project under the direction of Dr. Bill Swartout, ICT's Director of Technology.

General Pat O'Neil, having recently returned from Bosnia himself, became the content expert for the project and worked with writer Tuch to design a story that would challenge the members of a simulated TOC. The scenario that O'Neil and Tuch developed was based on a real incident that had happened in Bosnia involving members of a weapons inspection team visiting a small village. The team discovered that all the weapons in the local weapons storage site were missing. Moreover, when they attempted to leave the area they found that angry villagers had surrounded the site and would not let them go. The lieutenant in charge of the team radioed the TOC asking for assistance, and the members of the TOC, each a specialist in a different area, had to pool their knowledge to determine the best course of action to save the endangered inspection team.

O'Neil and Tuch's design provided a backstory that added true urgency and danger to the event. Tensions were already high in Bosnia as local residents who had fled their homes under pressure from the previous government were now being allowed to return once again. But buried deep in the intelligence that Tuch wrote for the simulation was information about a local dissident leader and exponent of "ethnic cleansing" who had much to gain by seeing the Americans embarrassed by a violent incident in a local village. The revelation of this character and his intentions was to play an important role in the rescue strategy selected by the members of the TOC.

TOCs can be created in different configurations. They are often set up in a several trucks backed together so that officers can work inside and set up communication systems from which they direct operations. The staff consists, in part, of a leader (Battle Captain), an operations noncommissioned officer (Ops NCO), an intelligence officer, and liaison officers for other units in the area. For the sake of simplicity the designers of the ALTSIM exercise limited the number of soldiers in the TOC to three: Battle Captain, Ops NCO, and Intel Officer. To train collaborative skills, information was usually sent to one of these three officers and not to the others. As a result the team had to *exchange* information to gain "situational awareness."

In military terms one major component of situational awareness is "ground truth"—the knowledge of what is really happening on the ground during a battle

or some other event. In the case of the ALTSIM story, the situation was not yet a battle and the members of the TOC did not want it to turn into one.

As in the StoryDrive design, the decision makers in the TOC received information from various sources. As often happens in current military situations the US news media is on the scene very early and that fact was taken advantage of in the story. One of the first bursts of information received in the TOC is a news story describing the plight of the returning refugees. The dissident leader mentioned earlier is interviewed as well, giving his opinions on the dangers that can result from allowing the refugees to return.

As pieces of information come into the TOC the Battle Captain must choose a course of action. Radio chatter is everywhere, members of the team are shouting out observations based on new pieces of intel that they have found or incoming e-mail messages. The Ops NCO can monitor images coming in from air reconnaissance, suggesting the availability of various rescue routes if the Battle Captain wants to consider them. Maps of the area, which would normally hang on the walls of the TOC, are made part of the computer interface and are consulted as options are weighed.

The ALTSIM simulation as conceived fed information to the participants in the simulated TOC but it did not force any actions. Instead, it waited for text input from the members of the team, which it read and interpreted and used to choose the next media elements to send, much as had been done in the StoryDrive scenario. As created, the ALTSIM story had a specific path (story arc) that it sought to follow. What happened if the members of the TOC made decisions or initiated orders that did not follow this arc? This issue is at the heart of realistic story-based simulations and became one of the core problems that the ALTSIM team attempted to solve.

Dr. Andrew Gordon (the PhD researcher assigned to the project) came up with an interesting solution, which was employed in the ALTSIM project and later published in the Proceedings of the 2003 TIDES conference held in Darmstadt, Germany, and subsequent research conferences. It will be described in detail later in this book. Simply put, Dr. Gordon proposed that the simulation story be described as a series of expectations in the mind of the story's "hero," the Battle Captain. In each case when the hero took an action it should match that list of expectations. When, however, the hero took an action that moved away from the list, its effect would be to move the story *off* track. To keep the story moving toward its intended outcome then, something would have to happen to put the story back *on* track. In ALTSIM the mechanism that selected media elements and presented the story to the participants through their computers was called the Story Execution System; the system that tracked the students' progress through the story and kept the story on track was called the Experience Manager.

In the ALTSIM story the TOC was equipped with the latest advanced computer information systems that presented all e-mail, gave access to intel and deep

background, presented video from surveillance aircraft, displayed broadcast news, presented maps and allowed for their updating, and contained all military forms and allowed for forms completion online. The ALTSIM computer system was a mockup of future technology that could bring together every relevant piece of military information and make it all accessible and usable on the computer desktop. The system also featured Webcams and audio headsets so that every member of the TOC could see and hear the other on his or her own computer screen. This last feature meant that members of the TOC did not have to be in the same location to participate in the collaborative exercise. They could in fact be members of a virtual TOC where each member was at a different military base elsewhere in the country and the world, and yet, felt as though they were in the same room together.

The Story Execution System controlled the flow of media elements to the participants' computers. The Experience Manager likewise selected and presented media elements on the participants' computers. But the purpose of these media elements was often to push the story back on track.

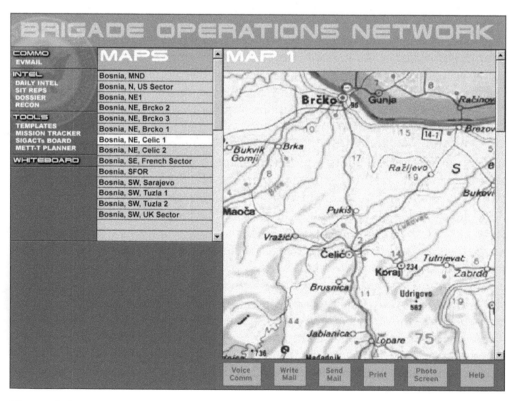

Figure 3.1 A sample screen from the ALTSIM participant interface employing the mapping tool that was built into the system.

The media elements that would intervene in the story and block an entirely new story direction were called adaptation strategies. Dr. Gordon's conception was that the simulation would have hundreds of these interventions at its disposal and would block actions that would take the story off track by applying the intervention according to a very strict set of rules—the first of which was: *if possible, don't block it.* The intention was to make the employment of the adaptation strategies as seamless and realistic as possible, and if there was any way that the action could be taken and not blocked and the story continue on track, that was the preferred method.

These kinds of interventions were helped by the very structure of the military itself, where strict organization and procedures require formal actions be taken in order to make things happen. To initiate troop movement, for example, the Battle Captain has to issue an order and that order had to be formalized though some kind of documentation. So the system always knows when the Battle Captain has issued an order and what it is. The system also knew which documents had been opened, how long they were opened, and if they were forwarded to any other member of the team.

The military hierarchy also provided a mechanism for intervention. For example, the Battle Captain has a commanding officer (CO) who reviews his or her most important decisions. The CO can simply say, "Don't do that," and an action that might take the story off track would be nullified.

Among the information that the TOC was getting was a message that reported that there were movements of paramilitary troops toward the town of Celic. This was shown by cars observed crossing checkpoints and other clues. The Intel Officer was expected to start monitoring this kind of information.

Of course, the Intel Officer's computer was loaded with all kinds of intelligence information about a great variety of events—very few of which related to the immediate problem at the weapons storage site in Celic. So, in a sense, the mission of the officer was to sift through the mountain of intel and piece together those few messages that had a real bearing on the actions that the Battle Captain had to take.

Since it was critical to the story that the Battle Captain be made aware of the movement of paramilitary troops toward Celic, the Experience Manager could send more obvious information to the Intel Officer until it recognized that the Battle Captain had become aware of the danger and had acted—sending a rescue mission to save the weapons inspection team before the paramilitary forces could reach the area and cause some real trouble.

As a check on the actions of the Experience Manager, ALTSIM once again employed the "man in the loop" strategy. It had an instructor workstation as a means of allowing an instructor to monitor the progress of the story. When the Experience Manager noted that the participants were doing things that would take the story in a direction that would not work, it first alerted the instructor and suggested that an intervention should be sent. It was up to the instructor to

approve the intervention, or even to create an original message of intervention that might fit precisely with the conversations that the members of the TOC were having about what should be done. The instructor could, after all, hear the conversations—something that the computer system could not do.

In the course of the original story, the Battle Captain should instruct the Ops NCO to assemble a task force to proceed to Celic and rescue the inspection team. At the same time, he should send air support to intercept the paramilitary troops before they reach the town.

At this point another function of the Experience Manager came into play. Its purpose was not only to monitor the progress of the story and keep it on track, but also to assure the quality of the educational experience. If the participants seemed to be breezing through the simulation, the Experience Manager could add events to make things more difficult. For example, it could introduce fog into an area where the helicopters were supposed to land. That would complicate the air mission. It then would become necessary for the Battle Captain to determine an alternate use of air support, if any.

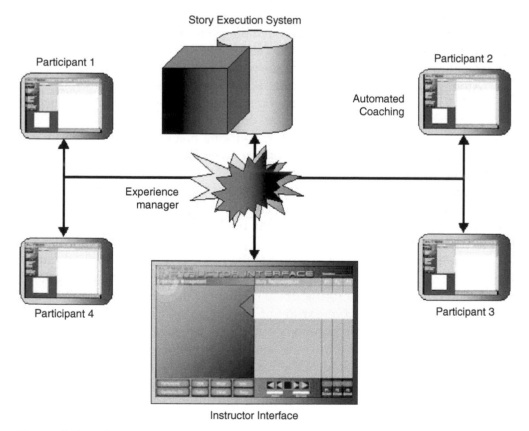

Figure 3.2 A breakdown of the systems that combined to create ALTSIM as it was demonstrated at the Institute for Creative Technologies.

While ALTSIM did follow one simple arc to the conclusion of its story, it did allow for multiple outcomes. The Experience Manager could calculate which decisions the Battle Captain made, and it could choose an ending that was appropriate to the quality of skill that was shown by the Battle Captain and the members of the team. In the ideal story, the Battle Captain made all the correct decisions and the rescue column reached Celic and saved the inspection team without firing a shot.

During the first year, ALTSIM was demonstrated to visiting military by using National Guard troops who acted out the simulation. Later, professional actors were used. By the end of 2002, a whole new scenario had been developed and members of the team could execute a true working simulation from start to finish.

At that time, a committee from the US Army reviewed the project and its research direction and recommended a significant change. What resulted was really a whole new simulation system focusing on commanders in the field instead of those in a tactical operations center. To accomplish this, the ALTSIM team had to move away from the development of training systems that focused on simulations of computer networks inside of command centers. Instead, they began to apply the concept of story-driven simulations to 3D worlds and virtual characters. In March 2003, the third and final collaborative effort between Paramount Pictures and the military was launched. It was called *Leaders*.

SUMMARY

The efforts of Paramount, USC, and the Department of Defense to initiate a system for creating story-based simulations extended into another project that was carried out for the United States Army at USC's Institute for Creative Technologies. The Advanced Leadership Training Simulation, ALTSIM, began with a focus on the technology needed to create a working story-based simulation. The system's Story Execution System brought together various media elements to tell the story of an inspection team trapped at a weapons storage site in the Bosnian village of Celic. The story was told through the computers of members of a tactical operations center. The TOC officers had to share their information in order to arrive at a plan that would save the inspection team. The steps in the plan were implemented by sending orders through the computers in the TOC and, by monitoring these orders, the system could employ an AI engine called the Experience Manager to keep the story on track and propel it toward its required climax.

4

Branching Storylines

The new simulation that the US Army proposed to Paramount Pictures and the Institute for Creative Technologies (ICT), as a redirection of ALTSIM (Advanced Leadership Training Simulation) was called *Leaders*. *Leaders* is in many ways a dramatic departure from preceding story-driven simulations.

The simulation was set in the field, and so the device of using mock computer networks as media presentation systems became unworkable. What had to happen instead was that the whole field operation had to be turned into a 3D virtual environment with participants given a complete captain's-eye-view of the world. In other words, *Leaders* ended up looking very much like a 21st-century video game. To allow participants to "talk to" the nonplayer characters (NPCs) within the simulation, ICT researchers developed a *natural language interface* that permitted a freewheeling exchange between the commanding officer (CO) and subordinates. It used sophisticated text recognition software to understand words and sentences that participants typed into the system.

Early in the design of the simulation the ICT, Paramount, and their Army advisors decided that the participants should actually be given a broader view than the first-person perspective of the commanders they were portraying. Participants were allowed to see events that were out of the field of view of their characters, if those events helped set up the story or reinforce the teaching points. This practice is a common convention of commercial computer games where characters will often suddenly and dramatically switch from a first-person perspective to a god's-eye-view of the world.

To be able to deal with each individual decision-making element of the simulation, the team members created a formal structure for each block of the story. They called these "molecules" and all molecules began with a setup scene, which provided background information for the given situation. Each molecule then progressed to a point where the leader had to make a decision. The decision was prompted by a question from one of the commander's NPC subordinates. At that point the leader would type in a response in his or her "own words." When the

25

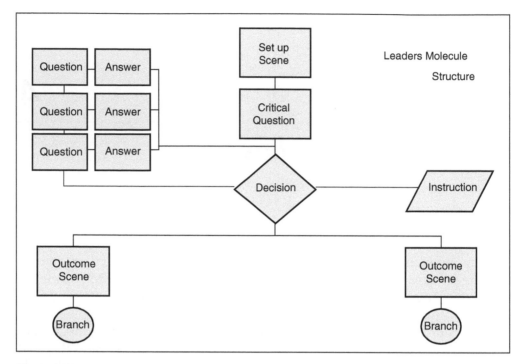

Figure 4.1 Basic structure of a molecule of *Leaders* content showing the key decision and the surrounding media elements.

response was recognized by the system, the appropriate NPC subordinate delivered a verbal acknowledgment. The story then branched to an appropriate outcome scene that gave a sense of the consequences of the decision. Within the conversation between the CO and NPC subordinates, there was room for questions and answers, more details, and even some instruction.

In 2002 and early 2003, when ALTSIM was working through complex research issues relating to the exercise of free will within the confines of a story-driven simulation, the ICT was experiencing great success in some of its other projects. *Full Spectrum Warrior*, a first-person game that showed troop deployment in battlefield situations, became an extremely successful learning simulation as well as a commercial game and its success probably influenced the decision to make the *Leaders* project a battlefield simulation. A second project called CLAS (Think Like a Commander—Excellence in Leadership) presented a dramatic portrayal of a leadership decision gone awry.

The research team at the ICT chose the story from the CLAS exercise as a perfect scenario for the *Leaders* project. The exercise began with an ICT original film called *Power Hungry*, produced by Kim LeMasters from a script by Jay Douglas and LeMasters and directed by Hollywood TV heavyweight Chuck Bowman (*Dr. Quinn, Nash Bridges, The Profiler*). The project was lead by the

deputy research director of the ICT, Dr. Randy Hill, working with Dr. Andrew Gordon (who also served as the chief researcher on *Leaders*).

In the film *Power Hungry*, a commander receives an emergency assignment to manage a humanitarian food distribution operation in Afghanistan. The previous commander has become ill and has to be airlifted out. The distribution operation is set to begin the morning after the Captain arrives. The Captain's immediate subordinates begin his first day by confronting him with a series of questions about the logistics of the operation. A humanitarian organization had dispatched a convoy carrying truckloads of food toward the site. The trucks are due within a few hours. The Captain has to determine the best allocation of troops to prepare the site. They need to string barbed wire for crowd control, they have to maintain the security of the route into the site, and they need to manage a large crowd of local villagers who have already begun assembling to receive food. The operation is suddenly complicated by the appearance of a local warlord who wants to participate in the operation. The appearance of this new personality presents a dangerous distraction for the locals and for the Captain and soldiers. In *Power Hungry*, a series of bad leadership decisions causes the situation to deteriorate rapidly. The warlord is not dealt with adequately and so he remains as a destabilizing influence at the site. The trucks show up early, the crowd rushes the trucks, shots are fired, and what was to be a peaceful and humanitarian food distribution operation begins to turn into an international incident.

In the CLAS exercise, an interesting set of interactive interviews with virtual characters from the film allows participants to investigate the disaster and figure out what the Captain did wrong.

The CLAS exercise was judged to be highly successful by the Army and the participants.

"But wouldn't it be great," suggested Dr. Bill Swartout, ICT Director of Technology, "if we could simulate the entire food distribution operation, create virtual characters that carry out the bidding of the new commander, and even allow a participant to *become* the commander and make the critical decisions? Wouldn't it be even better if we could do this in such a way that bad decisions would lead to the same negative outcomes as those seen in the film, but good decisions would lead to a successful operation?"

Content for the CLAS project was assembled by a research team that visited the United States Military Academy at West Point. The team included Dr. Randy Hill and Dr. Andrew Gordon from the ICT. The men conducted interviews with commanders returning from the field. The interviews were condensed and distilled into 63 teaching points. The most relevant of the teaching points were applied to the *Power Hungry* video scenario created for CLAS. But the new *Leaders* project could allow exploration of all 63 points.

The creative team from Paramount (consisting of Nick Iuppa, Gershon Weltman, writer and co-author Terry Borst and Janet Herrington), joined by Dr.

Gordon and research associate Brian Magerko, sorted the 63 teaching points into five chapters based on the commonality of their content. From these organized sets of teaching points the team then built a branching storyline in which each teaching point had only two possible outcomes. The first pair of outcomes led to another level of outcomes and then to another until there were four levels of outcomes per chapter. This meant that the participant would make four decisions before reaching the end of each chapter.

At the end of the chapter, the points all led to a common global event that brought all the possible branches back together and enabled the next chapter to start at a single point. This collapsing down of the branching storyline at the end of every chapter made it possible for the elaborate simulation to progress without growing into an unmanageable structure.

To fit the wide variety of leadership decisions into the *Leaders* simulation it was necessary to expand the basic *Power Hungry* scenario. To this end the Paramount team extended the story back into the previous evening. This allowed the inclusion of several personnel issues that were among the teaching points. Some individual soldiers would have important roles to play in the next day's operation and so the management of these soldiers and their problems could be seen to have a direct bearing on the outcome of the simulation.

Another challenge faced by the Paramount team was the need to determine exactly how the warlord could affect the mission and how the Captain could take

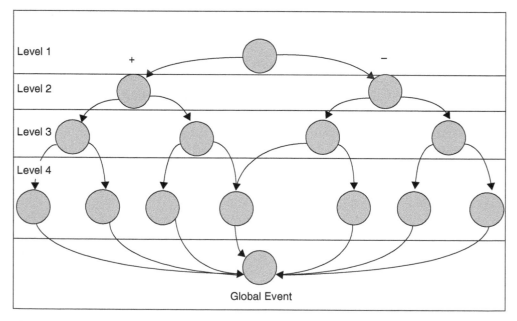

Figure 4.2 Organization of a single chapter of the *Leaders* story flow showing the branching of the decisions leading back to a single event that allows the next chapter to begin at a single point.

advantage of his presence to make the operation a success. Since the story within the *Power Hungry* film was in fact a *disaster* scenario, the possible positive effects of the warlord's presence were never fully explored. Working out the events that could lead to a positive outcome required additional research with military experts as well as good, hard story development.

The Paramount team also had to identify those especially dramatic teaching points that could serve to control the dramatic arc of the story. In addition, they had to place those teaching points at strategic moments within the simulation story so that they would provide the growing sense of drama and urgency needed to create dramatic tension.

The Paramount team also saw opportunities to create special challenges for the Captain in his relationships with his direct subordinates. They found related teaching points and included those elements as well.

Much was made in discussions with the military about the Hollywood formula for building exciting stories and the way it would be employed in the *Leaders* project. The screenwriter on this project (experienced in television and interactive videogames) applied a classic Hollywood story development approach to the *Leaders* simulation. This approach required that there be rising tension through out each chapter, building to a point of climax at which point the global event would occur.

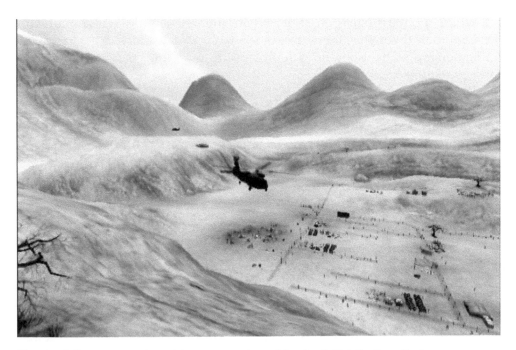

Figure 4.3 3D virtual world representation of the food distribution site in Afghanistan, which is the training ground for participants in the *Leaders* simulation.

Since the events were organized into a branching storyline it was necessary that each event flowed logically into the next and that each event built dramatically on the previous event. Although the screenwriter was scripting the simulation, the entire Paramount team designed the story. This is actually a very common practice in Hollywood screenwriting, especially in television where writing teams develop the story before a single writer creates the final script.

The story development team had to arrange the events (molecules) in each path of the story into a classic narrative arc, rising to a climatic moment. The task then was to (1) look at the content of events that were grouped together because they all dealt with the same kinds of skills and problems, (2) establish links between them so that they shared common characters, (3) order them so that the complexity and drama of the problem escalated, and (4) find a way to tell a dramatic story about each set of events. This daunting organizational and creative task was carried out by the story design team over a period of months, until there were complete flowcharts of each chapter with teaching points tied to characters and related types of problems and story issues that built dramatically from one to the next and the next and so on. The details of this activity are spelled out in Chapter Seven of this book.

As a validity check, the teaching points were cross-referenced against a classification of leadership skills that had been prepared by the Army and published in *Practical Intelligence in Everyday Life* (Sternberg et al., 2000), a text on tacit knowledge. This was done to make sure that each participant would be exposed to teaching points from each skill classification no matter which path their decisions took them on. The matrix of the task classifications, teaching points, and leadership skills was refined repeatedly through the course of the content development.

While the Paramount team was creating the final story for the simulation, a group of very creative graphic artists within the ICT, under the direction of Kurosh ValaNejad, began constructing the environment in which the simulation was to play out. They built a 3D model of the encampment for the company that was conducting the operation. They built the food distribution site in such a way that the semi-autonomous characters from within the story could complete the construction of the site. And then they built those characters as well. (Building a virtual 3D world will be discussed further in Chapter Twenty-Four.)

More sophisticated lead characters were fully scripted and their performances were acted out within the framework of the story as though they were animated characters operating within a conventional feature film. As in previous story-driven simulations done by Paramount for the military, character development included the creation of a complete character bible that explained the background and motivation of each major character.

The audio for the characters was recorded by professional actors who read through the hundreds of pages of alternate responses that the screenwriter wrote for every imagined eventuality, along with other responses needed to accommodate unanticipated input from the participants.

The complete set of questions and responses were turned into a text role-playing game and posted on several military training websites. Officers were asked to play the game and this gameplay helped "train" the engine that was driving the natural language interface. Additionally, the gameplay identified hundreds of other responses that needed to be authored to round out the complete database of *Leaders* verbal content.

As a further challenge to the *Leaders* development effort, the ICT decided to assemble the simulation using Narratoria, a new authoring tool created by Martin van Velsen, and a team of computer engineers at the ICT. (Narratoria is discussed further in Chapter Twenty-Six.) Narratoria took the script elements, the 3D world that was created, the characters, and the audio elements that made up the speeches of the characters and brought them all together into a working simulation. The assembled simulation was then repeatedly tested to debug its performance and to help identify scenes that could use a more dramatic rendering.

Roland Lesterlin, a Hollywood director, directed the performance of the actors for the audio elements of the simulation and staged the scenes. That is, he set dramatic camera angles and lighting and positioned the characters in order to give the simulation a Hollywood appearance. Lesterlin accomplished these tasks through the simulation integration system in Narratoria.

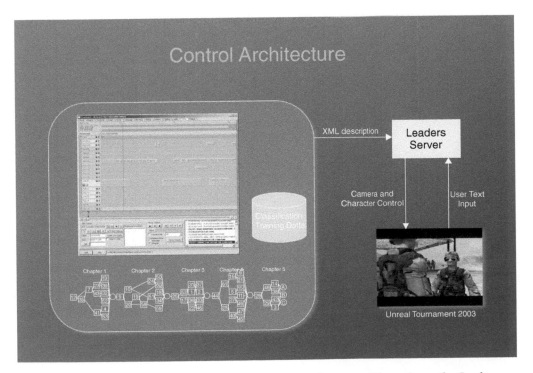

Figure 4.4 A diagram of the control architecture used to assemble and run the *Leaders* simulation.

The *Leaders* simulation and its underlying technology were successfully completed in September 2004 and today form the basis of serious game projects.

SUMMARY

The redirection of the ALTSIM simulation turned it from a computer-based command center simulation into a computer game set in the field of a 3D virtual world. The new simulation was called *Leaders* and adapted its story from an already successful training film called *Power Hungry*. In creating the interactive *Leaders* simulation, the Paramount team adopted all 63 teaching points that the ICT researchers had gathered for the development of the dramatic film that was used in its successful CLAS exercise. By classifying and organizing these points and dramatizing them through the use of realistic characters and events, the team then provided a story outline, which the screenwriter turned into a compelling set of scripts. The scripts were assembled into an interactive game through the use of a new authoring tool called Narratoria, created by the ICT. The same tool also integrated the graphics and audio tracks and text recognition engine into a final working simulation prototype by the end of 2004.

PART TWO

STORIES AND STORY DEVELOPMENT

A Good Story (The Simple Answer)

The representatives of the Department of Defense who came to Los Angeles in 1997 found the secret of making compelling movies very quickly. A really good story. Once they had the concept and even after they had tried to implement it in a series of training simulations, they were still faced with the interesting question, "What makes a good story, or what makes something a story at all?"

Certainly, everyone from Aristotle to Mel Brooks has voiced an answer to that question, but the best answer we have encountered comes from longtime Hollywood scriptwriter Bill Idelson. Idelson has written, edited, and produced hundreds of television shows (mostly comedies), but these days he spends his time teaching small groups of writers in his home. He teaches the craft of Hollywood storytelling. According to Bill, just about everyone in the world these days is a writer. And to his tastes, far too many of them live in the Hollywood Hills.

"Listen," he tells his class on the first evening. "Can you hear them . . . the writers in the Hollywood Hills? Night and day they are writing. They generate enough pages to wallpaper every room in Los Angeles, and all the cars, and all the highways too. In a few years they will have written enough to wallpaper the whole world. Can you hear them? What the hell are they writing?"

"Something they think is important," a student volunteers.

"Yes, important," Bill answers. "But will it sell? Never! None of all those pages will ever be turned into a screenplay or make it onto television. And so the scripts for television and films continue to be created by a few handfuls of professional writers."

"What do the professional writers know that the writers in the Hollywood Hills don't know?" Bill asks. The answer from the class is obvious: "How to tell a story."

"Right," Bill answers. "But you know that's not too easy. Everyone talks about stories but there are very few really good definitions of one. What is a story anyway?"

"It has a beginning, a middle, and an end," someone says.

"So does a piece of crap," Bill answers, paraphrasing a line originally attributed to Mel Brooks.

"Here's my definition," Bill says. "It's not perfect, but it's better than most." He goes to a rickety blackboard he has propped up at the head of the table and draws a circle.

"What is that?" he asks, and then he interrupts himself. "Better let me tell you . . . it's the hero. It can be a single person or a group of people but this is the hero."

He draws a star above and to the right of the hero.

"And what is this?" he asks.

"The goal," someone suggests.

"That's right," Bill answers. "The goal. We have a hero and a goal. But do we have a story? Hell, no! Why not? Because something is missing. What's missing that would make this a story?"

The class is silent for a long time. Bill studies them and then he draws a big rectangle between the hero and the goal. "What's that?"

Silence.

"It's an obstacle. Something that prevents the hero from reaching the goal. Why is that important?" Bill starts answering his own questions. "It's because the audience wants to share in the hero's experience of overcoming the obstacle. That's what turns them on. But if the obstacle is overcome too easily, the audience loses interest. They don't care. They go away.

"The obstacle has to be as big and awful and as monstrous as any obstacle could ever be. The hero has to throw himself against the obstacle again and again so that the audience begins to identify with the hero, to cheer him on. It makes their juices flow. That's what writers are after—making the juices flow, engaging the audience, making them remember, making them come back for more.

"It's not easy. It's very hard work. Many good writers have gone to an early grave because they couldn't do it successfully. But that is what you have to do if you want to be a successful writer."

Unlike many courses on writing that discuss structure and plotlines and review the great Hollywood movies, Bill's course is designed for skill building. That is, the students are given writing assignments to work on every week and then they bring their scripts in and have the members of the class read them aloud while Bill observes and comments and challenges.

"What kinds of obstacles are there?" he asks.

"There are only four:

1. Something from nature (a force or a creature or something—Moby Dick is a classic obstacle).
2. Another person.
3. The goal itself. If a guy is after a girl, the girl is often the goal and the obstacle.

4. Those rare cases where the hero is the obstacle. Hamlet? There would not have been a story if Hamlet were not his own obstacle."

Over the 13 weeks of the course, Bill drives people to write realistic dialog, to create believable characters, and most importantly, to create stories that have powerful obstacles.

There is one amazing assignment in Bill's extensive arsenal that really brings his point home. It goes like this:

"Listen," he says at the end of the third or fourth class, "I want you to write a short script based on the following idea:

"Two college professors are married and very much in love. She goes off to the Congo to do some research and she is gone for six months. At the end of the

Figure 5.1 Bill Idelson's simple answer to story construction.

six months, she returns suddenly. The husband is thrilled to see her. He runs up to her.

'Darling', he says, 'I've missed you so much.'

'And I've missed you.'

'Are you all right?'

'Yes, I'm fine, but so many wonderful things have happened, I just have to tell you about them.'

'Great, but first why don't we go upstairs for just a minute and get reacquainted?'

'That would be wonderful, darling,' she says. 'I'd like that. But first there is someone I want you to meet.'

"She leads her husband to the door, opens it and standing there is a *gorilla*."

"Give me a six-page script about that," Bill says to conclude the lesson.

A week later the class reassembles, very happy and proud of the very creative work they have done. The first student to have his story read has the husband and wife at odds with each other. Her leaving caused a big fight and now the husband is indifferent. She's not worried. She has found someone in the jungle that has helped her understand her husband and how to make things work for him. It's the gorilla, a female gorilla that is also a marriage counselor.

As the script reading ends, Bill's look turns sour.

"Why did you make the gorilla a female?" he asks.

"To avoid the obvious confrontation with a huge male gorilla," is the answer.

"Writers are cowards," Bill responds immediately. "Listen, if you are walking down the street and you see someone coming toward you, someone mysterious and menacing, someone who might do you harm, what do you do? You cross the street, right? You'll do anything to avoid meeting that person.

"Writers can't do that. Writers can't be cowards. They have to walk right up to the menacing person, look them in the eye and say, 'Okay. Now what?'

"I've given this assignment hundreds of times. I've had female gorillas, I've had baby gorillas, I've had gorillas who are sedated or in cages. What good is that? The dramatic scene, the scene that makes the audience's juices flow is when the gorilla is big and menacing and as much in love with the woman as her husband. The gorilla is a rival; the gorilla is a challenge. The gorilla is the obstacle. The husband's efforts to get his wife alone and away from the omnipresent protective urges of the gorilla, is what makes this a story."

COMEDY, DRAMA, AND PEDAGOGY

Bill Idelson is a comedy writer. His credits include *The Dick Van Dyke Show*, *The Bob Newhart Show*, *The Odd Couple*, among others. It could be argued that skills at comedy writing are not necessarily those that will lead to the successful

creation of serious games or military simulation training. The truth is that the formula for the successful construction of a story applies to comedy and drama. Though Bill may not want to admit it, his story structure is very much like that of the noted story lecturer Robert McKee, who brings all stories to a climax in which the hero must face the ultimate obstacle, which at that point, in McKee's words, is the embodiment of all his or her greatest fears and challenges.

Teaching is about having students confront obstacles and challenges, and find strategies to cope with and overcome those obstacles. In this and many other ways, story material can serve the delivery of pedagogy, investing it with even greater meaning and impact.

SUMMARY

One very clear definition of a good story requires that it have a hero who has a goal but who must face an obstacle standing in the way of reaching that goal. The bigger the obstacle, the better the story.

We will talk more about story structure in the next chapter. But when all is said and done, perhaps the best way to make sure that you have constructed a story that will make the audiences remember, learn, and come back for more, a story that makes the audience's juices flow is to start by asking yourself, "Where is the gorilla?"

Other Perspectives on Story

Stories are lies; and the storyteller is a liar. But few think in such terms. Honest, hardworking people sit enraptured, willingly absorbing the lies, finding within them reflections of themselves and their views of the world: right defeating evil, the worth of an individual will, the triumph of justice, the spirits of both man and woman raised above the mean existence of everyday survival. In the storyteller's lies, they find a kind of truth. Perhaps not the kind of truth that is but the kind that should be. During the story, the truths are lived; afterwards feelings of those truths remain, to be remembered and touched during reality's unceasing efforts to drive men and women into the futile mire of sameness. (From *A Science Fiction Writer's Workshop-I: An Introduction to Fiction Mechanics* by Barry Longyear)

So one way to look at story creation is to consider it as the organization of events. Even Bill Idelson's simple plan for the creation of a story requires that within the hero's quest for the goal, and the constant struggle against the obstacle, there should be an ordering of what happens. Essayist Bill Johnson expands on the idea by describing story this way:

Through experiencing a story's arrangement of its events, a story's audience has experiences of "life" more potent and "true" than real life. "Life" with meaning and purpose. Where people get what they want if they really believe. Wherein true love exists. Where inexplicable events are resolved. Where even pain and chaos can be ascribed meaning.

This makes a story unlike the real world, where experiences happen, events unfold, time passes, but not always in a way that offers resolution or is fulfilling. Every element in a story is chosen to create its story-like effect of a resolution that creates a quality of potent, dramatic fulfillment.

Thus, a story takes life-like events and gives them a sense of meaning and purpose that touches us. Even a story about chaos and the meaninglessness of life, if well told, can ascribe a quality of meaning and purpose to those states. (From *A Story Is a Promise* by Bill Johnson)

So, in order to create a story it is important to structure events in a certain way. Of course there may be many ways to structure a story, but, after all, the members of the US Military who came to Paramount looking for our approach to storytelling were looking for the Hollywood way. And there is a Hollywood way to tell a story. Make no mistake about that.

THE HOLLYWOOD STORY

In his book, *Story*, noted writer and lecturer Robert McKee goes into great depth on the structure and mechanics of Hollywood storytelling and screenwriting, further explicating the model identified by other screenwriting theorists such as Syd Field and Linda Seger.

In a nutshell, the Hollywood protagonist experiences a change in life caused by an inciting incident. The inciting incident is some action or event that abruptly changes the normality of the protagonist's life, causing him or her to envision a new, better state and set a new goal.

In the minds of the audience, the inciting incident also creates the need for another scene that must be experienced before the story is over. That scene is sometimes called the obligatory scene or the crisis. As in Bill Idelson's model, this scene happens when the protagonist, in seeking that better state, comes face to face with an obstacle. But in this crisis moment, the protagonist faces the *ultimate* obstacle.

As McKee and others have pointed out, when the protagonist comes face to face with this obstacle, the key issues in the story become crystal clear. The audience and the protagonist both gain full understanding of the values at stake. The protagonist faces a dilemma, must make a decision and take action. And that action becomes the climax of the story.

As the protagonist moves from the inciting incident toward the crisis moment the story moves forward through conflict. The protagonist and other characters make decisions and take action and things do not necessarily turn out the way they expect them to. This is critical because it is in the moment of conflict between expectations and reality that the audience and the characters are caught off guard. According to McKee, there is surprise, insight, discovery and excitement. The combination makes the audiences' juices flow. The story builds through a series of these conflicts, or progressive complications, which grow more intense as the story moves along.

McKee says that the arc of the story is the broad sweep of change that carries the story from beginning to end. But this arc is built through smaller changes, which occur through progressive complications, conflict and resulting insight.

Figure 6.1 shows a simple diagram of the arc of the story, which was used to explain the structure of Hollywood stories to members of the military. It identifies the inciting incident, progressive complications, the crisis decision, and the climax. This same model was used to classify kinds of story elements for the automated story development system described in Chapter Nine.

Figure 6.2 shows how the arc structure was later employed in the interface design for an authoring tool that was never built, but which was intended to enable writers of future story-driven simulations to create their scripts. The tool suggested that there were templates for certain kinds of simulation genres that could be used and reused, and that unique interface devices such as text entry systems, video clips, text documents, and audio files, could be created using special tools that would help assure that they were developed to the specifications of the system. AI assistants were hypothesized to ensure that the proper dramatic elements were present in the story. For example, they would assure that

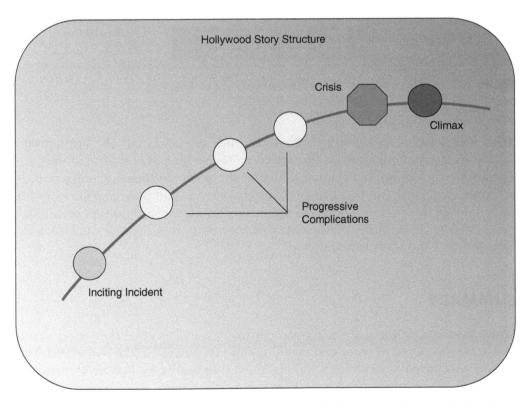

Figure 6.1 Slide from Paramount Presentation to the U. S. Army explaining the classic Hollywood Story Structure.

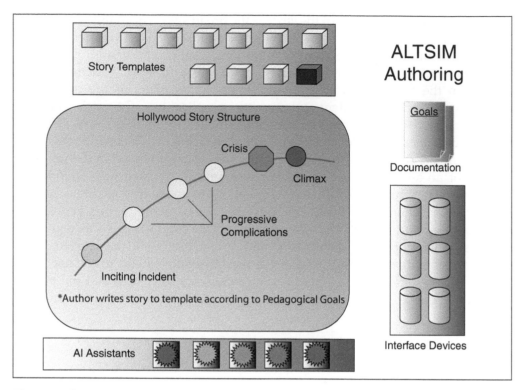

Figure 6.2 Conceptual model of authoring tool for ALTSIM.

there was indeed an inciting incident, a crisis moment, and the appropriate degree of dramatic tension in the selection of the moments that made up the story. As you will see in Chapter 10 one of the most obvious outcomes of participants exercising free will in a simulation system is that they take the story off track and in the process eliminate the crisis completely. So authors of simulations need to account for participant behavior that takes the story off track by assuring that the crisis is maintained.

SUMMARY

Many theorists define story as the structuring of events so that they make sense and achieve a sense of order and meaning not experienced in the real world. The Hollywood story, as described perhaps most thoroughly by Robert McKee, has a more detailed approach. An incident causes the story's protagonist to seek a new and better state. Forces of antagonism stand between the protagonist and the goal and reach their greatest strength at the crisis moment when the protagonist must make the ultimate decision and take an action, which becomes the

climax of the story. Between the inciting incident and the climax, the protagonist faces lesser conflicts that provide insights and a rewarding rush of discovery for the audience. It is the selection, organization and building up of these events that create the story arc that is at the heart of the Hollywood Story.

The concepts of surprise, insight and learning that come at key moments of the story have special meaning for stories used in serious games, and the next two chapters will explore them.

7

War Stories and Parables

From parables to fables to scripture, we think in terms of stories to explain our world. It's as though we can't think of ourselves without them. (Margaret Anne Doody, Professor of Literature, University of Notre Dame)

Let's talk about stories and their use in learning. In addition to providing a way to think about ourselves, and to give a sense of meaning to life, there are at least five other separate and distinct purposes that stories can serve in learning situations and serious games. Stories can serve as memory aids. They can function as examples of principles and behaviors that are too complex to be communicated by simple lists of descriptors. They can provide a context in which to introduce participants to other cultures and aid in that understanding. They can immerse learners in a complex experience and make them familiar with the kinds of stress and other difficulties they will face in that world. And they can be mechanisms for identifying the principles of correct performance. There are certain categories of subject matter that lend themselves to story-based instruction. These include subject matter relating to values, interpersonal skills, leadership skills, and principles for operating in very dangerous environments.

STORIES AS MEMORY AIDS

If you wanted to teach your child the very simple concept of perseverance, you could lecture them on staying with a plan. You could dig up that classic old Disney song, "Stick-to-it-ivity" (from the film *So Dear to My Heart*). Or you could tell them a fable about a very fast animal like a rabbit that decided to challenge a slow turtle in a race, and how the turtle wins because *slow and steady wins the race.*

If you wanted to make a point about racial and religious tolerance you could likewise sing songs, recite poetry, or tell the very famous story of the man

who was traveling along a road when he was attacked by thieves. They took everything he had, beat him, and left him for dead. In that story he tried in vain to get help from passing doctors and priests, but they ignored him. It wasn't until another man came by that our hero was rescued. That other man was from an ethnic group that was despised by the poor battered man and his clan. And yet the despised man carried our hero to the nearest town and paid for all his care until he was well. That despised man became an object lesson in tolerance and he taught the poor beaten man and everyone else that hears the parable that there are Good Samaritans in the world and it doesn't matter what ethnic or religious background they are.

Bottom line? If you want to teach a valuable lesson, make up a story that conveys your message, and then fill it with interesting characters and memorable events.

STORIES THAT SERVE AS EXAMPLES OF COMPLEX BEHAVIORS

We've all heard the term "war stories." The Army itself uses war stories as a unique tool in leadership training. In an introduction to the textbook *66 Stories of Battle Command*, which is used at the US Army Command College at Ft. Leavenworth, Kansas, General Tommy Franks writes:

> Years ago as a young officer on the verge of entering my first war, I knew an older soldier, a veteran of the Korean War. I listened to many stories told by this soldier, and embedded in those stories were lessons arising from the experience of combat. These were real stories of decision and the emotions surrounding them, set in actual wartime situations, not merely precepts in a leadership manual. Later, facing the challenges of combat, I recalled those lessons and the stories that had made them memorable. These war stories have been an important and unmistakable part of my preparation for combat.
>
> This book (*66 Stories of Battle Command*) contains stories from field and general officers commanding in training exercises. In their stories they describe their thoughts, their actions, their successes and especially their mistakes. In each story the commander tells how he learned an important lesson in battle command and he identifies the lesson. Their willingness to share is striking from every contributor.
>
> Few of these (stories) are about tactical maneuvers and doctrinal principles. Instead, they are stories of friction and confusion, friction generated by the challenging task of orchestrating the actions of a large

complex force to gain and maintain the initiative. This, under the pressure of a hostile environment, time and a wily punishing (opponent) who knew the habits of our commanders as well as they know the terrain. And they are stories about growth as the commanders strengthen their intuitive feel for battle command, a process achieved through study, practice, interpreted experience and the observations and experiences of others.

Command under fire is as complex a behavior as there can be. Harsh reality has taught the US military that the challenging task of orchestrating the actions of a large and complex force is one that benefits from the personal perspectives of the soldiers who lived through it. These perspectives illustrate the fog of war in which the learners will soon be operating and they provide a mental reference for soldiers in similar circumstances.

It is also important to understand that these same principles described as working for the military also apply to *any* individual or organization engaged in complex behaviors. Rescuers, firefighters, police officers, medical teams, athletic teams, teams of just about any kind of skill or profession, all need the kind of awareness that stories are best at conveying.

STORIES THAT PORTRAY OTHER CULTURES AND BUILD CULTURAL AWARENESS

Cultural awareness is a complex behavior, one that is broken out separately here because it is so important and so unique. It requires a break from traditional "us/them thinking" which has become ingrained in our natures throughout our violent history and pre-history. The key to cultural awareness is to recognize the commonalities in all humanity but also to understand and value the differences. In a world where cultural awareness is growing more important every day, not only for the US military but also for corporations and even individuals, stories can add great benefits to learning. Stories provide the context and setting through which to present the familiar and unfamiliar elements of culture. They introduce us to characters who we can get to know, understand, and with whom we can empathize. If you are training soldiers who face assignments in foreign lands, personnel departments in corporations or businesses, or individuals who must learn to work and live with fellows from entirely different cultures, stories can be the tool through which you can build understanding.

STORIES FOR STRESS-EXPOSURE TRAINING

Really great skills training will not be of any value if the performance that is taught cannot be transferred onto the job site in the real world. There are several

reasons why the transfer may not take place, but perhaps the most critical is the presence of stress and complexity in the real world environment. It is one thing to be able to do something in the antiseptic environment of practice, another to be able to do it on the job.

In a chapter-length discussion on stress exposure training, James E. Driscoll and Joan H. Johnston (1998) present a case for a training system that enables performers to maintain effective performance under stress. There are three steps to the model: (1) teach the performance; (2) enable the performers to transfer the correct performance to the real world by injecting stress into the practice experience; and (3) build performer confidence. This is done gradually so that the performer learns to gain familiarity with the stress environment and develop techniques for maintaining a high level of performance in the face of that stress.

In complex command and control situations as well as in management, one element in the stress situation is the confusion that swirls around the decision maker, causing distraction and even the paralysis of inaction. Another element is an awareness of the risks and dangers and complex consequences of actions. In other words, knowing the big picture can be stress inducing. Consequences, personalities, political complications, personal goals, individual conflicts, these are all the stuff that stories are made of. Building story elements into "stress exposure training" can strengthen it, make it more memorable and more effective.

STORIES TO IDENTIFY CORRECT PERFORMANCE THROUGH TACIT KNOWLEDGE

What Tommy Franks alluded to in his description of war stories and the benefit that they can provide to learners, is something called tacit knowledge. Sternberg's *Practical Intelligence in Everyday Life* identifies tacit leadership knowledge as "that which is based on personal experience, not well supported by formal training or doctrine, expressed in some form of action and pertaining to intrapersonal and interpersonal aspects of leadership rather than the technical aspects of job performance."

By interviewing leaders and collecting anecdotes about correct performance it is possible to identify this tacit knowledge. Once the anecdotes are collected they can be boiled down into the specific behaviors to be taught, and then reconstructed into new stories that are perhaps more relevant to the exact task at hand. The critical point here is that in addition to providing good ways to teach skills, listening to stories from experienced practitioners is a good way to figure out what the skills actually are. This whole concept and its specific application to the creation of serious games will be explored in the next chapter where we will

begin setting down some formulas and rules for building learning objectives out of tacit knowledge on our way to constructing story-based simulations.

SUMMARY

We have reviewed the most clear cut roles for stories in serious games:

1. Stories as memory aids
2. Stories as examples of complex behavior
3. Stories to build understanding and cultural awareness
4. Stories as methods for providing the complex environment in which to learn about stress
5. Stories as ways to gather tacit knowledge

It is important to note that the definition of story that we have been using throughout this book and the kinds of requirements that we say are necessary to create a good story, do not go away just because the story is serving educational purposes. In all cases, including item 5, stories still require the conflict and structure that allow them to speak to all of us in a compelling way.

Designing Simulation Stories from Tacit Knowledge

The idea of creating a learning simulation to teach the tacit knowledge of military leadership was employed in all three projects that Paramount Pictures did for the US Military. But it was most explicitly employed in the final of the three projects, *Leaders*, which was developed for the United States Army in conjunction with the Institute for Creative Technologies of the University of Southern California. Looking at the methodology used in this project can give a good illustration of ways to develop simulations for leadership and other skills that rely heavily on tacit knowledge.

STORYDRIVE SIMULATIONS

StoryDrive simulations are those that follow the classic structure of a Hollywood story complete with hero, arc, goal and obstacle. The participant takes on the role of the hero and sets off on a quest to fulfill that goal. As Robert McKee explained, every step toward the goal should be born out of conflict. To impose even greater demands on that model, especially for pedagogical purposes, we can now add the concept that the simulation should be *outcome driven*. Outcome driven simulations require that the steps that the hero takes be based on pedagogical objectives that move him or her not only toward the goal, but also toward better and better skills honed through the challenges of the simulation. It is the task of the author of the simulation then not only to construct the best possible, most dramatic story, but also to construct one that provides the challenges and opportunities needed to acquire and develop skills that reflect the pedagogical goals. How do you do that?

Identifying Tacit Knowledge

As noted in the previous chapter, stories are one way to identify correct performance. An easier way may be to find people who are really good at

something and just follow them around with a notebook writing down everything they do. Debriefings after each session can then help zero in on the specifics of the tasks and may lead to a correct prescription of correct performance. But tacit knowledge in skills such as leadership and management are hard to identify when you see them and harder to define once you've found them. That is how stories can help. Asking an experienced leader to define leadership might get you a lot of nonconclusive ramblings, but asking that same person to tell a valuable story about leadership can draw out much better, more specific data.

Roger Schank, the noted AI researcher, suggests that people understand the world because they form mental models of it. These internal world pictures are continually revised as they discover new things. The major revisions in people's mental models are so important that they tend to remember the details of what happened when they were surprised enough by something that it made them change their world view. The day the universe changed for them actually becomes a story that they tell their friends, and Schank and others have described the telling of these stories as a mechanism for collective learning. The day we were surprised to find out a very important secret of management we immediately told our fellow managers and we all learned. We keep telling that story and more people learn.

So a good way to learn about important skills like leadership is to go to a number of people who understand it and ask them to tell stories. Within the stories will be the essence of the surprise that changed their worldview. Within the stories will also be an implicit explanation of the old view that was changed when the revelation occurred. As a result of all this you should be able to learn two things:

1. The naive, expected view of the way something should be
2. The informed, experienced, and true way

The process of building outcome driven simulations begins when you collect numerous stories about a subject which largely consist of tacit knowledge, and which involve the moment someone learns something about it, which was true even though up until that moment he or she was convinced that it was false. Here is a formula, which helps clarify that point.

Initially you would expect X.

But, with experience, you learn that the truth is Y.

Or to put it more simply:

Expectation = X

Truth = Y

So you have arranged a series of interviews with experienced leaders, you have pressed them for stories of situations where they were surprised by something that taught them a valuable lesson about leadership. Then you and the rest of your team have transcribed the interviews, analyzed them, and determined

what was the expectation and what was the truth behind each story. The next step is to turn those stories into decision points based on the underlying lesson of the story. If you believed the lesson then you would do what the lesson said to be true, otherwise you would do the expected thing. Or, put another way,

If you were in a situation
And you believed the lesson of the story
You would do Y (what the lesson says is the truth)
Otherwise you would do X (what a novice would expect to do)

Here is an example from the *Leaders* scenario.

Situation: You are Captain Young and you have taken over the command of a food distribution operation in Afghanistan. Your subordinate officers have come up with a mission plan that they are very proud of. Later you are talking with an experienced officer outside of your command and he suggests that a different plan might be slightly better.

Novice choice: Accept the plan of the more experienced person and tell the subordinates that this is what they should do.

Expert choice: Stick with the plan developed by your subordinates.

Interestingly here, the key word in all of this is "slightly." Since the proposed plan will only be slightly better, it makes more sense to give your troops the motivational lift they will get from carrying out a plan that they designed and selected themselves. We'll get into this example more deeply later in the book.

Sorting Out the Story

Once you have completed your interviews and boiled down the scenarios into decision points, organize them according to topic areas. Then validate the decision points by having them reviewed by highly experienced personnel in the positions that you are trying to teach. If there are stories that just don't ring true or cannot be condoned no matter how true they may be, throw them out. In the case of the *Leaders* project we were fortunate to have two highly regarded members of the military training community reviewing our work and commenting on its accuracy and believability. We were also able to cross check the

work against the literature on the subject. As noted in Chapter Six, Sternberg's *Practical Intelligence in Everyday Life* had already documented an extensive study of the military and we were able to verify our data with the Integrated Framework for Tacit Knowledge in the Military that was part of the work. We were gratified to see that the 63 anecdotes that we had collected covered all the categories of tacit leadership knowledge spelled out in the framework.

Once your content has been sorted into groups and verified, you need to organize it into four to six chapters of equal size putting most of the situations relating to specific topics into the same chapter. In the *Leaders* project, the 63 decision formulations that were made by the creative team were sorted equally into five chapters that represented the five components of the mission: establishing a relationship with subordinates, mission preparation, dealing with threats, coordinating with superior officers, and successfully executing the mission.

Building the Narrative

What we have created with the decision formula we have described is a binary system of choices where every decision requires that you make one or the other. These then lead to another choice between two points, which then lead to another choice. These choices can be assembled into a graph or flowchart that takes you from one choice to the next. Given the 63 original decision points and five chapters, we built a simulation that consisted of 12 to 15 choices per chapter. To round out the number of choices needed we sometimes repeated decision points, rewriting them so that the situations and the details of the situation were different. Figure 8.1 shows the structure of the graph for chapter 2 of the simulation.

In the graph the first choice should be the most important instructional point in the chapter. This should happen for a number of reasons. First, the participants going through the simulation will all encounter this important point. If they go through the simulation again, they will always get this point again, so it is imperative that it be worth it. Second, this point leads to a major division in the action of the chapter, so right and wrong consequences of this choice can be most dramatic. Third, the challenge of this point will hit the participants when they are fresh in the chapter, most clear headed, with the least baggage from previous decisions. It is the most highly focused moment in the chapter, the best chance for undivided attention and dedicated response. Fourth and finally, this is the point by which the participants will judge the entire chapter. The quality of the insight gained at this point can motivate the participants to carry on through the rest of the exercise.

Once the initial point has been made, the decision points that follow should be arranged in clusters based on their content and the personalities involved in the decision. Events should be chosen that match the kind of decision required by the point, and they should be grouped together so that the same characters

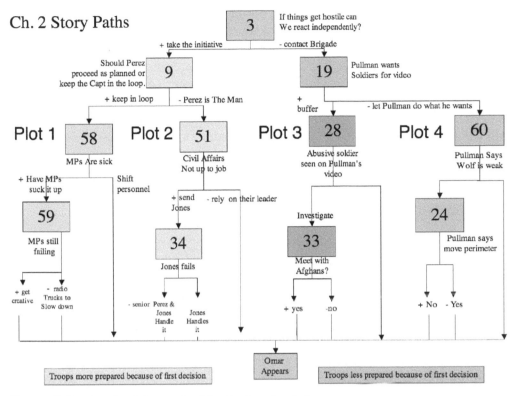

Figure 8.1 Graph of chapter 2 of the *Leaders* simulation.

and location can be featured. As we talk about developing characters we will point out how complex personalities can add great value to story-based simulations. The trick is to recognize opportunities to use the same character to deal with a specific point. Then find decision points that would fit in logically with the situation presented in the simulation. One way to handle this is in brainstorming sessions with a number of participants: a writer, an interactive designer, a subject matter expert who can mix and match decisions with situations and personalities. It is generally not necessary to retell the story on which the decision point is based, but rather to look at the new scenario and try to figure out what kinds of events within the scenario could put the hero into a situation where this particular kind of decision would be necessary. Then review the other decisions and see if there is one that can build on the previous decision with the same characters and location, but with new events and revelations. It ends up being like assembling a jigsaw puzzle, but one where you are creating the pieces as you go along. Once a good event is developed it may not be a perfect follow-on to the previous decision point. If that is the case, set it aside and hold it for a more appropriate moment later in the simulation.

As noted previously, *Leaders* was based on a film about a food distribution operation in Afghanistan. That was the framing device for all the decisions that would follow. In *Leaders*, an initial meeting with Executive Officer (XO) Lieutenant Perez at the start of chapter 2 tests the Battle Captain's ability to handle the first challenge to authority. Perez wants to run the operation. If the participant gives in to Perez, why not let Perez come back and challenge the Battle Captain even further? We found two important decision points about challenges to leadership authority among our 63, staged them at the same place and time, and put them into the hands of Lieutenant Perez. In the process, we made the simulation more interesting, the characters stronger, and the skills more highly exercised.

Dead Ends and Shared Outcomes

Two well-established techniques used in branching storylines are Dead Ends (if there is no outcome to a decision, simply say, "Sorry you're wrong. Go back and try again"), and Shared Outcomes (decisions can lead to many outcomes, not just the two pre-planned outcomes specified in the flowchart). Dead Ends provide immediate feedback for the participants, but they destroy the sense of story flow and immersion. For that reason we did not use them in *Leaders*. Shared Outcomes give the participant more choices, but they disrupt the clustering of content that we have just described. The net effect is less dramatic tension and a decreased ability to add levels of meaning that result from highly structured exchanges extended over several decision points. For this reason Shared Outcomes were also not used, though we did explore their use in our experiments with story molecularization (see Chapter Eleven).

Once the design team creates the basic structure of each chapter, the writer takes over and writes the script for the entire chapter, composing character conversations that present decisions and offer feedback. It is also important to write bridging material: additional scenes featuring other characters that set up each decision point and its problem and later comment on its success or failure.

A sample of the final script follows. It builds on the example that we cited earlier involving the decision regarding implementation of a plan put together by Captain Young's subordinates. A script sample featuring the conversation with Perez from the *Leaders* simulation is presented in Chapter 11 when we talk about character development.

```
Begin decision point 24
EXTREME LONG SHOT of distribution area showing
terrain, converging roads, and position of troops
setting up food distribution and security areas.
COMMAND POST
CLOSE UP: COMMAND SERGEANT MAJOR PULLMAN
Pullman looks down toward the roads.
```

 PULLMAN
Look, I don't want to go stepping on any
toes, but I was looking over your terrain.
I'm sure this site got chosen because of
the road access. But it's sure got some
problems.

He points toward the perimeter.

 PULLMAN
I would encourage you to bump your security
perimeter eastward, and put more distance
between the wire and the road. Even after
you've checked a vehicle through, damn thing
could surprise you. That extra distance
between the road and the perimeter could make
the difference.

He points toward a rocky overhang.

 PULLMAN
I'd also advise you start setting up the
space under that overhang, in case it rains.

 JONES
Captain, myself along with the XO and Second
Platoon, we put a lot of thought into this
configuration. Not saying the Command
Sergeant Major has an inferior plan. But
company personnel collaborated very closely
in strategy and tactics.

 PULLMAN
Captain, your First Sergeant heads a great
team—but if you make these changes, it'll
pay off. Just give it some thought.

Pullman leaves the Command Post. Jones turns to the
Captain.

 JONES
Would the Captain like changes made to the
security perimeter?

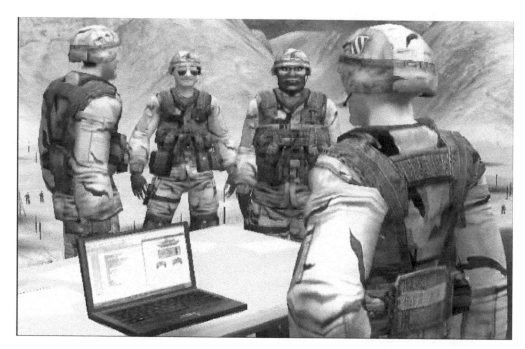

Figure 8.2 Final Leaders simulation scene showing Jones and Pullman addressing Captain Young while Perez looks on.

SUMMARY

In this chapter we have shown how tacit knowledge can be acquired by collecting anecdotes about hard to define skills like leadership. We also talked about how these anecdotes can be turned into teaching points, validated, and organized into chapters. We offered insight into the creative process that takes teaching points and turns them into story events and script elements. Finally, we showed examples of decision points set in a story context by providing examples from the *Leaders* simulation.

In the next chapter we will consider how to begin giving the participants a greater sense of free will within the context of the simulation story.

9

Simulation Stories and Free Play

In the previous chapter we showed how the *Leaders* team constructed a branching simulation storyline from anecdotal information that was gathered through interviews with experienced soldiers. The information was condensed and reorganized into teaching points and turned into a complete learning experience.

Because of the rigors of the branching structure the participants in such simulations could feel that they are locked into the flow of events in the story, and for that reason have no sense of their own freedom of decision making or their ability to affect the outcome of the simulation. Without this sense of freedom, the simulation becomes less believable, less interesting, less compelling, and generally less effective. Simulations that limit freedom of choice too extensively often negate any sense that the participants are actually controlling the world, and consequently they are distracted from applying the skills that they have learned.

There are a variety of ways to give participants a sense of free will within simulated stories. Two apply directly to branching storylines such as the ones we used in the *Leaders* simulation. We review those techniques in this chapter.

The more advanced and difficult approaches are really experience management systems that move away from branching storylines and aim to give the participants a greater sense of free will. We will review those kinds of systems and discuss their benefits and limitations in the following chapters.

But let's go back to our *Leaders* simulation and the need to give the participants a sense of free will within the branching story structure. How can we do that?

SIMULATED CONVERSATIONS

In the *Leaders* simulation, participants progress through the story until they have to make a decision. The elements of the decision are presented to them in the form of questions that are asked by one of the nonplayer characters (NPC). As noted in the example from the previous chapter, First Sergeant Jones asks the

61

participant (Captain) if he should move the location of the food distribution site as suggested by Command Sergeant Major Pullman.

The participant can type in a response to this question using any words he or she chooses, and the natural language interface of the *Leaders* system will interpret the statement and choose a prerecorded response from the many that are available. These responses are audio with attached animation of the characters.

To give the participants a greater sense of free will, they are also allowed to ask questions of the nonplayer character. So, in the case of the question about moving the location, the design team defined as many questions and responses as they could think of. They also wrote and prerecorded the answers to those questions. If a participant asks, for example, how moving the location would affect the morale of the troops who came up with the original plan, First Sergeant Jones has a prerecorded answer.

> JONES
> The platoon leaders and I spent a lot of
> time putting this plan together, Captain,
> and I'm sure that they would be very disap-
> pointed to learn that you were changing the
> plan.

To make the interaction as smooth as possible, we tested the prerecorded responses by creating a website with still pictures and a narrative story setup, but with the same dialog and choices as in the actual simulation. The site was posted on various military Internet sites and soldiers were asked to participate in the exercise in order to validate the questions and answers. We also tried to discover any new questions that we had not thought of. The answers to these new questions were recorded, added to the system, and contributed to a more robust version of the final simulation. For example, one additional question that was discovered and added to the simulation asked, "What do you think about the probability of rain in this location?" To which we wrote and recorded this additional response:

> JONES
> Captain, it's not supposed to rain here for
> months and certainly not today. I know the
> Command Sergeant Major has served here longer
> than I have, and he may be familiar with
> unusual weather patterns, but I can tell you
> that no weather forecast I have seen pre-
> dicts rain for the rest of this month.

In addition to adding appropriate questions that the participants might ask, we also recognized that soldiers might try and *game the system*, or try and

have fun with the conversations by typing in questions that were out of context or inappropriate. We adapted various devices to counter these actions. The simplest one was to assume that the system just did not understand what the participant was saying. So we recorded a series of responses that presented the possibility that they Captain's remark was unintelligible. These remarks also worked in those cases where the participants' comments were off the point. For example:

> JONES
> I'm not sure I understand what you are saying
> Captain, could you restate it?

Other responses dealt directly with statements that seemed to be off the topic. These remarks would be highly original or unusual and therefore unlikely to be anticipated. Our responses dealt directly with the fact that the participant was getting off the track. So, there might be words or phrases in the participant's question that made sense, but if the question was not related to the issue at hand it was judged to be a non sequitur. Here's a typical response to a non sequitur question that includes an attempt to get the participant back on track.

> JONES
> I'm not sure I know the answer to that ques-
> tion, Captain. I'm trying to find out if you
> want me to move the distribution site. What
> is your decision?

The response that the Sergeant gives if the participant asks to be reminded of the original question could also be used as a response to a non sequitur question. In our example the response to being asked "What was the question?" was:

> JONES
> Captain, the Command Sergeant Major has
> advised that we move the perimeter of the
> site to the north. Do you want me to order
> our troops to move the site or can we con-
> tinue with the existing plan?

INTELLIGENT TUTORING

Intelligent Tutoring is a unique feature of the *Leaders* simulation that allows instructional statements to appear on the screen to help move the simulation along or get the participant back on track. This response is not from an NPC in the scene (First Sergeant Jones) but from a tutor built into the system itself. We

decided not to give this feature a personality or a face but merely to let it appear as text on the screen. This seemed to be the least obtrusive way to introduce tutorial information into the experience. We tested various uses of the tutor and decided to bring in the intelligent tutor after the participant made two non sequitur responses in a row. We also made the statement more direct and included a third person reference to the entire event. In our example, the intelligent tutor statement read as follows:

```
Captain, the First Sergeant is trying to determine
if you want him to order his soldiers to move the
perimeter as Command Sergeant Major Pullman sug-
gests. Please tell him whether or not you want to
stay with the original plan.
```

Note that the final sentence is a complete restatement of the choices.

The intelligent tutoring system within *Leaders* served two purposes. The first was clarification, as illustrated here. A more sophisticated use of the intelligent tutor was designed to come into play if the participant went through the simulation for a second time and made the same mistake again. In this case the system would remember the participant and his or her response and would explain the teaching point behind the decision node. The participant would still have the free will to choose the wrong answer, but would be much better informed about the point and the intention of the lesson.

In the case of this example, a participant who has gone through the simulation for a second time and encountered this decision point, then asked a series of questions and eventually gave the wrong answer for the second time, would get this statement from the intelligent tutor:

```
Captain, soldiers who have developed a plan them-
selves will often show greater enthusiasm for car-
rying out that plan. So unless there is an important
reason for changing it, it is better to stick with
a plan developed by the soldiers who have to carry
it out. The First Sergeant is asking if you want to
change his soldiers' plan under the advice of the
Command Sergeant Major Pullman or to let his men
carry out the plan that they created themselves?
```

The *Leaders* team created the full conversation question and answer system for the simulation and in the process gave the simulation participants a greater sense of free play. We also designed an even more sophisticated solution to the problem of free play, which, though not implemented, was detailed in a report to the ICT and the Army. It is described here.

SPIDER WEBS

One classic way to add a sense of freedom to the story is to create story structures that look more like spider webs than branching trees. In these structures the outcomes of one set of decision elements (decision nodes) can lead to many different nodes. This greater flexibility in the development of the story allows a finer degree of differentiation between possible directives by the participants. If there are five paths out of a decision point instead of only two, the participant has a greater sense of control of the environment because the nuances of their choices matter more. Moreover, the dangers of the ever-branching tree are limited because the same number of decision nodes exist within the exercise, it is just that they interconnect because there are just more paths in and out of each node.

In a branching story structure where there are four levels of decisions and two choices coming out of each decision node, beginning with one decision then going to two possible outcomes, then four, eight, and sixteen nodes, any one path will allow the participant to experience no more than four nodes. That means that, of the 31 nodes that are created for the exercise, 27 nodes are not used. Allowing the participants access to those nodes through the device of spider webbing provides a greater use of the nodes. The result is that the participant can replay the simulation many times and have many different experiences at each playing, even if they do repeat some of their early choices. If AI is employed to keep track of the participants' paths through the story, the system can also direct the player onto those paths that they had not previously traversed and as a result expand the participant's options.

The trick to creating this kind of simulation story is all in the telling. As we will see, it is important that nodes lead one to the next in such a way that the tension in the story—and the logic of the story—builds. The problem with Shared Outcomes noted in Chapter Seven (that they disrupt the clusters of content) can be overcome by creative writing and the AI capabilities of the computer. Not every node can lead to another. But it is possible to identify certain characteristics about certain decision nodes so that an AI system can know whether or not one node can be the outcome of another node. Of the 31 nodes in chapter 2 of the *Leaders* simulation only four of them had conditions that made it necessary that another node precede them. That means that 27 of the nodes could follow any of the other nodes and the consequences would seem logical.

To create a spider web-based branching storyline in which most nodes can lead to most other nodes, an analysis of each node must be made, certain characteristics must be identified and coded, and then an AI system must be created which recognizes these characteristics and blocks the use of the nodes in those situations in which their use would be inappropriate. In addition, the story structure itself must be coded (as metadata), along with information about the previous path that particular participants have taken. If these elements can be taken

Decision Frame ID:	2–24	
Point Title:	HAND IN THE PLAN	
Set up Scene:	Command Sgt. Major approaches the captain re plan	
Set up Display Text:	JONES: Would the capt. like changes made to the security perimeter	
Characters Present:	Jones, Pullman	
Location Background:	Command Post overlooking site	
Required Preceding Node:	Node 9	**Outcome Scenes**
Required Following Node:	None	POS = 67 - JONES: The good news is he will probably forget all about it.
Number of Answers:	7	
Dramatic Tension Rating:	5	NEG = 69 - JONES: Bravo company prides itself on its flexability sir.
Pedagogical Importance	5	

Figure 9.1 Molecule Identification Form.

into consideration, it is possible to have a much more flexible version of the simulation chapter which could be replayed over and over again with the participants taking a completely different path each time.

Here is an example. Soldier X has been through the *Leaders* simulation once. He has had made all the possible decisions (four per chapter). The system can tell by his identification number who he is, which decisions he had made, and in what order. The first question the system then asks itself (the next time the participant goes through the system) is: Which other possible start nodes can the participant get this time? Since there are a limited number of nodes that have the qualities needed to start the simulation, that decision is made rather quickly. From that point on the possible path is chosen by the system during the real-time play of the exercise. So the participant goes into a node, makes his decision and then the system chooses a new target decision point (node) based on several factors. Figure 9.1 shows a sample form that indicates information and ratings that the authors of the *Leaders* simulation gave to the decision node that we have been using as an example in this chapter. That node is called Hand in the Plan.

We can see a number of elements are identified so that they can be considered in choosing the next node:

- Is there a required preceding node or a required follow-up node to this node?
- Which characters are present in the scene?
- What is the background of the scene?

- What is the amount of dramatic tension in the scene?
- What is the degree of pedagogical importance of the decision?

In addition, this form is used to record other pertinent information about the node:

- Its name and number
- The text of the question itself
- Summary positive and negative responses
- Specific wording of the outcome scenes
- The number of question and response pairs available to the participant

In the case of our example we can see that, while this is an important decision, it requires certain prerequisite information not available in the node itself, so that another node must precede it. So while Hand in the Plan could follow a good many nodes, it cannot be the first node in the chapter.

Note the ratings for dramatic tension and pedagogical importance. This is part of the metadata for the node, and is done to make sure that the simulation follows the rules of storytelling and pedagogy. (See Chapters Sixteen and Twenty-Six for further discussion on simulation integration and automated story generation, using this sort of metadata.) Ideally the nodes get more dramatic as the story progresses. On the other hand, pedagogically it is important to put the nodes with the highest degree of instructional importance early in the chapter so that there is a higher probability that they be encountered.

In the case of the decision in our example the concept is not especially difficult nor does it carry especially dramatic consequences. Combine that with the fact that it requires a prerequisite node and it looks like Hand in the Plan is an ideal node for the middle of the simulation exercise, not the first nor the final node of chapter 2.

Handcrafted Spider Webs

Though it would be possible to create an AI system that assembled the simulation as it were in progress (a possibility further discussed in Chapter Sixteen), sort of like an engineer standing on the front of a locomotive and laying out sections of track as the train roars ahead, it is clear that there are only so many combinations of nodes that follow all the rules for drama and challenge and the presence of characters and available prerequisites, etc. This means that with these limitations it would be possible to construct something like 25 different handcrafted, hard-coded branching storylines that would provide a great deal of participant reusability and represent almost all the possible paths that a player could take through the simulation. The high-powered functionality of having an AI engine that would build the story structure as the simulation progressed might

not be achieved in the creation of such an exercise, but the learning experience would be just as good.

All the foregoing, however, assumes a simulation structure like *Leaders*, where the participant stands still at the command center and his or her subordinates ask all the direct questions that need to be asked. If the participant is able to move around the terrain, encounter different characters, and initiate conversations, we have a whole different kind of simulation, one that was not addressed in the limited scope of the *Leaders* project, but certainly one worth exploring. Participant-driven movement over a large terrain populated with numbers of soldiers, all of whom can respond to questions, adds new variables to the simulation and would certainly be better served by something like the auto-assemble spider webs we have just described. In fact, there are even more sophisticated kinds of simulation strategies designed to give participants a greater sense of free will (such as the ones created for the ALTSIM project) which address many of these problems, and whose technology we will describe in the following chapters.

SUMMARY

Giving participants a sense of free will is one of the core needs of effective story-driven simulations. Even a simulation based on branching story lines such as *Leaders* is capable of employing a number of techniques that improve the participants' sense of free will. One such technique involves giving the participants the ability to ask questions, creating a wide range of answers to these questions, and developing strategies for handling non sequitur statements. Intelligent tutoring operates against the player's sense of free will but can still be used effectively if it is employed as a tool that operates outside the confines of simulation. Spider webs allow branching storylines to give the participants greater range throughout the simulation and, if well crafted, can add greatly to the sense of freedom, but to do this they must follow a rigorous set of rules that assure that they are used effectively. Handcrafted storylines may be just as effective as those driven by artificial intelligence, but become more difficult to manage in simulations where the participants can move around the terrain and have discussions with anyone they meet.

10

Experience Management

In the previous chapter we talked about the need to give simulation participants a sense that they have the ability to control the progress and outcome of events so that they don't feel that they are merely being swept along in a stream of experiences that will occur, regardless of what they do. It is also important that the interactions that they do perform are not irrelevant. Shunting action over to some side activity doesn't do the job either. The film *Titanic* may be a good example of this principle. In a simulation based on the incidents surrounding the sinking of the *Titanic*, the actual sinking of the ship is not really the story. It's the background. Whether or not any individual character escapes alive is *their* story. Creating a simulation story that allows the participants to prevent the collision and the subsequent sinking of the ship is probably to miss the point here. James Cameron understood this when he wrote and directed the highest grossing film in motion picture history to date.

He put his heroes on board the sinking ship and left them to their own devices to find a way to survive. Players in a simulated *Titanic* adventure would probably enjoy this aspect of the story the most—saving themselves and someone they love. What they and all simulation participants want the most is interactivity that is relevant and meaningful.

Dr. Andrew Gordon, the lead researcher on the ALTSIM project, may have stated it best when he wrote, "The central problem of creating interactive drama is structuring a media experience in which a good story is presented while participants are still able to have a high degree of meaningful interactivity." There are many key words in that statement: "meaningful" being the most important, followed by "high degree" of interactivity and, of course, "good story." What appears to be a struggle between the free will and free play of the participants and the events of the story itself ends up being, behind the scenes, a struggle between the participants' desires to do what they want and the simulation system's ability to manage, control, and enable the telling of the story.

We have already described the *Leaders* project, which uses a fixed branching storyline to direct players toward the simulation's dramatic goals.

In this chapter, we will look at an alternate approach, the one we took in ALTSIM, which in its own way was even simpler than that of a branching storyline. The ALTSIM approach uses a piece of technology called the Experience Manager, which allows participants to play a very active role in a highly developed story-driven simulation.

In order to do this in the ALTSIM simulation, the Experience Manager needed to understand the story. The device Dr. Gordon came up with to make this possible was a set of formal descriptions of the actions that the player would take as the story moves along. These descriptions were based on the players' perceptions of the events that were happening and the actions they would take based on those perceptions. That set of representations (the metadata of the story), which we called the Story Representation System, in a sense served as the Experience Manager's coded script. When the expectations in that coded script were wrong—that is, when the participants did things other than those written in the Story Representation System—the Experience Manager called up a Story Adaptation Strategy that would adjust the participant experience. If possible, the Experience Manager would do nothing—or, if doing nothing would not allow the story to continue toward its dramatic goals, the Experience Manager would adjust the story, take the participant on a brief but temporary side track, or block the participant's action completely.

The important elements needed to make the Experience Manager work were an effective and accurate coded script using the Story Representation System and, just as importantly, a set of story adaptation strategies that would not seem too far-fetched or intrusive, and yet would re-set the story so that it was still allowed to progress toward its dramatic goals.

EXPERIENCE MANAGEMENT

In ALTSIM, the story is told though media elements (individual video and audio clips, text messages, and graphics) that arrive at the computers of the participants in the simulated tactical operations center (TOC). The delivery of the media elements is timed to correspond to the passage of time in the story. Each media element carries with it an expected action by the player. In some cases, the actions are expected immediately or within a very limited time frame; in other cases, they are not, and sometimes it is a combination of elements that require a specific action. In rare cases, there are branches that have been anticipated in the story. These are triggered by specific actions but these branches are extremely limited: so that in fact the story has one, two, or three arcs that split and occasionally come back together as the story progresses.

When the players in the TOC encounter a media element, they take an action. As long as the encoded script of the Experience Manager anticipates the players' actions, the story progresses on track and more media elements are

delivered. If the players do exactly what the encoded script describes, they have a rewarding learning experience and the Experience Manager has had to do no more, figuratively, than to sit back and watch.

As an example, consider creating an interactive drama out of the classic western movie *High Noon*. Assume that the story is told through clips from the film but that additional scenes can be added using a style that matches the film but somehow does not need to employ the original actors or new dialog on their part. The reason that we are imagining this is because the copyright issues surrounding a star-studded feature film like *High Noon* would make it prohibitive to turn into an interactive drama. But the story is so clean and direct that the subject is irresistible. Also, *High Noon*, set in the most mythical old west, is perhaps the best example imaginable of a simple story that is all about decision making.

Say that somehow we got the rights to this great film. Now, imagine that in our simulation the player is asked to become Will Kane, the hero of the story, and that each segment presented ends with a question about what to do.

Figure 10.1 shows the arc of *High Noon* recast in the first person so that the player is the hero, Will Kane.

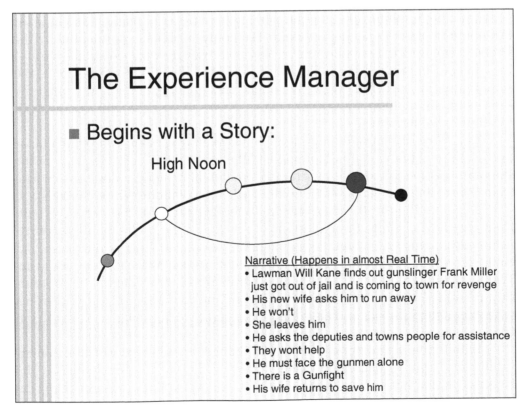

Figure 10.1 The story arc of *High Noon*.

In a sense the entire story of *High Noon* is about the decision to stay or run, but it is presented over and over again in different contexts. In our simulated version of *High Noon* the player decides what to do (if anything) and uses the computer keyboard to compose a response back to the system, e.g., "I decide to let my wife go by herself and I will stay to face the gunslingers." In cases where the player response matches exactly what Will did in the original movie, the story moves forward and the next scene is presented, e.g., "I head into the saloon to ask some of the townspeople for help."

If we were to create another branch to the story (the most probable branch to the events that might occur) and we create all the media to support that path, then we would still have a similar situation. As long as the participant made decisions that conformed to the path of the story that the author laid down, there is no need for any kind of intervention. The story just plays out as planned. We can even allow the sheriff to convince some or all of the townspeople to join in the confrontation.

In this case, however, to preserve the dramatic goals of the story, the sheriff needs to have a crisis moment when he knows he must face the villains alone. So the author of this new branch of the story develops a scenario in which some townspeople agree to support the sheriff but at the last minute back out again. That way the dramatic climax of the story, when the sheriff realizes that he must face the bad guys alone, is preserved. The confrontation is represented by the largest circle on the flowchart and is the most dramatic moment in the story—the moment of truth. The smaller black circle that follows is the outcome, the actual gunfight, which, though memorable and exciting, is not really what the story is all about. Once the sheriff finally decides to stay, the dramatic goals of the story have been met.

In a story-driven simulation (which has been expanded to provide one or two additional branches to accommodate the most likely alternate paths of the story, and which maintains the dramatic goals), if the player does not deviate from the established story paths, no dramatic interventions are necessary.

Notice in Figure 10.2, there are two alternate paths for the story. The path from the third circle to the largest circle represents the path when the towns-people decide to join Will and then change their minds. The path from the second circle represents the consequences of the discussion Will has with his wife. The author of this path decided to take advantage of the pedagogical opportunity presented there, so that, if Will handled the conversation badly, then his wife may not come back and save him in the end (which is what she does in the film).

Within this framework, one or two added branches or not, the central problem is how to deal with player behavior that is not anticipated in the Experience Manger's coded script. After all, as soon as Will finds out about the bad guys, the user could respond in a way that is outside the storyline. He or she could have Will leave town the moment he gets the message. If that were the

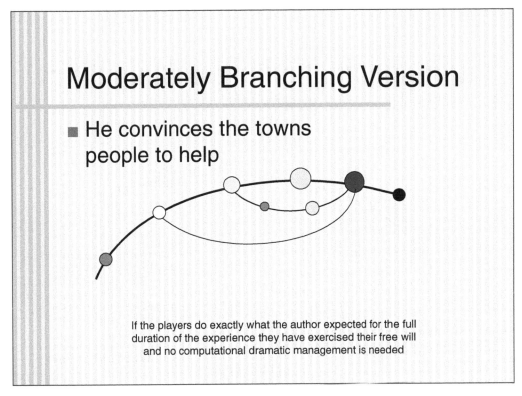

Figure 10.2 Alternate story paths for *High Noon*.

case, the next required scene would not be present in the existing movie. However, a single new scene could be added that could accommodate this action in such a way that the rest of the film would still work. For example, the new scene shown in Figure 10.3 would probably work as follows: "As Will walks back home to tell his wife about the message and his plans to leave town, he runs into a young boy who proudly says how much he admires Will and his fearless protection of the town."

In this simple case, the expected action is that the boy will shame Will into staying and facing the bad guys. Note that this specific response works at a single story point as shown in Figure 10.3. But following this approach and writing and producing the media elements that would allow a separate specific adaptation response for every point in the story would be all but impossible.

Now, let's look at that response again and rework it slightly as follows: "As Will walks from his office **ready to leave town** he runs into a young boy who proudly says how much he admires Will and his fearless protection of the town." That slight redefining of the adaptation strategy would work at any place in the story where Will decides to leave town, no matter when it is. The fact is that the

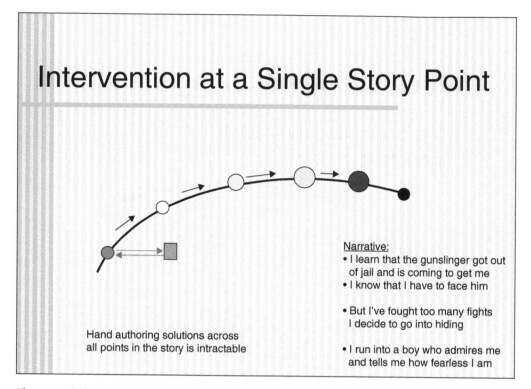

Figure 10.3 A way to handle unexpected player behavior.

revised scene is a **general** piece of adaptation media and it is for such media that ALTSIM's Experience Manager was designed.

Let's assume again that we have created an interactive version of *High Noon* by chopping up the original film into a series of sequences. For example, Will gets the letter; Will talks to his wife who says she will leave him if he doesn't run away; Will talks to the townspeople; Will talks to his deputies, etc. At the end of every sequence the participant who plays the part of Will Kane has to make a decision. Most decisions are variations on whether or not to stand and face the bad guys in the light of increasingly negative evidence. For example, Will could decide to join his wife and run away; or make up his mind to hop on his horse and ride out of town; or he could get on the next train; or go into hiding.

We could create a decision matrix for Will by plotting the decision points at the end of the movie sequences against Will's possible actions. If we add the option of doing nothing at all, then we really have covered all the possibilities. The Experience Manager's job is to fill in the blanks in such a matrix, that is, to complete the formula that says, "At this moment, with this action, the way to keep the story on track is to employ this adaptation strategy."

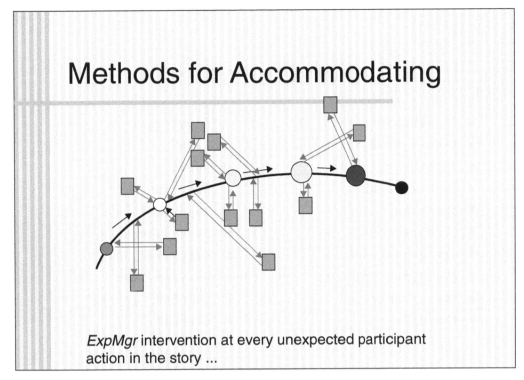

Figure 10.4 Story adaptation strategies applied in reaction to unexpected player behavior.

Figure 10.5 shows some examples of adaptation strategies that could be used in an interactive simulation based on *High Noon*. They include sending misinformation such as "he's not really out of jail," text messages in the form of telegrams urging Will to stay the course, and weather that makes the roads impassable so that he can't leave town.

Once the simulation story has been represented in a way that the computer system can understand (see Chapter Twelve) and a robust set of adaptation strategies have been identified and created, what is needed is the appropriate set of rules by which the system can operate. For example, one obvious rule is that the first thing for the Experience Manager to do after the participant takes an unexpected action is to check out the consequences of the proposed action. If the storyline can continue as written, the dramatic goals met and the action can still be carried out, then that will certainly provide the most rewarding experience for the participant and give the greatest sense of personal control. Other criteria might include whether or not the adaptation strategy has been employed before. If Will Kane, for example, had already run into the young boy who tells him how proud he is of Will's protection, then it is unlikely that the participant will be affected positively by going through the same experience again.

Intervention Examples

- No Response
- Orders from Superiors
- Synthetic Arguments
- Text Messages
- Distracters
- Time wasters
- Transportation failures
- Communication failures
- Misinformation
- Natural Events

- To Messages
- Mayor
- Deputy
- Telegrams
- Rowdy Cowboys
- Games - Practice
- Stage Coach Delay
- Telegraph Down
- "He's NOT Out of jail"
- Weather

Figure 10.5 Examples of adaptation strategies.

SUMMARY

In this chapter we have talked about Experience Management, a system whereby simulation participants follow the arc of a prescribed story that may have one or two branching paths. As long as they stay on those paths the story stays on track. But when the participants do something that the storywriter did not intend, then it is up to the Experience Management System to get the story back on track. It does this by employing an adaptation response of some kind that either adjusts the story or blocks the participants' new action and forces the story back on track.

The keys to successful implementation of Experience Management are (1) a way to represent the story with metadata so that the computer can understand and manipulate it, and (2) a sophisticated set of general adaptation responses that can be used to block user actions in a way that will not seem too manipulative to the participants, but which will still get the story back on track.

Story Representation in Experience Management

In Chapter nine we suggested that the Experience Manager needs a metadata-encoded script that represents the story so that it will know when the simulation is deviating from the path that is planned. Without such a script, the system will allow the participants to have an experience that does not provide all the dramatic moments intended by the writer. In addition, in a simulation based on delivery of media elements, not having such a script would also mean that the participants could very well take actions that called for media elements that do not exist, and so the participants would find themselves facing a blank screen abandoned at the edge of the virtual world.

ELEMENTS OF THE ENCODED SCRIPT

In creating the encoded script for ALTSIM we chose to represent the story as expectations in the minds of the simulation participants, so that each element of action was written as though the participant was thinking about it and deciding whether or not to do it. In our *High Noon* example in the previous chapter a small series of actions might be as follows:

I receive an urgent telegram.
I read the telegram.
It tells me that Frank Miller has gotten out of jail and he and his men are taking the next train to town . . . to kill me.
I consider the options, flight or fight.

For an experience-managed simulation, as the actual script is being written, the author of the story must also author this detailed list of perceptions that will form the metadata of the encoded script. One way to understand this is to realize that the author is describing media that he or she believes will have a predictable effect on the participants and their perceptions and actions within the world. If that is the case, then the outcome of the employment of each piece of media can be predicted and described before it occurs, at least as the author intends it to happen.

Matching Events and Predicting Outcomes

The Experience Manager begins with a list of anticipated perceptions and actions as described by the author. As the story progresses this list can be split into two different lists: the list of actions that have already occurred (previous story), and the list of actions that are needed to occur (future story). Because each action within the simulation is somehow being carried out through an interaction with the computer, the Experience Manager knows what participant actions are being taken. So it can create a third list (Evidence of Player Action). It can then match evidence of actual actions taken by the participant to the past actions and the expected actions that the story requires. It can determine which new player actions will make it impossible to tell the future story. When this is the case, the Experience Manager can then employ adaptation responses in order to adjust the story or to move the participant back to the point where he or she *must* take the action that will allow the story to continue on track.

Employing Adaptation Strategies

If the information in the three lists (Previous Story, Future Story, Player Evidence) is rich enough, it is possible to identify the conditions under which each specific adaptation strategy will work, and, just as it was essential for the writer to create the actual description of the story that the Experience Manager uses, so too it is essential that the writer identify these situations that call for adaptation strategies and the conditions that will work in those situations. Then the writer must define the story adaptation strategies that will be triggered by unexpected user actions.

One thought is that the strategies developed for one simulation story will very often apply to another so that—like stock footage scenes in the movies—the library of story adaptation strategies will grow and grow. That does not mean that such elements may not have to be remade to suit the style of the individual simulations, but as such elements are accumulated they at least will not have to be redefined and reinvented, which is the most difficult part of the task.

Experience Manager Formalisms

According to Dr. Andrew Gordon of University of Southern California, who conceived of this approach to Experience Management and did the primary research on the topic, "The basis of our formal representations of the expectations of player experiences consists of logical formalizations of commonsense psychology." Dr. Gordon used "first order predicate calculus statements that allowed [him] to refer to the mental states and actions of the participants in a highly structured manner." And he adds, "Given this formalization of the triggering conditions for a story adaptation strategy, a simple pattern-matching algorithm can be used to determine whether any available strategies are applicable given the current state of the player experience as encoded in the Previous Storyline, Future Storyline and Player Evidence Lists."

SUMMARY

The Experience Manager needs an encoded script to keep the story on track. Such a script is based on a detailed list of perceptions that the writer creates while writing the narrative of the simulation. The list of perceptions is based on expectations of what will happen and what the player will do at each event in the simulation, and it is written in the first person, as perceived by the player. The Experience Manager uses the list as a predictor of future events and notes evidence of what the player is doing whenever he or she takes action through the simulation computer. When an action will take the story off track the system uses the information in the encoded script and the story adaptation strategies to select and implement a strategy that will get the story back on track.

A detailed technical review of the concepts presented in this chapter, including sample code from the Story Representation System, was created by Dr. Andrew Gordon of the Institute of Creative Technologies at USC and was originally part of a larger paper which was published in the *Proceedings of the 2003 Conference on Technologies for Interactive Storytelling and Entertainment* at the Zentrum fur Graphische Datenverarbeitung in Darmsdadt, Germany.

PART THREE

CHARACTERS

<div align="right">

12

</div>

Creating Multidimensional Characters

"A Story"

Once upon a time in a certain place there lived a being who had both strengths and a flaw. This being wanted to achieve a goal. However, there was an obstacle between the being and its goal of such a nature that it attacked the being at its weakest point–its flaw. The being realized that, to achieve its goal, it must overcome the obstacle.

The being struggled to remove the obstacle, trying first one thing, then the next; each time failing–the goal remaining just out of reach. The being at last designed a plan that would make its weakness invulnerable to the obstacle and would, at the same time, achieve its goal.

The plan failed; the being realized its weakness could not be made invulnerable.

The being put on one last, desperate effort to overcome its weakness, and by so doing, the being overcame the obstacle and achieved its goal.

The End.

<div align="right">

(From *A Science Fiction Writer's Workshop-I:
An Introduction to Fiction Mechanics* by Barry Longyear)

</div>

This simple story plan goes a bit beyond Bill Idelson's definition of story. It states that an important element in a story is that the main character has a flaw that makes the hero particularly vulnerable to the obstacle. The story then involves finding ways to get rid of the weakness and overcome the obstacle.

That definition of story can be of great value in simulation design. In serious games it is not enough that a hero is overcoming an obstacle. The hero has to deal with a personal deficiency. How do people deal with personal performance deficiencies? Well, certainly one very good way is through training!

Stories allow people who take on the role of hero to discover their own deficiencies and learn how to overcome them. As Longyear suggests, the deficiency can never fully be overcome, so the hero has to use a combination of skills to overcome the obstacle despite of the deficiency.

In serious games, giving heroes the skills to overcome their deficiencies is the behavioral objective of the exercise. If the goal of the exercise is to teach the participants how to make decisions under stress, then the participants selected to go through the exercise are those who have performance deficiencies in that area. The obstacle is created especially to challenge those kinds of deficiencies. In the end the hero gets better at making decisions under stress until, at the climactic moment of the story when the hero must make the most critical decision at the moment of highest stress imaginable, he or she will be able to reach the goal by integrating a number of additional skills.

If the system is smart enough, as ALTSIM intended to be, it would read the performance of the hero and tailor the obstacle to match the hero skill for skill, to challenge strengths and take advantages of weaknesses. A leader who is clear thinking enough to get a strong troop movement toward the town of Celic to rescue a trapped inspection team might suddenly have the ALTSIM system itself add elements to the obstacle to make the job even tougher.

Part of the function of an interactive simulation is to help the participants (heroes) discover their own flaws and figure out how to overcome them. Then the system must keep challenging those flaws to help the heroes minimize them. In the meantime, the participants actually become the heroes and are personally engaged in the struggle. As Bill Idelson would say, the juices flow.

NONPLAYER CHARACTERS (NPCs)

Captain Moran (the former leader of the food distribution mission in Afghanistan, the one who the participants were to replace in the *Leaders* simulation) was a real presence, though he was never seen. Like so many leaders who are gone but not forgotten, his looming authority and methods added an element of challenge and realism to the experience. Other NPCs were present and served as the principle mechanism for presenting information to the participant/hero and asking for decisions. Again, their perceptions and opinions would color the participants' view of the world.

Two of the most important characters in the *Leaders* project were First Sergeant Jones and the company Executive Officer (XO) Ricardo Perez. We chose to give these two characters especially rich backgrounds, and as a result they became complex challenges for the new Captain. For example, we gave Perez personal ambitions of command so that he did not really want to cooperate with the new Captain. He would always want to do things himself, he would give information grudgingly and, during one of the earliest encounters in the simu-

lation, he would actually try to convince the Captain to turn the entire operation over to him. His reasoning was that a new Captain should not just come in and take over an established plan that had already been well worked out. He should leave the plan to the XO who was already well versed in it. Perez's goal was to run the operation himself. We created the character and the situation in order to allow the participants to encounter one of the most important teaching points in the simulation, the need for the leader to establish control and credibility immediately upon assignment to a new unit. The following is a bit of dialog from that section of the simulation. (Developed by Paramount for the ICT.)

```
LOOKING OUT OVER SITE-PEREZ PITCH
Perez stays in the frame, but we should be able to
see much of what's going on on the site floor.

                    PEREZ
        Captain Moran, Top and I reconned the site
        yesterday morning! Made risk assessments and
        laid out the timeline! We began setup yes-
        terday afternoon! Everything's in motion!
        With your permission, we'll continue our
        operation as planned, sir...unless you'd
        like to step in.
```

If the participants give the response that Perez is looking for they will receive a very positive response from Perez, but later in the simulation they will suffer the consequences.

```
FIELD COMMAND POST-PEREZ GETS CARTE BLANCHE

                    PEREZ
        Smooth as glass, sir! That's how your first
        full day here is gonna be!
```

If the participants give the correct response, then Perez will acknowledge the response and the reinforcement will come from the other person present in the scene (First Sergeant Jones). Of course, the most positive consequences of the correct decision will only be learned much later.

```
FIELD COMMAND POST-CAPTAIN WANTS CONTROL
Perez looks down at the ground with some concern
then looks up and smiles a trifle uneasily. He doesn't
see Jones coming up behind him, within earshot.
```

> PEREZ
> You'll know about everything that's happen-
> ing, sir.
> Jones gives a thumbs-up.

> JONES
> We're all for a hands-on C.O., sir! Oh, by
> the way. We'll be getting a SITREP from our
> MP detail any minute! They should be fully
> deployed now!

First Sergeant Jones has much purer motives; he wants the Captain to succeed and wants to help anyway he can. But Jones, like everyone else in the world, has his own weaknesses. Jones is old school, and has lots of experience with and confidence in old school motivational techniques. He feels that he is a great motivator. Even though he can be, he is not always.

> FOOD DISTRIBUTION AREA
> In the background, we can see the wayward Afghan
> militiamen, the soldiers who found them, and
> Lieutenant Cho. We enter as Perez and Jones are
> already discussing the situation with the Captain.

> PEREZ
> (TO JONES)
> I still don't think we have a problem!

Jones, squared off with Perez in front of the Captain, looks angry.

> JONES
> Lieutenant, we've got Afghans wandering
> around inside our perimeter like they're at
> a resort! You can't call that managing secu-
> rity! The Civil Affairs guys can't be doing
> much at their checkpoints! They gotta get
> with the program!

> PEREZ
> Let em be, Top! They understand the situa-
> tion! They know their jobs!

 JONES
 (TO THE CAPTAIN)
 Sir, just in case they don't understand, I'd
 like to give them a little motivation talk,
 Bravo style!

 PEREZ
 (ANNOYED)
 You're just going to tick 'em off! Give them
 time to fit in with Bravo Company! They'll
 come around!

 JONES
 Sir! Requesting permission to give a pep talk
 to Civil Affairs! Make them see things the
 way the infantry does!

In this case Jones overestimates his own motivational powers and eventually it takes a combined effort of Jones and Perez to get things back on track. The ability to gain a quick understanding of the personal strengths and weaknesses of subordinates is a critical task that all leaders have to master to be effective. It is also a challenge to the creators of the scenario who need to understand their characters to their souls. Hollywood has developed a tool to aid in this effort and it was used in all the projects that Paramount Pictures did with the military.

CHARACTER BIBLES

The key to creating believable characters is to determine who they are and what they want. That is, to answer the actor's inevitable question: "What's my motivation?" In Hollywood, TV shows and movies require that the writer of a screenplay create *character bibles* in which the writer invents and documents each major character's life experiences and goals. Once these things are known, the characters can be written in a believable, consistent, and useful manner. In the cases of Perez and Jones, the screenwriter detailed their childhoods, the lives of their parents, their educations, marriages, accomplishments, spoken goals, and secret desires. Some of this documentation was turned into dossiers: text files within the simulation that the Captain could access and read as he or she took command and began to deal with personnel. The following is a sample of the character bible created for Lt. Perez (developed by Paramount for the ICT):

First Lieutenant (and XO) Ricardo Perez
Ethnicity: Mexican American. Height: 6′2″. Age: 24. Hair color: black. Apparel: officer uniform.

Military Service
Commissioned as an officer in 2001, after four years of enlisted service. Went to Army Ranger School, Army Airborne School, and the Bradley Fighting Vehicle Leader Course. Platoon Leader for Rifle Company and HQ Company at Fort Carson. Very recently deployed overseas. Platoon leader for HQ Company in Qatar. Deployed in Afghanistan with new responsibility as Exec Officer (XO) in Bravo Company, 145th Infantry Battalion.

Backstory
Born just before American hostages were taken in Iran, Ricardo grew up with two brothers and two sisters in Norco, California–a dusty, hot, semi-rural stub of northeastern Orange County, where horses are common, a slaughterhouse lies not too far away, and lower middle-class Latinos and Anglos commute miles to work in order to pay the mortgage on inexpensive tract and pre-fab homes.

His father, Sergio, a first-generation Californian, runs a gardening service in Pomona, and served in the Army in the last days of the Vietnam War. Coming home, Sergio took a few classes at Mt. San Antonio College, met his future wife Lorena, but had to take care of a dying alcoholic father, who ran a desultory one-man gardening business. Beginning to raise a family, Sergio realized he could build up his father's business, and now runs half a dozen crews. While Sergio may not be living in Beverly Hills, he and his wife have raised five kids and head to Las Vegas for weekends several times a year.

Ricardo was always glib, charming, a go-getter when he set his mind to it. He grew up a typical Southern California kid, but the there's-nothing-to-do-out-here mentality of outlying Southern California communities lead to his ignoring classes, racing street cars, and getting high. Sergio dreamed of his oldest son getting into UCLA, but Ricardo's lack of discipline meant he has a tough time passing community college classes, before a run-in with the law made him take stock in who he was and where he was going.

Not a fan of the Army himself, Sergio nevertheless encouraged Ricardo to enlist. The enlistment gave Ricardo a chance to break away from Norco and see the rest of the world.

In the Army, Ricardo excelled. The boredom factor disappeared. The military gave him just enough structure to fully realize who he is, and his innate charm came to the fore. Ricardo liked being a soldier enough to apply for officer training school. He advanced quickly, and soon returned to college to finish his A.A. and begin building credits toward a bachelor's degree.

Figure 12.1 Dossier of First Sergeant Jones, part of participants' briefing kit. Created from the Jones character bible.

The Perez character bible goes on to describe his education, marriage and divorce, hobbies, and opinions about Captain Moran and fellow officers. It also outlines his personal and professional goals, especially as they apply to the mission at hand. In this way the writer will have thought through the character's motivation at every moment of the simulation experience.

CREATING CHARACTERS TO SERVE THE LEARNING OBJECTIVES

The challenge of creating complex and realistic characters for a simulation based on teaching points is finding opportunities to employ the character. A training simulation storyline may require one or two identified personalities and many nonspecific people. The key is to combine these nonspecific people into single personalities as often as you can. In this way you create a small set of consistent characters who will appear regularly throughout the simulation.

For example, in Chapter 2 of our simulation story, we introduced a very senior NCO named Command Sergeant Major Pullman who is present at the

food distribution operation in order to make a documentary video about it. Pullman asks the Captain if he can make movie extras out of some of the men who are involved in a key part of the security preparation. This request will affect the manpower assigned to the mission and is an immediate challenge to the Captain's command. We made this confrontation a key high stress decision point in our simulation.

Having created one dramatic moment with Sergeant Major Pullman, we could then have forgotten about him and used different characters to deal with other teaching points, but we did not. Instead, we chose to use Pullman again and again. As noted, Pullman questioned the overall location of the distribution site. He suggested that the entire operation should be moved to a better spot. Using Pullman to address this point allowed us to continue to build tension. Finally, we had Pullman criticize one of the junior officers in the unit and urge the Captain to remove him from the operation. Once again, we added another dimension to the decision because the recommending officer was Pullman, someone who brought a good deal of complexity to each of the decisions he was involved in. Introducing a self-involved character who comes in from outside the unit and begins to question decisions, challenge authority, and create conflict is a terrific ingredient in any story. If you can employ such a character in the service of the learning objectives, there is greater continuity to the story, greater complexity to the exercise, and a more compelling and interesting learning experience.

CHARACTERS REPRESENTING OPPOSITE POINTS OF VIEW

Because the *Leaders* project is about decision making, the principle nonplayer characters are able to play another valuable role: they can represent opposing decision options. On the issue of whether or not to seek the advice of experienced people before addressing a warlord who has arrived on the scene, First Sergeant Jones argues that it is critical to do so, but the more impetuous XO Perez provides arguments about why it is better not to waste time, but to respond immediately. The logic of these positions is well grounded in the background personalities and the goals of these characters as defined in their character bibles, so they provide a natural way of presenting both sides of the argument to the user before the decision is made. Here's an example, from the moment when the warlord and his troops appear on the ridgetop overlooking the distribution site:

```
AT THE FIELD COMMAND POST

                       PEREZ
                 (TO THE CAPTAIN)
        Sir, we need to send someone up there right
        away. Otherwise we're just going to keep
```

guessing about their next move. And I don't have to remind you that the clock's ticking on our operation.

 JONES
But Lieutenant, I've gotta find out the pro-
tocol first. If we just go charging up there,
no telling what we'll unleash.

 PEREZ
Sir, we don't have time for conferences and
meetings and running things up the chain of
command. You have to show you're in charge
and the only way to do that is to get someone
up there now, to find out what they want.

 JONES
We don't know the best procedures here, Lieu-
tenant. I think we need to get the Command
Sergeant Major and Civil Affairs to give us
some input.

 PEREZ
Sir, what's your order? I can put together
a team to head up there right now. Or we can
go Top's way on this and gather up some per-
sonnel for a consult.

 SOLDIER
First Sergeant Jones, look!

UP ON THE RIDGE-WARLORD HAS A GUN

The warlord stands up.
He extends his hand and an AK-47 is handed to him
by one of his men. He keeps the weapon pointed down
but turns left, center, and right surveying the scene
in front of him.

FIELD COMMAND POST

 PEREZ
We don't have any time, captain. What do you
want to do?

In the *Leaders* simulation Perez and Jones represented opposite sides of most arguments and so could help the hero/participant explore their complexities. We had to take great care to make sure that their opinions were internally consistent and yet each character was correct an equal amount of the time. Otherwise, the Captain would begin to make decisions based solely on the track record of the person who made the recommendation.

Another dramatic use of an NPC occurred in the final simulation exercise that we created for the ALTSIM project. In that exercise we employed a character whose whole purpose was to lead the Captain in the wrong direction.

ARGUMENTATIVE CHARACTERS

In the second version of the ALTSIM simulation, the Battle Captain was in a tactical operations center (TOC) commanding troops in the field. The crew of the TOC was monitoring a cross-border incursion into a neutral country by troops lead by Colonel Kurgot, a hostile warlord in a neighboring country. Kurgot's goal was to encourage the Captain to send forces to oppose him and then to lead those forces into a city that had already been infiltrated by his supporters. Once in the city, the Battle Captain's own forces would be outnumbered and destroyed.

In this simulation there were parallel arcs to the story: the arc in which the Battle Captain allowed troops to pursue Kurgot into a trap, and the arc in which the Captain outwitted Kurgot and avoided the trap.

Remember that the Battle Captain is away from the action in a command center and has to communicate with soldiers in the field under the direction of a field commander. In this case, we named the field commander Red Hunter. The critical decision came when Red Hunter asked the Battle Captain in the command center for permission to pursue Kurgot. Red Hunter's function in the exercise was to operate as an obstacle, encouraging the Battle Captain to take the bait and order his troops to follow Kurgot into the trap. The Battle Captain in the TOC had enough information to recognize the trap if he listened to his subordinates who were monitoring the incoming intel. But Red Hunter, fresh from what appeared to be a successful strike against Kurgot, was eager to pursue his enemy and did not want to be distracted. Being in the field, he was more than a little impatient with a person giving him orders from behind the lines.

In the critical exchange and throughout the remainder of the simulation, he continued to urge the Battle Captain to do the wrong thing. His hostile attitude created a whole new level of stress in the simulation and, at the same time, helped teach the Battle Captain (participants/heroes) how to deal with strong-willed field officers who do not always see the entire operational picture.

As in the *Leaders* simulation, the ALTSIM participant talked to Red Hunter by typing text into a computer, which then used natural language processing to select the appropriate prerecorded audio and video responses. Here is a sample

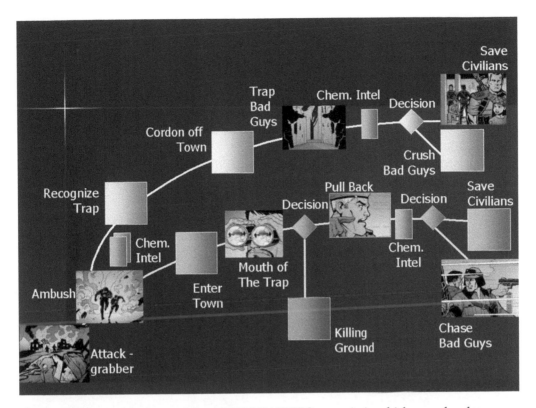

Figure 12.2 The two arcs of the ALTSIM RAIDERS scenario in which cross-border incursions draw American troops into a confrontation with Colonel Kurgot and his troops. The confrontation is an ambush, forcing the Battle Captain to choose between two paths: one leading to safety, the other leading to defeat.

response from Red Hunter that shows not only his desire to pursue his prey, but his hostile attitude toward a Battle Captain who is trying to give him a contrary order.

Participant

I want you to pursue Kurgot at a distance. Monitor his progress and rely on air intel for added information. Let's see what his objective is.

Red Hunter

In my book you break the bastard's legs before he has a chance to get near his objective. Need you to rethink your position! Over!

CHARACTERS WHO PORTRAY CULTURAL DIFFERENCES

Story and character go hand in hand and this is never better understood than when trying to tell stories and employ characters to portray cultural differences. In a sense characters such as Lieutenant Perez and First Sergeant Jones can be

thought of as illustrations of the cultural diversity of the US Army. Because they are well-rounded personalities and their backgrounds have been fully explored in the character bibles, they should help soldiers of other ethnic backgrounds understand something of the culture that they represent. But their individuality is also an important factor in their development, and so Perez, for example, is not present in the story to help people understand how to relate to soldiers of Hispanic origin. He has a dramatic role to play as an individual and that role is not essentially about his ethnicity.

But stories can turn on issues of cultural diversity and it is in these situations (when the culture itself becomes an issue) that specific lessons about cultural diversity can be learned. In the *Leaders* simulation, Omar, a local warlord, appears and is interested in participating in the mission. As seen in the discussion earlier in this chapter, there is some disagreement between the characters in *Leaders* on exactly how to deal with Omar. Eventually, Captain Young will meet with the warlord, and again, he will be getting advice from all sides on exactly what to do and say. We chose the meeting as the perfect place to introduce and deal with our teaching points that had to do with cultural diversity. We used the character of Omar to illustrate the kinds of reactions one might expect when

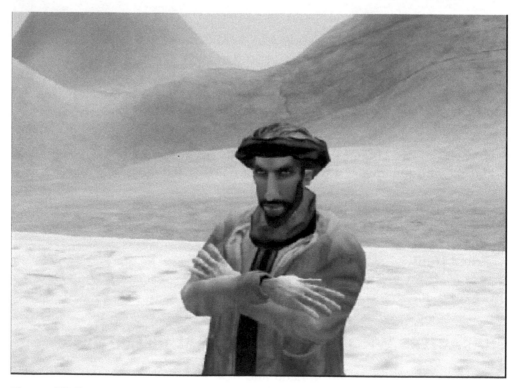

Figure 12.3 Warlord Omar who can play a major role in the success of the food distribution operation in the Leaders simulation.

facing a person of his station and heritage. And we added to the interest and engagement by making the meeting with Omar the pivotal moment when the warlord would either choose to support the mission or not. That choice, it turned out, would be the key to the mission's success, because the Captain would need Omar's support, not interference, to complete the mission successfully.

The US Army in Afghanistan had military leaders who were involved in such meetings and this story-based rehearsal of such a meeting was clearly a way to drive their lessons home. But it was not the story situation alone that helped teach the lesson. It was the well-crafted, nonstereotypical characterization of Omar that made it so effective. The character was developed through a highly evolved character bible, interviews with soldiers who had met with such warlords, and experts in the native culture who understood the psychology and motivation of such men. Even the actors who played the roles were allowed to comment on the proper turn of phrase and expression, all of which made this element of *Leaders* a most effective use of character.

SUMMARY

We've talked about the creation and uses of NPCs and stressed the value of creating character bibles to ensure consistency in their actions and motivations. We've explored ways to build characters to serve learning objectives and the needs of the story. We've also shown how two or more characters can represent opposite sides of an argument so that the participants can make more informed decisions.

The complex tasks involved in character creation can seem daunting to any author, screenwriter, or game designer. A tremendous amount of detail must be worked out before one word of character dialog can be written. Nevertheless, no one will ever question the richness and realism that these characters bring to a story. It is also worth noting that the same care and dedication should go into the forming of the minor NPCs as goes into the development of the hero and the major supporting cast.

But as challenging as is the creation of those NPCs, imagine how much more care and dedication must go into the formation of the personality who will serve as that great looming obstacle for the hero. That task is vital because, let's face it, there is nothing more valuable to a story—more compelling, engrossing, or juicier—than a really good villain.

A Really Good Villain

I asked a gamer friend of mine to answer a pretty simple question. "Tell me something about one of the characters in a video game you've played recently." He looked up from darning his socks (or whatever he was doing), and told me to clarify. "Not anything external, like appearance or the way they talk. I mean that character as a person. The kind of thing you know about someone after reading a good book." He seemed a little surprised by the question, so I told him it was for an article I was writing.

This guy isn't stupid, and knew what I was getting at. He thought for a little while, and eventually told me, "You know, games don't usually do that."

(From "The Importance of Story" by John Campbell)

In a sense, you could think of the supporting players in *Leaders* as adversaries. They have their own goals. These goals sometimes don't match those of the hero, Captain Young. Executive Officer (XO) Perez wants to run the operation and is hesitant to give the Captain input. He represents one of the first obstacles that the Captain has to overcome. Yet, in the story structure described by Robert McKee and others, he is just the first level of conflict that our hero has to deal with. And the goal of overcoming that first obstacle and establishing control and authority in the operation will enable the Captain to serve the larger goals of the project: conduct a successful food distribution operation.

Command Sergeant Major Pullman has more subtle goals that are even harder to figure out. Like XO Perez he wants a piece of authority as well. The Captain must once again assert authority, this time in the face of someone from higher command, who could disrupt the operation and video tape the whole disaster as it unravels.

In the previous chapter, we mentioned that a warlord shows up and wants to participate in the food distribution operation that the Captain has to oversee.

The warlord has his own goals, which seem dubious from the first and do not necessarily mesh with those of the Captain. Also, cultural differences made it more difficult for the Captain to understand the warlord and trust his motives.

Interestingly enough, the *Leaders* scenario, as we explained in Chapter Four, is based on a training film created for the Army by the Institute for Creative Technologies. In that film, the role of Omar the warlord was not fully explained, and it did not need to be because the film was a quick trip to disaster in which everything went wrong. But in trying to find a path to a successful outcome, our Army advisors agreed with us that Omar might just be the key to a positive outcome. If the Captain can see through the cultural differences, understand Omar, and assign an appropriate role to him and his men, the film's negative consequences could be avoided. So the critical meeting with Omar in act 3 of the *Leaders* scenario, which we described in the previous chapter, gives the Captain and all the other players in the simulation a chance to get Omar on their side, so that he can help move the story to a final positive outcome. In any event, though Omar provides a challenge to the Captain's leadership and decision-making skills, even if the Captain does not make proper use of him, he is certainly not the villain in the piece.

In fact, *Leaders* presents the most complex and difficult authoring scenario of all, because it is the Captain's own weaknesses that led to the eventual disaster in the story. Like Hamlet, the Captain himself has the potential to be the villain. To make it a little clearer, we could use Bill Idelson's terminology. The Captain's own weaknesses become the obstacle. It was Captain Young and his inexperience that created the disaster at the end of the *Power Hungry* film, in which shots are fired and the crowd overruns the relief trucks. In the *Leaders* simulation, the participant/hero/captain takes the same path to the disaster, one decision at a time. It could be argued that any inexperienced officer given this situation would make the same mistakes that Captain Young did and would end up with an equally disastrous outcome. One way to build a gripping simulation story is to determine the weaknesses that the hero has to have to bring about his or her own downfall, and then construct the story as though it were a series of tests of increasing difficulty. Participants without experience in a given task bring that inexperience to the simulation. Bringing those participants face to face with those deficiencies over and over again in increasing degrees of difficulty until the obstacles combine into one massive, all-consuming obstacle is a perfect example of what McKee calls the "Education Scenario," and as he says it is the ultimate scenario.

BUILDING FLAWS INTO THE HERO

Is it possible or valuable to have participants play characters with deficiencies other than their own? Not entirely. After all, the purpose of serious games is

education and the objective is to overcome real deficiencies. However, in the process of overcoming their own deficiencies, participants can also build on some of their strengths. Can I become a battle captain who has, for example, a difficult time handling subordinates, though that may not be a glaring deficiency of mine? Can I play a captain who is easily distracted and has difficulty focusing on the most important issue, when I myself may be pretty good at handling distractions? Is it possible for the simulation to let me play a character whose deficiencies are different from mine and is there any value in that?

The answer is: of course. There is value because forcing participants to deal with the flaws in the characters they play only strengthens their performance. It is like asking a man to perform a task with one hand tied behind his back, knowing that if he can do it he will be able to perform the task much better when he has the use of both hands.

How do you build added flaws into your heroes? You, as the game designer, have control of the environment. You are the author, and we have all experienced the narrative tricks that great authors like Edgar Allan Poe can play when they want their heroes to possess great flaws. Poe and the poet Robert Browning, for example, had their characters approaching madness, and allowed us to see the world through their insane eyes. As the game designer, you can crank up the distractions, you can manage the flow of information, and you can distort the hero's picture of the world until the participants are seeing through the eyes of people who have flaws in their vision. In turn, these flaws give them performance difficulties beyond those that they possess.

In ALTSIM, the Battle Captain in the tactical operations center had to rely on messages from his subordinates. We controlled the frequency and content of those messages; we could make them more or less confusing. We could build up the distraction in the cross-talk in the radio signals until that too began to simulate the noise in the head of a participant that had less ability to sort things out. We could speed up the flow of information, until the participants felt that it was more difficult to make decisions quickly. There were many tricks that we used to make participants feel that the faults they were experiencing were their characters' and then their own, and not simply those created by the environment.

Of course, one of the easiest ways to build flaws into hero/participants is to use nonplayer characters to reveal those flaws. In ALTSIM, we designed a scenario in which there was an especially difficult officer representing a foreign power that controlled another sector of the country. The participants had to deal with that officer in order to achieve their goal. In one proposed scenario, the officer was not only a difficult person to deal with, but had a personal history with the participants and had a definite attitude about them. The participants could be briefed on the history of the relationship or could figure it out as the simulation progressed. But the participants had to account for personal weaknesses of characters even though they themselves may not really have possessed those weaknesses. If the foreign officer was difficult to deal with, the participants

had to figure out how to overcome that difficulty. If they were successful, the participants would master some pretty important interpersonal skills, but they could just as easily fall prey to the contrary attitude of the foreign officer, respond in kind, engage in escalating negative interpersonal strategies, and in the end become the kind of difficult person that the simulation is trying to teach them not to be. In that situation, the simulation has bated them into becoming the villain in that part of the simulation story.

One way to achieve a similar effect is to have participants play characters who are brought in to replace people with a very established way of doing things. The behavior of deciding whether or not to maintain practices that have already been instituted is not the same as finding and correcting your own faults, but there can be similar judgments involved. In *Leaders*, the participant played the role of a captain who was brought in to replace Captain Moran, a commander who had held a very tight reign on his troops. The participant was constantly reminded of Captain Moran's practices. If the participant wanted more information we had prepared detailed responses for subordinate officers who would go on and on about how Captain Moran would handle each and every detail of the mission. In truth, Captain Moran was not a perfect CO and some of his practices were not the best. In the *Leaders* scenario, part of the new participants' job was to determine the weaknesses of the leadership position, which they now held, as instituted by the precedents set by Captain Moran. In a sense, their troops had expectations about the way the leader would behave. If Captain Moran had weaknesses as a leader, the new captain would have to figure out what they were and somehow deal with the expectation of those weaknesses. In many cases the new captain would have to change policies and reverse procedures and practices as set by Captain Moran. Of course, if the entire problem with the operation were the fault of the shortcomings of Captain Moran, then he would be the villain of the piece—and the task for the new captain would be to deal with the ghost of Captain Moran.

BUILDING THE ULTIMATE VILLAIN

Philosophically, the ultimate villain may be the hero, but dramatically it may be far easier to create an external villain who represents the forces that the hero must oppose. In ALTSIM we talked about putting a face on those forces. In other words, it is not enough to say that you are being opposed by a foreign power. It is better to identify the person who represents and exercises that power and develop an understanding of him or her. The job for the developer of simulation stories is to create those personalities, make them interesting and complex, and give them the traits needed to challenge the skills of the simulation participants.

In our first ALTSIM scenario, set in Bosnia, it was our job to represent the forces that made US involvement necessary. We needed to put a face on a minority who were in favor of ethnic cleansing and displacement of people whose

ancestors had lived in the region for centuries. These people did exist and there were leaders of such movements. What would such a personality be like? In our media savvy world, they would understand the power of news sources. They would be able to articulate their positions logically. They would be able to make a case for their goals. They would be able to talk to the press. They could be charming and charismatic, so much so that it might be the job of the participants to see through their charm and recognize the reality behind it.

In Idelson's words, the writer, on spotting this person coming toward them, could not run away but would have to dare to walk right up, look them in the eyes, and say, "Now what?" In fact, it is not enough to look into their eyes, it is necessary to look into their souls. The writer has to understand them and what motivates them, even learning to see things through their eyes and sympathize with them. This is where the character bible becomes so important. It is through the character bible that writers force themselves to explore the factors that motivate and drive the characters. Our villain in the ALTSIM Bosnia scenario was named Dragon Vatroslav. He was a well-educated, colorful man, but also an outlaw. He had been involved in international robbery and had served prison time. Yet at the time of our story, he had become a successful businessman and established a relationship with Slobodan Milosevic. Still not giving up on underworld activities, he organized his own army to take advantage of the ethnic unrest in his native state, the former Yugoslavia. He expressed himself very well. When a national news organization went into Bosnia to cover the incident at the weapon storage site, which was the basis of our simulation training, Vatroslav was the first person they talked to on camera. If the Battle Captain had the TV on during the simulation, he would have seen and heard his adversary.

Vatroslav was eloquent in describing the political consequences of forcing the repatriation of the minority into Bosnia. He cautioned against the participation of the United States in the relief effort and urged them to get out. He defended the crowd who had trapped the inspection team in the weapons storage site. But, in truth, what lay beneath that eloquence was a deep hatred for the ethnic minority. Generations of distrust and violence on both sides had turned him into a predator who was good at hiding his intentions, yet was constantly on the offensive. It became the job of the participants in the ALTSIM simulation to recognize that Vatroslav himself had orchestrated the attack on the weapons inspection team, and at that very moment was summoning paramilitary forces from the surrounding countryside to create an international incident. If the Battle Captain could piece together the true picture of Vatroslav's plan, it would be clear that the required response would have to be much more complex than a simple rescue. Time was of the essence. The action itself might not be able to be contained to the town itself but might include much of the outlying area. Movement of troops and ammunition was as much a factor as the action surrounding the storage site. The challenge for the Battle Captain was not to engage Vatroslav in any kind of hand-to-hand combat, but to recognize his ruthless nature and the scope of his plan. Only when thinking strategically with a true

awareness of the entire picture could the Battle Captain mount a successful operation. All this information was being fed to him through the simulated systems of ALTSIM's communication interface, often buried amid reports on much more mundane military operations. Also, to pull off the resolution of the exercise would require gaining the cooperation of that antagonistic leader of the foreign office, who you may remember being described as being a minor obstacle because he did not get along with the Battle Captain.

Figure 13.1 shows a piece of the "Vatroslav Dossier" made available to players in the ALTSIM simulation. Writer Larry Tuch developed the dossier by summarizing the Vatroslav character bible, which he also created.

As diabolical as Dragon Vatroslav was as a villain, and as good as he was at articulating his genocidal point of view, he pales in comparison with other simulation scenario villains who do not have the clear criminal records or outspoken hatred of the United States. The screenwriter who created the character had come up with a far more sinister cast for the Final Flurry exercise. As Chapter Two points out, in that simulation participants played members of a national security advisory team making recommendations to the president on international matters at a time when every hot spot in the world had erupted at once. Leading the cast of villains in that exercise was the president of a Middle Eastern country who had been very well indoctrinated in the ways of the West. He appeared on a popular evening news magazine show and graciously accepted a New York Yankees baseball cap—his favorite team, he said. This warm-hearted interview was shown to the participants in the simulation as part of a news summary that was supposed to be prepared for them every day by the intelligence community. It so endeared him to many of the participants that they automatically decided he was a friend, a good guy, and later when he began taking a very active path on the road to war, the participants still thought that he was bluffing and at core he was really on their side.

If they had dug deep into the intel available to them, they would have learned that his father played a role in the first World Trade Center bombing and that he blamed the United States for the death of his father and the plight of his country. This deep-seated anger festered beneath the mantle of friendship that he put on if only to disguise his true intentions. This villain, who masks his intentions in the guise of friendship, offers the greatest challenge to participants in these types of simulations, especially if the writer is skilled enough to build a character who has the capacity to lie because he understands and even sympathizes with his enemies.

A VILLAIN'S INTERNAL CONFLICT

So far we've talked about those steely-eyed villains who know exactly what they want and how to get it. They may be duplicitous but their threat to the hero is

DOSSIER SPECIFICS

Biography: Dragen Vatroslav
Born: Pozarevaca, Serbia, November 16,1945
Education: studied law at the University of Belgrade (1966) but left before finishing his degree.
Wife: Lidija Velichovic
Children: 2 (one son/one daughter)
Current whereabouts: unknown
Criminal Record: Described as a heavyweight of Belgrade's criminal underworld. Vatroslav before his most recent disappearance is said to have enjoyed status of being above the law. He distinguished himself by his flamboyant appearance and his close although recently strained friendship with Slobodan Milosevic and his wife Mirijana Markovic.

Arrested: 1974 by Belgian police for armed robbery. In 1975 he was sentenced to 10 years in prison. He escaped from prison.
Arrested: 1979 by Dutch police as an accomplice in three armed robberies. He was sentenced to seven years in prison. He escaped from the Amsterdam prison that same year and went underground.
Arrested: 1981 during an armed robbery in Frankfurt, Germany. Wounded during the arrest, he was placed in a prison hospital and promptly escaped. He is implicated in three additional armed robberies and other crimes.
Anecdote:
He is credited with entering a courtroom carrying two guns threatening the Swedish judge. He is said to have thrown one of the guns to an alleged accomplice and both escaped through a window in the courthouse. There is no information on hand to substantiate that story. Stories like this added to his hero status. Warrants for his arrest also were filed in Italy. Interpol had warrants for his arrest. Den Haag most recently issued indictment for alleged war crimes.
VATROSLAV:
US intelligence reveals that Vatroslav worked for the Serb State Security Service since age 14. He had spent his childhood in Pozarevaco and Zagreb. Where he attended high school. He enlisted in the naval school and wound up a stowaway who made it all the way to Trieste before entering the University of Belgrade to study law. In later years he had three passports including Yugoslav and British passports. He is said to have accumulated and used some 40 aliases. In the mid-'80's he returned from Western Europe to Belgrade to take over a string of well-known restaurants. He extended that business west and into Western Europe.
THE WAR YEARS:
He formed the Lion Brigade in 1990. Vatroslav pressed a number of people from his organized crime years into service. Shortly thereafter, Vatroslav and a group of his soldiers were arrested near Zagreb. The group was charged with the attempted assassination of Franjo Tudjman, who had been just elected president. Sentenced to 20 months in jail he was released after serving eight months. Later he and his soldiers were blamed for some of the worst ethnic cleansing during conflicts in Croatia, Bosnia and Kosovo. Among the carnage attributed to the Lions was the 1991 massacre of 250 wounded men taken from a Croatian hospital in Vukovar. The Lions joined the ranks of the JNA (Yugoslav National Army) and reportedly enjoyed privileged status. After the Croat army was expelled from Vucovar, Vatroslav's soldiers continued expelling remaining Croatian civilians and looting their houses. Vatroslav and his soldiers moved to Bosnia when it became

Figure 13.1 A sample ALTSIM character dossier.

clear and direct. The hero, facing self-doubt and trying hard to figure out the adversary, may have a rough go of it. But what if the villain is as conflicted and confused as the hero? What kind of a burden does that put on the hero? You would think that a person who rises to a position of power and has the ability to launch armies, attack cities, plan terrorism would end up being determined and single minded. But we know that is not always the case.

Hector Cantu was an opportunistic and idealistic young man who found success in dealing with an international drug cartel. He considered himself a man of the people. The cartel gave him the opportunity to run for president of a Latin American country, if he would represent their interests as they instructed. He agreed, but once in power he found himself caught between the wishes of the cartel and the needs of the people. His erratic foreign policy began to threaten world interests. He popped up on the radar of the Final Flurry exercise and became yet another challenge for the participants. Of course, Cantu was really a creation of the screenwriter, and the man's personal conflicts were designed to challenge even the finest statesmen-in-training. How could they figure out what Cantu would do next when even he didn't know? When the great obstacle between the hero and the goal is a loose cannon with almost no predictable behaviors, the simulation gets more engrossing, more powerful, and more instructional. The key to creating this kind of character, again, is the character bible. What confused history lead to the kind of inconsistent decision making that makes national security nearly impossible? Is it really only in Cantu's DNA, or is he just indecisive? It is in the best interest of the writer to take the behavioral approach and try to figure out a history that sets up and explains every action of the villain.

It may seem as if designing these deep character motivations and behavioral traits can only work in the high-stakes setting of a military or political conflict. However, similar motivations drive character behaviors in any sort of business, negotiation, managerial, or first-responder situation. Think about the drama, high stakes, and machiavellian behaviors we have all witnessed in the Enron and Tyco scandals, as well as the Hurricane Katrina disaster. Interestingly, complex character motivation and behavior exist in every walk of life, and conflict and high stress will inevitably bring these to the surface.

SUMMARY

Creating characters for simulation stories requires that the writers and designers explore their motivations, backgrounds, and complexities. This especially applies to the creation of villains who, in simulations, must represent the greatest obstacle to the goals of the hero. They must also be given the capability to challenge the skills of the hero in the areas that the simulation is trying to teach. The villain's background must provide them with experiences that will motivate

their actions: anger, deep hatred, bitterness. But these characteristics must also be balanced with a broad range of knowledge, understanding, and sympathy, all those things that allow people to act in unpredictable but internally consistent ways. A classic villain with a strong backstory provides a good adversary. A villain with internal conflicts makes the job of overcoming villainy even more difficult. And the educational story simulation may be at its best when it designs in features that make it possible for the hero's own weaknesses to actually make him or her the villain as well as the hero.

14

Synthetic Characters

After all of our technology, the pseudo intelligence algorithms, the fast exception matrices, the portent and content monitors and everything else, we still can't come close to generating a human voice that sounds as good as what a real live actor can give us. (Neal Stephenson in his futuristic novel *The Diamond Age*)

We have talked about the value of characters in presenting obstacles in story simulation and in guiding the progress of the story. We described the Final Flurry exercise created for the Department of Defense and implemented at the Industrial College of the Armed Forces. In that simulation the students were divided into groups, which represented advisors to the National Security Advisor (NSA). After a day of deliberation, the group would make recommendations to the NSA who would then pass those recommendations onto the President of the United States. The president in turn would then present those recommendations to the nation in a speech whose highlights were shown to the class as feedback for their deliberations.

We talked about the value of having predicted what the class would say and having the president's remarks restate the class's recommendations. We noted how the instructors of Final Flurry selected video clips from prerecorded segments that could be arranged into a tight presentation. We also pointed out that, in those cases where the class missed the point, the instructor could send a message to the class (usually a text e-mail) that explained exactly *why* their specific recommendation was not followed. Immediately after the first presentation of the StoryDrive version of Final Flurry, the development team from Paramount and the DoD agreed that it would be far better if the president could always respond to the specific recommendations of the class.

In ALTSIM, we said that one way of keeping the story on track was to use the Battle Captain's commanding officer (CO), who as a matter of procedure would always review important orders that the BC was issuing. The CO could be in videophone-contact with the BC and could direct, guide, and if necessary,

override the orders. This may have been the very best way of keeping a military simulation on track. In this case too, while the simulation author anticipated many reactions from the CO and prerecorded them, we again thought how effective it would be to have a real-time CO who could discuss the operation with the Battle Captain.

In both cases what we were imagining was a synthetic character, not just a nonplayer character with prescripted lines, but also a simulated character who reacted in real time to the specific input of the participants, a character who could address their recommendations to the letter.

LIVE ACTOR PARTICIPATION

The low-tech solution to the problem is not to use a synthetic character at all but to have a live person playing the role of the CO. The actor's image could be captured and presented on the participants' computer screens in real time. Imagine an actor playing the role of the president in the Final Flurry simulation. The instructor for each session selects elements for the president's speech that are prescripted and adds comments and remarks that tailor the speech to the exact recommendations of the class. The actor then reads the tailored speech on camera and the presentation is either fed live to the participants in real time or is recorded for delayed use.

In ALTSIM the simulation instructor could play the CO and his or her voice could be forwarded in real time to the participants in the simulation. This process is a true extension of the *man-in-the-loop* philosophy of instruction and leads us directly to the question of the role of the instructor or game manager in learning simulations. We will deal with that issue in the next section of this book. But for the purposes of this chapter, we have to say that this approach may solve a lot of problems, but it does not scale up to large instructional settings, does not make use of a synthetic character and it was not part of our research objectives.

TEXT-TO-SPEECH AND SYNTHETIC AUDIO

Currently, synthetic speech is so limited in its presentation of the human voice that characters' remarks sound robotic. While this works very well in simulations where you can actually portray the character as a robot, it seems very much out of place in simulations where a speaker is supposed to be a human being and is featured alongside video and audio clips which present the speech of actual actors. The jarring sense that the participants get when they hear the synthetic audio totally destroys the reality of the simulation. Yet as limiting as the technology is, we did experiment with it in the ALTSIM project.

We used a standard text-to-speech engine, which the simulation instructor could use to send specific messages to the participants. The instructor merely

typed in the required recommendation and the system presented it through its text-to-speech engine. To provide a face to go with the speech, we used photos of an actor that captured his face as he expressed different phonemes (mouth expressions). We then created a program that matched the facial expressions with the related audio syllables as they were spoken by the text-to-speech system. The video image was far more believable than the sound of the audio. It did allow us to experiment with the concept of virtual characters and also forced us to realize early on that, at least given the current state of voice synthesis technology, the loss of believability from prerecorded audio comments that did not exactly match the participant's responses was not nearly as great as the loss of believability created by the use of synthetic speech.

This finding was disappointing, but well in keeping with other studies that looked at the educational value of production values within simulation systems. These studies show that the closer the simulation gets to reality, the higher the need for accuracy. Participants accept a virtual world if the world is internally consistent. So when a highly realistic world is created, single elements that are not true to the realism of that world break the believability of the system. (See Chapter Twenty-One for further discussion of this concept.) The best things that could be hoped for in such a case would be creative solutions that at least explain the inconsistency.

A CREATIVE SOLUTION FOR LOW PRODUCTION VALUE TEXT-TO-SPEECH

In the case of our synthetic commanding officer, if the officer is said to be using a radio system whose properties include a good deal of radio static and which also digitizes the human voice, it may be possible to inject a synthetic character who can deliver completely original lines that are totally in keeping with the exact input of the participants and yet are somewhat believable in the context of the sound of the rest of the media in the simulation. This seemed to be the case in the few tests that we ran with ALTSIM, before we decided to drop the use of synthetic characters in favor of greater reliance on prerecorded audio and text messaging from the instructor. (We'll discuss this and other audio techniques further in Chapter Twenty-Five.)

SUMMARY

Text-to-speech and synthetic audio can be combined with images of real people to create synthetic characters. These characters allow simulations to directly match input from the instructor and can be a valuable tool in experience management (keeping the story on track and challenging the participants). However,

the current limited quality of synthetic audio creates a distraction for participants in simulations, especially when a large amount of realistic prerecorded audio is used. In the end, prerecorded audio that approximates answers to questions appears to be better than synthetic audio that is right on if the voice quality of the synthetic audio is distracting. The inclusion of text messaging from the instructor or a text-driven coaching system was found to be preferable in the three simulations that Paramount and USC did for the US military.

PART FOUR

MAN IN THE LOOP vs. THE AUTOMATED GAME MANAGER

15

The Instructor as Dungeon Master

The role of the simulation leader can be played out in a number of different ways in both military and industrial training simulations. In some cases leaders frequently take on the role of the opposition forces (the enemy or corporate competitors). In other cases the system operators become tacit but nevertheless highly visible system operators.

An example of the former case can be seen at the Army's National Training Center in California, where live military maneuvers are held in the field. The leaders who portray the opposing forces actually participate in field maneuvers as the red team. These simulation leaders are so skilled and experienced that the student-soldiers seldom have a chance of winning the simulated encounters. One professional trainer dubbed such exercises, "learning by defeat." Nevertheless, it is a strategy that has been followed successfully by the Army and by numerous corporate training organizations as well.

The following is an example of the latter kind of simulation management, in which the leaders are highly visible system operators. In the late 1990s, the US Army ran a series of military simulations at the National War College at Carlisle, Pennsylvania. The simulations were part of an effort called Army After Next in which the Army's Training and Doctrine Command attempted to anticipate the kinds of demands that the Army would be facing in the far future (circa 2025). The scenario for the game was built around a set of research objectives created in response to a request from the Army Chief of Staff. The political situations in the scenario were selected to provide a test bed in which the research objectives could be analyzed.

One such complex simulation dealt with an international crisis that was fomented by a dictator who established an independent state or a rogue nation that operated outside the bounds of international law. Participants in this simulation were divided into groups who played the leaders of all the nations involved in the crisis. Each nation group was called a cell and was identified by a different color that represented their geographic entity. The United States was represented by several cells, most notably the blue cell.

In this exercise the leaders of the simulation became the white cell, a controlling organism that ran the entire simulation. The white cell included game management and assessment personnel, an analysis team, a media production team and various content experts. The white cell monitored the progress of the participant groups through the exercise and modified the exercise to accommodate the unfolding events.

Every afternoon, members of the individual cells presented their decisions as a group. These presentations were monitored by assessors who, that evening, discussed them with the rest of the white cell. A chief assessor determined upcoming game events based on a reading of the actions and intent of the participant groups as weighed against the objectives of the game. Later that same night, the media team created new media elements to accommodate the previous day's events, and to kick off activities for the next day.

Organizations such as the white cell are common in other military simulations as well. Often in simulated warfare, tactical military maneuvers are simulated by groups of officers who take on the roles of field commanders who must deploy virtual troops in response to simulated enemy activity. Again, the people running such simulations form white cells to monitor their game's progress and adjust it in response to participant actions. They can see trends in the participants' behavior and can predict outcomes. As such they can inject events that present unique training challenges or counter trends that will lead to less positive learning experiences.

As noted in previous chapters, managing the events of a simulation to lead to desired outcomes for pedagogical reasons is not exactly the same as pursuing dramatic goals. But it is similar. The reason for pursuing a dramatic goal might be to maintain the highest possible level of tension, or keep the simulation story and the characters' actions consistent. Pedagogical goals might be to make certain that the participants have a learning experience that will teach them a particular lesson. Other pedagogical goals might seek to make sure that participants are in a position to deploy the desired assets in order to learn how those assets will operate in a specific environment. Leaders of most military simulation white cells don't have a story to deal with, nor do they have the tools necessary to create, maintain, or modify a story. In a typical white cell scenario, for example, there may be some attention paid to the psychology of the enemy leaders but not the same kind of effort to detail the experiences of their youth and the shaping of their character that might lead them, in a moment of crisis, to issue some seemingly inconsistent directive that could have devastating effects on their cause. That kind of focus is the result of the creation of character bibles, which lead to more formal explorations of character and its effect on the shaping of events.

In these simulations little attention is paid to the creation of the arc of the story which seeks to ensure that there is rising tension throughout the experience. There is also little attention paid to the construction of a formal crisis

moment just before the end of the simulation. It is at this moment when all the key performance goals are tested. Attending to the arc of the story helps simulation planners make sure that story elements are carefully placed so that they will all be available for the crisis moment.

In story based versions of these systems, the activities of the white cell will have to be guided by added design materials, media, and training that will enable members of the cell to complete these story-related tasks. The members of the cell will have to be aware of the dramatic elements present in the situation and know how to use them to enhance the power of the event. Moreover, in the best of all possible worlds, they will be able to construct new story elements that are consistent with the dramatic goals of the story and can influence the story in the most appropriate way.

Imagine a story-based simulation conducted in anticipation of the final days of World War II, one that was so well crafted that it could have anticipated the inexplicable decisions that Adolph Hitler made as allied armies advanced on Berlin. Seems impossible, doesn't it? And yet *only* a story-based simulation would have suggested that such bizarre decisions and events were ever possible. In other words, white cell guided simulations can become more powerful, more memorable and can gain instructional value by adding a well-crafted Hollywood story to the effort.

Having suggested that adding story-based elements to these large-scale training simulations could be of great value, the question then becomes how to provide the white cell with the kind of support and information they need to enable them to introduce, maintain, and enhance the story without making the effort seem unwieldy and irrelevant.

The tools needed to allow a large-scale simulation white cell to create and manage a story-based simulation are similar to those we have been describing in previous chapters when we talked about the role of the instructor in the Final Flurry, ALTSIM, and *Leaders* simulations. And the model for all those activities comes from role-playing games like Dungeons and Dragons. In D&D, as you may remember, it is players' job to construct their characters and make decisions for them as they move throughout the fantasy world. But it is the Dungeon Master (DM) who provides the context and the consequences of actions. You make the decisions, but the DM tells you what happens as a result of your decisions. In the finest sense of the role, the DM is a classical storyteller.

You've chosen this character, you've amassed these weapons and these strengths, and now you choose to go down this corridor in order to confront and kill the Giant Spider. You know what the Giant Spider is capable of, you know its strengths and weaknesses, but at the moment of truth it is the DM who decides the most exciting way that the spider confronts you. In its finest sense your battle with the Giant Spider is collaborative story telling with both you and the DM using one great storytelling trick after another to gain the advantage.

The instructor who is controlling the activity in a military simulation has a myriad of roles to fill. He or she must make sure:

- The system is running properly. The participants are staying within the bounds and rules of the simulation structure.
- The simulation story stays on track.
- The story stays internally consistent.
- The participants receive the appropriate feedback for each of the critical decisions.
- The simulation follows a path that will assure the participants of gaining the highest-level educational experience.

If necessary, the instructor must be ready to create content that will support and enhance the dramatic goals of the simulation.

In Final Flurry, the instructor monitored the classroom discussions of the student participants who were trying to deal with a world in which everything was going to hell at the same moment. The instructor had to feed them content as the simulation progressed. The instructor, in fact, chose the content that would lead the participants in the appropriate direction required by the goals of the simulation. If necessary, the instructor also created content that would help maintain the veracity of the story and provide specific feedback needed to keep the reality of the simulation intact. For example, if the participants made recommendations to the National Security Advisor about points that the president should make in his speech to the nation that night, then it was the instructor's responsibility to review the content, select matching prerecorded responses, and if no response matched some recommendations, to create content and send an e-mail back to the participants explaining why the president did not make that point (see Chapter Two).

In ALTSIM, it was the instructor's job to monitor the flow of content from the automated simulation system to the participants, and to select additional pieces of optional content to send when it became clear that those pieces of content were not understood or put to proper use. Moreover, in ALTSIM—a system that simulated an entire communication network—the instructor could choose among a variety of media: video clips, text messages, audio that screamed out of the participants' computers like frantic messages screaming out of the loudspeaker system in a real tactical operations center, etc. Again, the instructor could create content to reinforce messages in the form of e-mails, voice calls, or video command messages delivered by a simulated character.

In both cases the instructor was acting as a techno-wizard impresario, orchestrating the simulation event, adding interpretation when needed, and creating compelling content when it was absolutely necessary. In this way too, the instructor was acting as a Dungeon Master.

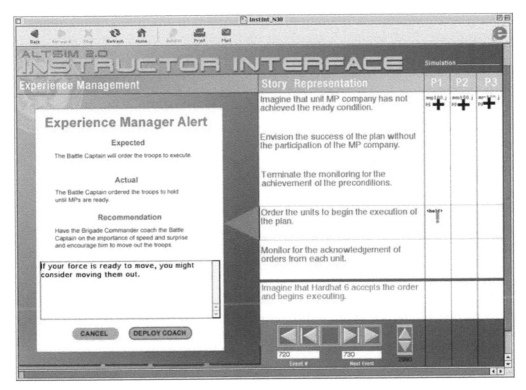

Figure 15.1 The ALTSIM Instructor Interface, which tells the woman or man in the loop when to intervene in the simulation and even what kind of content to create.

The ALTSIM system went very far to automate the system, in that it prepared many alternate messages in every form of media. Its Experience Manager monitored the activities of the participant and recommended interventions when it appeared that the participants were getting off track (see Chapter Ten). But all these were presented to the instructor for approval, and the instructor was always given the option to create additional content that he or she thought would provide better or more targeted feedback to the participants.

What all this means is that the authors of the Final Flurry and ALTSIM simulations constructed systems that were flexible enough to allow instructors to play a major role in the implementation of the exercise. The tools that were created by the simulation authors built in processes for instructor approval of pre-written media elements and allowed for the creation of original content by the instructor, in a variety of media, when that content was necessary.

ALTSIM (though it was built to use a man in the loop) did not require it. That is, the methodology that sent content to the instructor for approval before sending it to the participants could be overridden so that the simulation would,

in fact, send information directly to the participants. ALTSIM could be totally self-sufficient. In doing so, however, it had to sacrifice the benefits of original content creation. A fully automated ALTSIM had to rely solely on content created before the simulation began and which anticipated as best it could the activities of the participants.

The *Leaders* project followed a similar course. It was constructed entirely as a branching storyline where all content had already been created. The role assigned to the instructor then was that of a mentor, who monitored student progress and only participated in the simulation when he or she interrupted the exercise because the participants had gotten so far off track that instructor participation became mandatory. Such approaches place heavier burdens on the creators of the original content to anticipate the actions and decisions of the participants. They give up a great deal in dispensing with the custom-tailored, high storytelling craft of our new age Dungeon Masters. Nevertheless, they anticipate and lead the way for the automated Dungeon Master, white cell, and automated story generation systems of the future. Nevertheless, while the creation of the automated Dungeon Master is a great research problem, for those constructing simulations that are not purely research oriented, it's clear that participants learn more when a live instructor or game manager is built into the system.

SUMMARY

There are a number of different approaches to the management of simulation games. Leaders can run simulation by taking on the role of the opposing forces, or they can become highly visible system operators who manage the events of the simulation in order to achieve pedagogical goals (the white cell).

This role gets far more complex in managing story-based simulations. Managers of story-based simulations play roles similar to those of classic Dungeon Masters, who are actually participant storytellers. These leaders must be able to select appropriate content to respond to user actions and even create content tailor-made to respond to unique participant actions. But all of this must be done with an eye on the dramatic as well as the pedagogical goals of the simulation.

Automated leadership systems for story-based simulations will actually have to be able to generate story elements synthetically, if they are to rival the powers of the current "man in the loop" simulation management systems.

Automated Story Generation

In her seminal book *Hamlet on the Holodeck*, Janet Murray expands on the concept of ancient stories (such as the *Iliad* and the *Odyssey*) working as highly formularized communication systems. As she recounts, other examples, such as Russian fairy and folk tales, bear solid evidence that a few dozen basic plot events can generate hundreds and even thousands of stories. The storyteller of old—armed with "meta-data" about his story functions or morphemes—could easily shuffle his deck of "story cards," redress them as necessary for the current location or audience, and produce a performance-specific, site-specific story to tell. Evaluating the audience immersion and understanding of the story (are they laughing? are they crying? etc.), the storyteller could refine and alter the telling as necessary, on the fly.

In theory, robust software AI should be able to accomplish the same thing: building stories on the fly, based on pedagogical needs, user reaction, input, etc. Audio libraries of phrases and phonemes could be swapped in to assemble fresh and original dialogue and voiceover narration (a sort of "mad libs" approach); video snippets could be shuffled around to create content; a real-time 3D engine could load up a new game level and customize the level for story needs. (Game levels are a standard videogame convention dividing segments or movements of the experience: packaging up a terrain, sets, events, and nonplayer characters (NPCs) that a user must engage with in order to advance.)

However, this would require a much finer granularization of story content than has been discussed earlier in the book: we have to go well beyond the classic ideas of 3-act structures and inciting incidents, setups and payoffs, ticking clocks, and the like.

To aid this effort, characters would need to be separated from plot events. As Janet Murray points out, oral storytellers would do just this: a clown figure, or a damsel-in-distress, could be pulled into a story when necessary, and given its basic behaviors, the stock character would then find a way into the current story actions and movements. (The storyteller would place this character into the story at this moment because of a desired emotional or story-arc objective.)

These stock players would be independent agents, entering and leaving story events as required. Naturally, backstory histories would need continual updating, and progress toward both story events and learning objectives would need monitoring and evaluation.

If this doesn't sound hard enough, then add the crucial element of user interactivity. The more freedom and response gradation allowed the player, the harder all this assemblage of story and learning content will become. What happens when users stray from defined story paths, or test the limits of the system, or just behave in "irrational" ways? Will the automated story-generation system be intelligent enough to work around (and even try to correct) these problems—or will it have to construct increasingly artificial roadblocks, eventually undermining user confidence in the integrity of the interactivity and the "realism" of the simulation? In the worst-case scenario, will the automatic story generator end up creating incoherent storylines and irrelevant learning content?

These are only some of the questions and challenges facing researchers attempting to create automatic story generators. The advantages to creating such a generator, particularly in the context of creating fresh story-driven content for simulations, should be obvious. Simulation systems could respond to new data, news events, studies, and learning points, and immediately generate new scenarios. Users having trouble with the pedagogy of a simulation could return to the environment again, and be confronted with new storylines, rather than rehashing the same old plot turns.

The system we've just described would seem to be a long way off. Although story AI systems, similar to what's been described, have been tested in highly circumscribed, "miniaturized" story worlds, no automatic story generator has been able to author a truly usable, real-world simulation or videogame.

However, smaller steps toward this goal are being taken. One such approach is the Interactive Drama Architecture (IDA) being proposed by Brian Magerko, a researcher out of the University of Michigan (and a collaborator on the *Leaders* project). Magerko accepts as a given that fully automated storytelling isn't yet executable. However, it may be possible to substitute an "omniscient story director agent" mechanism for the traditional "director"; and this "director-agent" can, along with the original human storyteller, collaborate in creating an interactive story on the fly. The trick is in giving a user maximum freedom within the environment, while still respecting the construct of the story and the essential plot points and outcomes designed by the storyteller.

According to Magerko, an author begins by creating a "story space" which would include the following:

- Expressivity (dialogue, staging, character behavior, pacing, and environmental conditions)
- Coherency (content is associated with other content in terms of temporality and various conditions, in order to prevent incoherence: for

example, an introduction can only take place the first time a user meets
an NPC)
- Variability (multiple story paths are supported and encouraged, based on
user input)
- Player prediction (if player input can be accurately hypothesized, the
omniscient director can make a better decision about how to manage the
story's progress)
- Full structure (the full artistic vision—all creative and learning objec-
tives—is rendered in the story space: user input will not truncate the
experience)

Authors need to create narratives that are topological, rather than strictly
linear. Represented visually, plot points become nodes in an event topology. The
plot is no longer an action-by-action line, but a skeletal framework, with as few
plot constraints as possible.

NPCs within this world can become semi-autonomous, providing that they
have been given specific objectives to undertake within the topological narra-
tive. This will make NPC behavior more believable and the environment more
immersive: instead of being puppets (as NPCs so often are in videogames), they
become unpredictable characters with real motivations confronting obstacles to
their objectives.

The omniscient director can change the objectives of the NPCs, depending
on story progress and user input. Providing the director understands the state
of the story world at any moment, and has a good grounding in believable objec-
tives and transformation arcs, a truly rich, interactive, dynamic story space can
theoretically be achieved—without the human storyteller stepping in to tweak
scenarios and restructure the narrative.

In a sense, the omniscient director in the IDA becomes an on-scene Dungeon
Master or man in the loop, affecting the pacing, the story, and the emotional
experience, based on user interaction and psychology.

All this presumes that an ontology of interactions has already been devel-
oped, with an encoded syntax for interactions between all game agents (be they
NPCs, environments, event triggers, or users).

While not qualifying as pure automated story generation (and not pre-
tending to do so), this approach offers a new paradigm for immersive storytelling
that uses all the classical tools of Hollywood-style narrative and still stresses the
primacy of story narrative in a simulation experience. Users, however, should
experience dynamic, highly responsive story worlds with the feeling that they
share fully in the story creation, rather than feeling narrative and plot events
imposed on them, impossible to budge.

Magerko, as part of an interactive drama team at the University of
Michigan, has created a story space called *Haunt*, built around the Unreal game
engine (see Chapter Twenty-Four for discussion of real-time 3D game engines).

As of this writing, *Haunt* has undergone two iterations, and successfully balances autonomous NPCs, maximum user "freeplay," and dramatic developments and turning points, albeit in a very defined and specific environment. Magerko's work can be explored further at http://www.magerko.org.

The University of Michigan is not the only school to explore the automating of story content. Research in the arena of automated story generation is now a hot topic at different university programs, given that we now seem so close to arriving at tools that can achieve this. However, progress toward this goal is likely to be incremental, and for now, offers more hope than immediate usability.

Some will argue that "machine-driven" story-intensive simulations will necessarily be soulless and mechanical, and unlikely to ever feel immersive and real in the way that a great movie or great videogame can. But this may be like arguing that the only way to build an aesthetically beautiful and satisfyingly functional automobile is for the designer to hand-build each unit.

Even the most automated story generators will continue to require the spark of human imagination and ingenuity. And if automated story generators are truly to work, they are likely to require that human authors dig down even deeper into the source of their creativity, in order to define a story space that AI routines can shape and manage. In addition, when brought into the interactive realm, where there will be one or more human users (and perhaps an instructor-in-the-loop), automated stories (at their best) should feel absolutely unique, authentic, and original. They'll feel human, because everything about them is human.

SUMMARY

Janet Murray's *Hamlet on the Holodeck* suggests the possibility of an AI "cyber-bard" automating the process of story generation within an interactive simulation, thus creating the possibility of greater replayability, greater user customization and greater user immersion. To date, progress toward achieving this has been quite modest. Various approaches, including the Interactive Drama Architecture (IDA) proposed by Brian Magerko, begin to build bridges toward this illusive goal. IDA suggests the creation of an "omniscient director" who can operate as a kind of on-site Dungeon Master for a simulation experience. Research in this arena should continue to be monitored, and incremental progress toward automating story generation is something we should expect in the decades ahead. The daunting nature of this endeavor—aimed at the illusive core of creativity—is much more difficult than increasing CPU cycles or accelerating graphics processing. No matter how much progress is made, the "human storyteller" will stay central to the conception, creation, and composition of immersive story experiences.

PART FIVE

COMPLETING THE PYRAMID

17

Game Play

Although the first half of this book discussed the shaping and execution of story narrative in a simulation environment, the fact is that story alone will not carry a successful simulation. Compelling interactivity will be critical for maintaining user interest in the simulation, and for the dissemination of pedagogical and training content that the user can begin to engage, practice and master. The development, deployment, and evaluation of effective pedagogy in effect "completes the pyramid" of simulation building.

Inevitably, compelling interactivity should be "play"–what we usually refer to as "gameplay." Much has been written about theories of play (the study of which is known as "ludology"; see bibliography for references), but in a nutshell, play involves a set of rules and allowed behaviors, user actions that offer both pleasures and challenges, specific goals or objectives, and motivation to reach those objectives, which, when met, constitute an achievement, advancement, or victory. Failure to meet objectives constitutes the opposite: lack of advancement, or a loss.

Great gameplay can sometimes disguise sub par or mediocre storytelling. But as this book has argued, the addition of great story to great gameplay will get us much closer to a deeply immersive simulation that advances pedagogical goals.

Because different media and delivery platforms will deeply influence the quality and delivery of gameplay, their evaluation and selection are critical. In this chapter, we'll discuss some selection criteria for media and delivery platforms, as well as strategies for deploying, balancing, and testing gameplay. But first, we should carefully define elements of gameplay, and how they may better serve our pedagogical and training goals.

USER INPUT/ELEMENTS OF GAMEPLAY

It is helpful to look at the types of input available to a user, and the elements of gameplay we can begin to work with. Often, gameplay is defined too narrowly,

125

and we overlook interactivity and functionality that will create or enhance gameplay.

If we think of input as a selection of verbs (i.e., actions) the user can sort through and choose, we begin to see that the verb set itself is pretty limited. Users can select. They can execute (e.g., press a mouse button, fire an onscreen weapon, etc.). They can navigate. On a strictly 2D screen (for example, a webpage, an early videogame "side-scroller," or a 2D real-time strategy game), they can scroll left, right, up or down, or push around an icon or avatar vertically or horizontally. On a screen that simulates 3D space, the user can move forward, backward, and turn around within the space. The user can also climb or move up or down, via some means (e.g., jumping capability, a ladder, or a "jetpack"). The user can interact with and manipulate screen objects, e.g., via a pointer (using the drag-and-drop metaphor), onscreen hands, or other organic or mechanical device (feet, hips, knife, etc.). All interactivity and navigation is executed via keyboard, control buttons, mouse or pointing device—unless we employ a touchscreen (where the pointing device is an actual human finger) or a true virtual reality world with which the user can physically become engaged (to be discussed briefly in Chapter Thirty).

Given the limited actions or verbs available to a user, what will he or she find fun, challenging and worth repeating?

We've all seen the movie scene where a released prisoner first enjoys his or her freedom outdoors, and moves around in sheer delight, sometimes running, sometimes braking to a stop. We recognize the essential truth of this scene: one of the innate pleasures of living is the freedom to navigate space. This truth carries over to any sort of digital space we create, whether 2D (e.g., a webpage) or 3D (e.g., a first-person shooter game). Being able to navigate, and explore, gives us the feeling of control over the world. Janet Murray defines this as "agency," a critical element of successful interactivity.

Sheer exploration will hold a user's attention for awhile, but virtual navigation becomes more engaging when there is purpose behind the navigation. In 3D space, users will get even more pleasure in navigating with speed if they have specific goals to achieve: get information, beat a time, interact with an object or virtual character. Navigation is equally important in 2D space: the World Wide Web took off partially because of the pleasure in "surfing" webpages, moving speedily from page to page with the goal of gathering specific information.

Users enjoy learning when it is a clear means to a desired end. Learning to navigate more quickly, effectively and efficiently is a pleasure when it helps a user reach a goal. If the goal is viewed as worthy of achieving, then a user will gladly practice and repeat a navigation or other activity in order to claim it, and will happily embrace a challenge because it invests the objective with greater significance. We cannot underestimate the value of having clear-cut goals invested with meaning, and here is where story can do so much for us, as has been discussed in previous chapters. When goals carry not only abstract value or eco-

nomic value (e.g., "I will do my job better if I learn this, and get a promotion") but emotional value (e.g., "and then they will all love me again!"), the player is likely to undertake even harder challenges and take away more meaning from the engagement.

If we alternate between challenges (necessary to claim the goal) and rewards (that are offered upon achieving the goal), we'll begin to create balanced gameplay that will engage the user in a concentrated learning experience.

Navigation alone, no matter how goal-oriented and challenging, would eventually become monotonous. Interestingly, making choices is also a pleasurable experience for users. We see this whenever anyone takes a "Cosmo quiz" (the self-assessment game feature in Cosmopolitan magazine): the cerebral engagement of examining a situation that demands action and selecting from several alternatives is empowering and invigorating. (It is another form of agency, because we again exercise control.) Indeed, one of the signs of clinical depression is when a person avoids making choices in his or her life, and leads an increasingly passive experience.

These choices, however, must contain real consequences that the user can perceive. Users quickly lose interest in inconsequential choices: they will refuse to be lab rats, pushing buttons just to keep themselves busy. The Cosmo Quiz would be uninteresting if it ended each month with "to be continued." Instead, quiz takers are rewarded after meeting all the challenges (making decisions) by getting a score and gaining knowledge about themselves. The goal is both desirable and fun.

Both navigation and decision making keep a user interacting with his or her environment. Some learning is best achieved when the interactivity is synchronous with other events and actors (characters) in the environment; other learning, often more cerebral, is better served by asynchronous, or turn-based, interactivity. Think about a game of chess, which is all about reflection, study, and strategy. Real-time situational awareness, or scenarios where decision making must be made based on reflex, instinct, or emotion, may be better served in fully synchronous worlds.

Object manipulation is yet another source of play. We are, after all, toolmakers and tool users: our desire to create, control, modify, and destroy objects seems to be encoded into our DNA. Firing weapons and destroying life and property may be more fundamental to our natures than we care to admit. Fortunately, dragging, dropping, targeting and firing virtual objects is a more politically correct method of indulging this pleasure. Rich 3D environments give us the ability to engage gears; assemble disparate parts into objects; fight, dress, or embrace avatars; or eliminate dangerous items or characters.

Puzzle solving is one of the classic elements of gameplay. It involves some form of navigation, coupled with decision making and, often, object manipulation. But puzzles need to be integrated into the simulation, not merely busy work. Perhaps a code needs breaking, or a DNA pattern needs reading. Perhaps

equipment needs assembling, or a door needs to be unlocked in order to rescue a potential victim.

Ticking clocks can often enhance gameplay. This is really a dramatic device that gains even greater meaning when the user pits him or herself against it. A decision may need to be made, a corridor may need to be navigated, or a piece of equipment may need to be assembled in X amount of time. The ticking clock further crystallizes the importance and urgency of the goal and gives us a very easy-to-measure rate of progress (e.g., I have improved if I can beat the count-down by 7 seconds instead of 2; I have improved if the clock just beats me, rather than my having made little progress before time runs out).

Hide-and-seek is another activity that extends a sense of fun. If you've lost your keys and then find them, you know the pleasure and satisfaction you feel—not all of it is because you need your keys! Instead, there is a deep feeling of accomplishment, of having used brains and perseverance to succeed. Quests—the key activity in so many action and adventure games—are really just extended hide-and-seek activities. We enjoy navigating so that we can locate objects, and we gain greater pleasure when we are racing the clock to do so.

Donning masks or disguises, i.e., role-playing, is yet another significant form of play. We see this with the advance of Halloween as possibly the most popular holiday of the year (Christmas time, with its onerous shopping and entertaining duties, becomes something we *must* do; Halloween is something we *want* to do.) Centuries-old Carnivale, particularly in places like Venice and Brazil, is also more popular than ever.

Janet Murray identifies this mask donning and role-playing with "trans-formation," another key element of successful interactivity. Transformation again empowers the user, allowing him or her to "be someone else" and loosening the usual bonds of inhibition that are part of our daily personas. These activities (exploring alternate personas and behaviors) are pleasurable for the user, par-tially because no cost is associated with them. In addition, transformation may grant the user new powers, which may aid the user in navigation, puzzle solving, object interaction and other crucial gameplay elements.

Interestingly, even quizzes offer some degree of transformation, since at the end you become a quiz winner or quiz loser, or, according to the Cosmo quiz, you are crowned a "great lover" or a "lousy lover." Momentarily, you have a title: you are something you weren't (or weren't aware you were) before.

During their transformation (particularly when they fully assume a role, e.g., the newbie company commander or a union shop leader), users are more easily able to learn, because they see the environment and their belief system in a new light. Here again, if we can create a story space that aids users in under-taking transformation (by role-playing or promotion, e.g., a new employee becomes a company VP), we enhance the opportunities for training and trans-ference of pedagogy.

Beat-the-clock, solve-the-puzzle, hide-and-seek, ace-the-exam, kill-the-enemy, don-a-mask . . . if you think about it, most gameplay will fit into one of

these categories, and all of them involve some combination of navigation, decision making, and object interaction and manipulation.

You may look at your simulation as one involving complex interactions (between individual users, or between a user and nonplayer characters, or between a user and the environment), informational transactions, dialogues, and high-level decision making. But when we look at the basic actions, we still have a lot of puzzle solving (we'd like outcome Z based on situation Y and problem X—how do we do it?) and ace-the-exam gameplay, often with a beat-the-clock component.

When we think about the pedagogical content we wish to impart, we begin to see that much of it dovetails with these pleasurable play functions. Our goal is to impart knowledge, guidelines and experience so that a user can solve problems, locate information, recognize new facets of a situation, eliminate potential threats and function in a timely manner (even under pressure). From this standpoint, the more we can incorporate effective and engaging gameplay into our simulation, the more likely we are to succeed in the delivery of training and pedagogy.

CALIBRATING GAMEPLAY FOR EMOTION AND INVESTMENT

We can begin to use gameplay elements such as time and pressure to calibrate a user's emotions. Think of these elements as sliders to move between maximum and minimum parameters while we step through a typical interactive process.

- Situational awareness: What's around me? Where do I go? If we have lots of time, the game and our emotions are calmer; an ever-changing and threatening environment invokes panic, discomfort, and stress.
- The actionable decision: Now I know the situation, what do I do? Again: time, pressure, and stakes will change the emotional complexion of the game.
- Implementing the decision via game controls: Is the real stress in the decision making, or in a tricky navigational or manipulation maneuver?
- Feedback from the game environment: Do I instantly get new challenges? Do I get a do-over if I erred? Or will the situation now re-set itself (and at what speed)?
- Reaction decision: How do I respond to the game feedback, and at what speed? If I made a mistake the first time, can I now correct the mistake—or am I doomed?
- Reaction: Do I have to master new game controls, or can I use the old game controls? Has my agency been reduced because of my earlier action?
- Win/lose: Is there an immediate outcome? Can I recognize it? Is there a "victory lap"? If I lose, is it important? Do I die or get reborn?

(The above discussion on calibrating gameplay elements is largely drawn from a seminal Ben Calica game design article, cited in the bibliography.)

GAMEPLAY DESIGN RULES

Game design veteran Noah Falstein is assembling an ambitious compilation of game design rules he calls "The 400 Project" (http://www.theinspiracy.com/400_project.htm). These rules run the gamut from "Make the Game Fun for the Player, not the Designer or Computer" to "Add a Small Amount of Randomness to AI Calculations." For anyone serious about designing compelling gameplay, these rules are a good place to start. Check out the website.

In these brief sections, we have only begun to explore gameplay and ludology. But the more we understand how gameplay works, the more engaging we can make our interactivity. Ludology without technology won't get us very far, however. As we begin to conceptualize the interactivity we deem necessary for our simulation, we need to ask which media and delivery platforms will best serve our gameplay.

MEDIA: TEMPERATURE AND DELIVERY BANDWIDTH

In Chapter Twenty, we'll more thoroughly examine media through the prisms of "temperature" (as originally defined by Marshall McLuhan in his groundbreaking book *Understanding Media*) and "bandwidth." These two principles will affect our gameplay. Media that is cooler and requires lower bandwidth will often be more appropriate for more strategic, turn-based, cerebral gameplay (see the complete media temperature/bandwidth matrix in Chapter Twenty). However, there are exceptions, which we'll see momentarily. In general, 2D visual media (e.g., webpages, slideshows, charts and spreadsheets, documents, still images) will support puzzle solving, ace-the-exam, hide-and-seek, and beat-the-clock. However, the style of game here may be slower and more contemplative: something akin to fantasy football, where the pleasure is derived from the study of player statistics, the weighing of potential player combinations, and the anticipation of the next big milestone.

We can imagine a political science simulation or macroeconomics simulation (either one of these offering an amplification of the solve-the-puzzle play instinct) that relies wholly on this sort of low-bandwidth media, which is highly appropriate for Internet or networked delivery, although physical disk distribution would work equally well. (In the next chapters, we'll discuss delivery platforms in more detail.)

Conceivably, a simulation might consist solely of textual content and text input (something like our Cosmo quiz). This could literally be delivered via cell phone SMS messaging. And although this probably stretches the definition of a

simulation to the breaking point, it illustrates the point that gameplay can be delivered using any media (cool or hot).

Audio and live action video require greater bandwidth, and their temperature is variable enough to support different kinds of gameplay. That said, their temperature is always higher than the media mentioned in the previous paragraph.

For example, we may use audio to simulate phone calls, voicemail, and news radio broadcasts that supply content to our poli-sci or econ simulation. Although the audio may carry almost purely informational/pedagogical content, the fact is that the audio will create greater urgency and "heat": the inclusion of human voices makes the simulation more immersive, and radio broadcasts, voicemails, etc., are almost undoubtedly going to up the stakes in our simulation. (Voicemails are likely to request or desire actions; radio broadcasts are likely to convey troubling news or new developments that change the situation, etc.)

Similarly, video may be used to simulate newscasts, teleconferences, recorded presentations, etc. The human presence again adds greater weight and urgency to the content. (If a character tells me that a leading economic indicator has declined or that the nuclear seals have been broken, this will mean more than the same information delivered textually.)

However, audio and video can be used to deliver even more heat when used in conjunction with gameplay that emphasizes the tactical, visceral, and synchronous. This kind of gameplay is best served by a 3D environment that user avatars (first or third person) can navigate. The puzzle-solving, hide-and-seek, ace-the-exam, kill-the-enemy, beat-the-clock, and don-the-mask play styles will become much more immersive in a real-time navigable space, where the simulation is about making quick decisions within a specific environment.

Though unlikely, it could be that the only gameplay we need can take place in the 3D virtual environment; we can bypass webpages, images, audio, and live action video. Chances are, however, that gameplay we envision in a 3D space will also require the use of lower bandwidth media. The combination will enrich the experience—and the gameplay—even further. A printed Briefing Kit greatly enhanced the participant experience in the 3D virtual world of the *Leaders* simulation.

Because any simulation environment is costly and complex to develop, you'll especially wish to avoid choosing an environment you don't need, and which gives you gameplay features you're not planning on using. For example, if user avatar spatial navigation isn't critical to interactivity, then choosing a real-time 3D environment for development and delivery is inappropriate. If sensory stimuli are unnecessary, then you should stay away from any virtual reality considerations.

Ideally, you'll exploit the appropriate media types—and the gameplay they deliver—for your platform of choice. The challenges that any platform presents

in deployment should be challenges you *need* to meet. Choosing a platform because it's "sexy" or "exciting" or "hot" is a first step toward failure. Not all gameplay and all simulations require real-time synchronicity. No game is more asynchronous than chess, yet its level of difficulty, its addictiveness, and its user immersion are enormous.

GAMEPLAY ISN'T EVERYTHING

Although gameplay is critical, it is not the only determinant for which delivery platform to select. Issues arising in building the immersive environment will be discussed in the following chapters. You may need to balance the needs of gameplay with production, budget and personnel needs. All these elements should factor into the final selection of media and platform.

SUMMARY

Gameplay will breathe life into any simulation. Without compelling and immersive gameplay, the best story-driven simulation will fall flat and fail to impart desired training and pedagogy to the user. Breaking down gameplay into basic components will help in designing and developing gameplay. Often, we overlook what really is at the core of good gameplay. The more we understand the components of gameplay, the better we can calibrate their use to create emotion and user investment, and the better we can synch up gameplay to narrative. Once we know what gameplay we'd like, we can begin to select the right media and the right platform for our simulation. Gameplay alone won't determine the final selection of platform, but no factor should have greater weight.

18

Evaluation and Testing

Once a commercial videogame is released to the public, the only evaluation and testing the game needs is the return on investment (ROI) it generates. It's either a hit or a miss. While much focus group testing will be done if a sequel gets placed on the drawing boards, the creators are able to move on quickly. The release date is the finish line.

Pedagogical and training simulations are a different matter. The ROI isn't measured in dollars, but whether users learn and grow. Precisely measuring inherently internal states has forever been the bane of education experts. While we can more easily evaluate rote memorization and ability and speed in accomplishing certain tasks, quantifying improvements in understanding and experience is much more difficult, even though outcome-based assessments have been a key emphasis of pedagogical evaluation this past decade.

DEVELOPING COHERENT PEDAGOGY

On the plus side, computer simulations offer the potential of gathering and culling rich data sets, which should aid in comparative and contextual evaluations. However, knowing what user behavior and input to log—and how to draw meaning from raw data—doesn't come so easily.

As discussed earlier in this book, research, need, and observation should drive the formulation of the pedagogy to be transferred to the user. But sometimes the purpose of the training or pedagogy can get lost in the data collection and research. Once teaching points and decision crossroads are forged, they need to be sifted and checked against the "Big Picture" of the pedagogical goals. The training or pedagogy needs a coherent throughline: both for the user, who must navigate the complex pedagogical storyworld and quickly master the transferable content, and for the evaluator, who must effectively measure the content transfer.

Without a clear-cut throughline, pedagogy can easily fragment into disparate pieces of knowledge transmission, some redundant or even contradictory.

In attempting to teach a lot, authors and content experts can wind up teaching very little. Users finding contradictory material can begin to feel: "I don't trust this game. It doesn't even know when it contradicts itself." Similarly, redundant or contradictory pedagogy can trigger a loss of user motivation, threatening the integrity of all collected data. (Users who lose the desire to show they're mastering material may begin behaving inconsistently or irrationally, a sign they're bored or confused.)

The dangers of unfocused pedagogy increase the more that the desired content transfer is high level. If we're teaching users how to dismantle a bomb, we can more easily design evaluation tools that measure our success or shortcomings. If we're teaching executive management skills for a variety of typical situations, measuring progress can become more difficult and unreliable, especially if the skills we're teaching are too varied or hard to define.

Our goal should be to construct a Big Picture of the pedagogical content. The content itself should have narrative fidelity and coherence, in other words: a storyline. And simulations should focus on the transfer of one or two Big Picture concepts. Given the cost of simulation development (especially in the initial ramp-up), it's easy to feel compelled to try to cover *everything* in a single experience. But training and skill advancement should be viewed as a continual process. And if simulation design and construction workflow are in place, bringing new simulations online should become progressively less expensive.

PEDAGOGY MUST DRIVE SIMULATION DESIGN

If simulation design occurs prior to the development of pedagogy, final assessments of the pedagogical transfer may become unreliable. Questions will always arise as to whether the authored content, the user experience, the user input, and the selected evaluation tools were appropriate for the content. Indeed, successful integration of pedagogical content with inappropriate delivery, media, and interactivity would be impossible.

It can be very tempting to use the latest and greatest in technology. Often, the selection of "sexy" technology can aid fundraising and help garner project go-aheads. However, many simulations do not need the latest 3D game engine or virtual reality environment to achieve their goals—in fact, simulations can become less immersive the more they rely on cutting-edge technology.

For example, a simulation located in the stock-trading world might be better served by using a strictly 2D, Internet-delivered platform. While it would be possible to create a navigable 3D world where a user could walk onto the trading floor and interact with other traders, this may be distracting when the primary goal is (let's say) the improvement of user decision making during a world economic crisis (which is supposed to be based on incoming 2D data). User distraction is bound to negate some of the learning and also offer up potentially misleading data when measuring user comprehension and advancement.

Clearly, project budget, along with available facilities, personnel and technology, will also impact the choice of simulation platform and environment. But given that the least expensive approaches always entail unexpected costs—and that the cost of today's high-end technology can suddenly plummet—first emphasis still needs to be placed on how the selection of platform, interactivity, and media can further content transfer and assessments of that transfer.

As discussed in the previous section, only a coherent pedagogy will give us a reliable sense of our technology, interface, usability, and measurement needs. With this in hand, we can begin to ask questions about how to achieve effective teaching and about the user experience that may facilitate this.

Are we stressing interaction with fellow humans (whether fellow users or synthetic characters) in a spatial, synchronous (i.e., face-to-face) environment—or is the desired kind of interaction asynchronous and remote (via e-mails, documents, voicemails, etc.)? Are we focusing on the rapid assessment of similar kinds of input (spreadsheets, charts, etc.), or of disparate types of input (spreadsheets, colleague concerns expressed face-to-face, news videos, an unpleasant supervisor encounter, unexpected workplace events [e.g., a layoff, an industrial accident] that unfold, etc.)? Are we more interested in rapid decision making, or in contextual user behavior? What knowledge level are users starting out at, and what knowledge level do we want them to ascend to? Are users comfortable within this simulation environment, or will there be a steep learning curve and likely discomfort throughout the experience? (For example: users younger than 30 will probably be very comfortable in a real-time, 3D, computer graphics environment, and more inclined to enjoy the training; middle-aged users will probably be more comfortable with a 2D environment, and may not be motivated to master a 3D simulation.)

Deconstructing our pedagogy, and exhaustively examining the user experience needed to both simulate the real-world environment and open the door to teaching and modeling behavior and knowledge, should begin to lead us to the appropriate selection of platform, simulation environment, media, and user interactivity. However, we will also need to ask whether the platform will allow us to effectively measure progress, retention, and mastery of material.

Only when we've reliably determined how the pedagogy can best be rolled out, what the user interactivity needs to be to advance the pedagogy, and how we can evaluate user learning, can we make a fully informed decision about simulation design.

STORY CONTENT AND INTERACTIVITY AS IT RELATES TO PEDAGOGICAL EVALUATION AND TESTING

In earlier chapters, we've provided evidence that story content can help transfer pedagogical content. However, story content needs to be examined in light of the evaluation and testing to be done. Are the pedagogical goals remaining "loud

and clear" after the infusion of story, or, are the training elements getting diluted or contradicted by the story elements? Will the story content undermine learning evaluations, or even worse, render them invalid?

The story needs to be analyzed for its ability to capture the attention of the user and its ability to complement, and not overwhelm or distract from, the training goals. Is the story aiding in motivating the user, or is it obscuring the primary intent of the simulation? If the story is viewed as being a drag on the user or getting in the way of the user (as many videogame storylines do), then new effort needs to be placed on creating a more compelling and necessary story. (Perhaps the story has been pasted on top of the primary simulation, or fails to integrate with user interactivity and testing.)

The addition of story content can easily lead to a lengthening of simulation running times and user sessions, and the attention span of a typical user needs to be considered. Complexities of story can diminish user focus and attentiveness, decreasing learning retention and comprehension and threatening in-game evaluations. Story content needs to be "bite-sized," or easily re-accessed if necessary, to support user attention spans and pedagogical activities.

We need to look at the assessment process as well, particularly if we are considering repurposing previously designed learning assessments. These older assessments will not be focused on how the story content moves the learning narrative along, and may not adequately embrace the added nuances and ambiguities that story content has brought to the experience. Consequently, the assessments may be one-dimensional and misleading with respect to what the user has learned.

Rather than being created in a vacuum, assessments will need to be created with an eye toward what the story content has added to (or subtracted from) the experience. Assessments themselves may need more nuance and precision, and may need a complete redesign, rather than a band-aid modification for the new simulation.

With the further addition of user interactivity into the simulation, evaluation and testing becomes even more complex. If there are branching storylines, will every path offer the same matrix of pedagogical content? If not, will the evaluation tools take this into account and recognize different levels of content transfer? If the simulation offers more nuanced and complex user interaction (where the simulation dynamically adjusts content and builds stories on the fly depending on the simulation state engine), will testing be able to fully evaluate the user's decision making and performance? If solutions are open ended, how do we measure user reasoning and skill acquisition, rather than simply marking the "correct" solution? If cooperative teamwork and leadership are at the heart of the interactivity, how can we quantify their progress?

In short, the addition of story and interactivity will have tremendous impact on the evaluation and testing we do; and unless we account for this impact, we will fall short of fully evaluating user progress.

FORMATIVE EVALUATION

Once the research and data collection have coalesced into (1) a coherent pedagogical narrative, and (2) discrete teaching points and decision points, a front-end evaluation of the planned user demographic should be done. This is often called a *formative evaluation*, which typically explores a simple but critical question: Where do our users currently stand in relation to the pedagogical content? We need to set a baseline. Where are they strong, where are they weak, and how do they evaluate their own skills and knowledge in the area?

These formative evaluations should be done on paper and in focus groups, so we can gather a broad spectrum of data sets and have confidence in our understanding of the proposed users. Obviously, the evaluation instruments may vary wildly: Do we need to measure students' mastery of soft skills, or their ability to plan strategies, or their situational awareness and tactical decision making in a dangerous situation?

USC professor Dr. Patti Riley, who led the evaluation and testing for *Leaders*, says that testing is more than a matter of putting together a couple of questionnaires and tabulating results: "You need someone with a couple of years of college statistics [to guide the testing and develop useful measurement tools]." This person on the development team should collaborate with a subject matter expert to help shape and guide the evaluations—and not lose sight of the pedagogy's "Big Picture."

Aside from knowledge in statistics and analytics, the ideal assessment leader should have a good foundation in psychometrics. Psychometrics studies the seemingly unquantifiable: cultural baggage, quality of life, personality, and other high-level mental abstractions. Psychometric assessments and data collecting will broaden the scope of our initial testing and end-of-simulation testing.

The more we know about our users, the better we can design the simulation around their expectations, behaviors, and needs. Given the addition of story content into the learning arena, we should also find out how comfortable users are with ambiguity and nuances. Can they see the underlying learning principles within the context of story, or are they going to need additional help in navigating the story space?

If users have previously been getting the training content via a classroom setting or assigned readings or quasi-simulation experiences, then attention needs to be paid to the progress they typically made in these situations. Part of the summative evaluation (which we'll soon discuss) will be determining whether the story-driven simulation has enabled students to make greater progress with content or enabled them to master content more quickly.

Good testing and evaluation practices dictate that summative evaluation commences with the simulation's "proof of concept." The proof of concept should dole out enough content transfer that user progress can be measured, and

the summative evaluations planned for the full project can be rolled out, tested, and refined.

EVALUATIONS DURING THE SIMULATION

In an interactive environment, it becomes tempting to allow the user complete freedom of action. If the user makes mistake after mistake after mistake . . . well, that's real life, and the user has the right to do this in an interactive story space.

However, according to Dr. Riley, research has consistently shown that users showing a pattern of incorrect decision making need intervention. Allowing the user to consistently fail, with no feedback on the shortcomings, will actually reinforce the undesired behavior. In addition, user data and evaluations will begin to lose their integrity and value if users are allowed to compound their errors over a sustained period.

In addition, users begin to get demotivated if they are recognizing that their performance is sub par; and if the storyspace environment is giving them no feedback whatsoever on their performance, then that's an inherent gameplay design flaw (users should be able to see or experience results deriving from their input). Instead, users need to get frequent feedback on their progress, and even more feedback when they're not engaging with and understanding the pedagogical content.

This certainly argues for simulations to be broken up into identifiable chapters or intervals, with "after action reviews" or "in process assessments" concluding each chapter. Ideally, the after action review can be designed to gather further insight into user reasoning and motivation for decisions, and can offer guidance for the user who's gone astray. The most sophisticated interactive simulations will then be able to customize the next chapter (or an additional chapter) of the story space to give the user further opportunity to master the training material. (See earlier discussions on the Experience Manager (Chapter 10) and on automated story generation (Chapter 16).) An alternative approach is to guide users in repeating the chapter, so they can implement the feedback they've received in the after action review.

The instructor-in-the-loop approach may allow for minute interactions with users to keep them on-track, and prevent them from continual repetition of incorrect behaviors. In essence, the after action review would be happening throughout the experience. For certain simulations, it may be preferable to offer nearly continual feedback to users. However, this will clearly diminish the feeling of "free will" that interactivity grants users, and this amount of handholding may reinforce an undesirable dependency on superiors, rather than independent decision making and confidence building.

Dr. Riley recommends that pedagogical content be "chunked," with smaller issues or less complex material appearing in the early chapters or levels of a

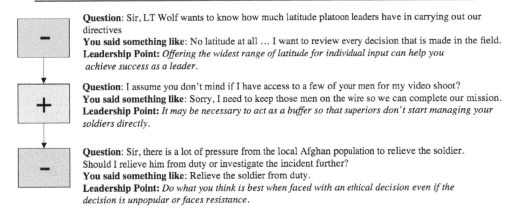

Leaders After Action Review
2 of the 3 decisions you made were incorrect

Question: Sir, LT Wolf wants to know how much latitude platoon leaders have in carrying out our directives
You said something like: No latitude at all ... I want to review every decision that is made in the field.
Leadership Point: *Offering the widest range of latitude for individual input can help you achieve success as a leader.*

Question: I assume you don't mind if I have access to a few of your men for my video shoot?
You said something like: Sorry, I need to keep those men on the wire so we can complete our mission.
Leadership Point: *It may be necessary to act as a buffer so that superiors don't start managing your soldiers directly.*

Question: Sir, there is a lot of pressure from the local Afghan population to relieve the soldier. Should I relieve him from duty or investigate the incident further?
You said something like: Relieve the soldier from duty.
Leadership Point: *Do what you think is best when faced with an ethical decision even if the decision is unpopular or faces resistance.*

You should repeat this chapter of the Leaders exercise

Path 8 -20 -> 19 -> 28 -> wrong

Figure 18.1 Sample after action review screen from the *Leaders* simulation.

simulation, allowing for a user ramp-up in the uses of the system and a more holistic understanding of the story space. Fortunately, this type of rollout complements the classic story structure, which should also ramp up plot developments and character revelations. In addition, this mirrors the training and assessment techniques that commercial videogames already use: most games will start with one or more tutorials, gradually ramping up the level of difficulty and familiarizing the user with the game environment, control behaviors, and game flow.

One critical component in users' absorption of learning materials in a simulation environment is whether both the learning and the simulation space meets their expectations. Learning that seems disconnected from the simulation environment, or from users' constructions of their own realities and needs, becomes easy to ignore or distort. User progress will stall, and learning assessments will be less revealing.

In this also, the learning process mirrors the suspension of disbelief necessary for stories. Most narratives carry with them genre expectations: we know the basic rhythms and underlying assumptions of a crime story, a horror story, a teen comedy, and so on. And when these are severely violated, defeating our expectations, we have difficulty enjoying the story.

As discussed earlier in this chapter, the pedagogy needs to drive the simulation design. Designers, training leaders, and evaluators need to collaborate in making sure that the learning is matched to the simulation environment and narrative, and that both are matched to user expectations.

SUMMATIVE EVALUATIONS

Summative evaluations attempt to verify whether defined objectives are met, and whether teaching content has been effectively received by the target audience.

If the simulation has been designed hand-in-hand with testing and evaluation instruments, and if the data logs (and page tagging, if used) are accurately constructing the reality of the story space, the potential exists for deriving extremely rich assessment data: data whose capture could only be dreamed of before. On the simplest level, this can include user elapsed time in meeting objectives or handling tasks, number of self-corrections, number of mistakes made or dead ends taken, and so on.

With the totality of this kind of data, evaluators should be able to study the internal learning process that users undertake: they can measure users against themselves (such as runners are always competing against their previous race times) and see how users change the way they make decisions. Assessments can also get to the underlying reasons for user assumptions and user decisions, via a comprehensive or "final" after action review that would be a full debriefing of the experience.

Dr. Riley envisions the day when evaluators may be able to "slot in" an assessment package with large databases of peer data, means, and standard deviations, making learning assessments for a simulation much easier to design, execute, and evaluate. But for now, each story-driven simulation is likely to require highly customized assessment tools and instruments.

Simultaneously, we can expect to see pedagogy engines and assessment engines that are as robust as today's game engines. Work in this arena is already underway. But for now, pedagogical and assessment implementation will still need to be "hand-tooled" and will lag behind the game technology itself.

Despite this, we can see that possibly the biggest single advantage of computer-based pedagogical simulations is in the collection and analysis of complex assessment data, allowing training leaders to better refine their teaching, target more precisely the difficult areas of their pedagogy, and build better and more complex simulations. This advancement from multiple-choice exams and computer-read scantron forms is like the advancement from a stone-flaking tool to computer-based 3D modeling.

SUMMARY

For effective, trustworthy evaluations and assessments to be performed on a simulation, a very coherent pedagogy needs to be designed: the "Big Picture" of the intended learning. This pedagogy should drive the design of the simulation. While simulation design is being undertaken, formative testing should commence: gathering data on the expected user population, evaluating previous methods of disseminating training, and assembling a user baseline for the start of the simulation. Assessment instruments need to take into account the challenges that story narratives and user interactivity present: old assessment tools will need substantial redesign, or more likely, replacement. Throughout the simulation, users should get both in-game feedback and after action reviews, particularly to avoid the reinforcement of poor user decision making or incomplete comprehension of pedagogy, as well as user demotivation. If the proper formative testing and in-game feedback have been done, summative testing of story based simulation training holds the potential for gathering very rich assessment data, giving a much better picture of user progress and behavior patterns, and contributing to the building of even better or more complex simulations.

PART SIX

BUILDING THE IMMERSIVE ENVIRONMENT

19

Content Scripting Tools

Having discussed many concepts and principles underlying the successful creation of interactive story content for simulation environments, as well as considering how gameplay and pedagogy integrate with story, we now turn our attention to the actual building of our prototypes and projects. What software tools can we use to move from the idea stage to a virtual world that we can begin to use and evaluate? Will you have to be a hardcore coder in order to build a story-driven simulation?

The answer to the latter question is no (although it won't hurt if you are!). And to the first question: in this part of the book, we'll take you step-by-step through the decision-making and building process, looking at some of the available tools and the pros and cons of using them.

Story-rich environments (feature films, documentaries, "reality" TV shows like *Queer Eye for the Straight Guy*, or videogames like *Half-Life* or *Halo*) are necessarily scripted environments. A script indicates a set of underlying premises, initial actions, and then reactions triggered by the initial actions, which in turn continue to trigger actions and events. Within this framework, no "improvising" is allowed: everything that happens follows predictably, dictated by the author. Even the interaction we define will adhere to a set of assumptions, rules, and allowed behaviors.

Not for nothing do software programmers talk about writing "scripts" for their programs and subprograms. In fact, we can look at a feature film script as "program code." The script only exists to be run (by a program) or produced (by a media maker), and is a representation (as well as a set of instructions) of what the finished product will be.

So we're going to need to write a script. But before we do this, we're going to need to brainstorm or outline some of the content, so we have some idea of the direction we're going, and so we can communicate our goals and execution concepts to others on our team.

Our assumption is that a coherent pedagogy for the simulation has already been hammered out. As Chapter Eighteen discusses, we shouldn't design

pedagogy around our simulation: if we do so, both our pedagogy and the evaluation of user progress through the pedagogy will be compromised. Only when pedagogical goals and content are clear-cut and agreed upon, should we begin brainstorming concept.

OUTLINING THE PROJECT

Creating for a visual medium using only words has always been a curious paradox—creating for an interactive, visual medium using only words is an even greater paradox.

Nevertheless, no cheaper and easier and more accessible development tool exists than word processing. And if you're already using Microsoft Word, Open Office/Star Office, Wordperfect, or Abi Word, you already have a great outlining tool.

There is no single "correct" way to begin composing an outline for an interactive simulation environment. Each project makes its own demands, and the chief goal of an outline should be the effective communication of goals and execution for part or all of the project.

Let's take a look at part of a sample outline for *Leaders* (described in Chapter Four):

Introduction: 0720 hours. Southern Afghanistan, valley site. Bravo Company prepares for a very important, first-time NGO food distribution operation. A HELICOPTER brings in CAPTAIN YOUNG (the user), an emergency replacement for the company CO, med-evac'd out only hours earlier. He's quickly briefed by XO LIEUTENANT PEREZ, who's surprised that Brigade got a replacement captain out to Bravo so quickly. The company's under a tight deadline, as the delivery trucks are due to arrive at 1000 hours. Wire emplacement, site prep, and security management must be in place by that time.

Personnel: First Platoon is handling concertina wire emplacement, with the help of a handful of Afghan civilians. Second Platoon is handling on-site security, including the processing of local village militia who have been invited (by Civil Affairs) to help with security when the food distribution begins. Third Platoon mans observation posts, manages recon patrols, and comprises the Quick Reaction Force. An MP unit has been assigned to the company to handle route security for the incoming delivery trucks. A Civil Affairs team has also been assigned to the company, to interface with the local population.

[Teaching Point 3—Rules of Engagement]

0730 hours. Northeast perimeter. Afghan civilians begin to gather outside the concertina wire. Meanwhile, Afghan militia members from the nearby village are being allowed inside the outer perimeter of the site, as Civil Affairs has arranged for them to serve as security for the upcoming food distribution. This is creating some tension, as Second Platoon has been assigned to manage the overall site security. Responding to his men's concerns, Captain Young is called down to the eastern checkpoint, where 2ND PLATOON LEADER WOLF urgently requests clarification regarding the day's rules of engagement (ROE): in the event of serious threat, does Bravo Company need to clear all actions with Higher Command, or are the field leaders the final arbiters of the ROE's meaning and interpretation? Captain Young must *decide* whether it is necessary to consult with Higher Command in the event of immediate unfore-

seen actions. If the Captain says interpretation of the ROE rests with the men of Bravo Company, this will meet with Lieutenant Wolf's immediate approval, and he will more confidently issue orders to his subordinates regarding their management of the village militia who are checking in. If the Captain says they'll need to clear actions through Brigade, Lieutenant Wolf will express his displeasure after his departure from the Captain.

Story 1—Trouble with MPs

[Teaching Point 9—Staying in the Loop]

0800 hours. Field Command Post. In this storyline, Captain Young has already decided that ROE interpretation rests with the men of Bravo Company. XO Perez, having gotten used to having autonomy as acting CO, wants to find out if the Captain will allow the operation to stay completely in his hands. He asks Captain Young whether the Captain needs to be kept in the loop, or if the Captain would prefer that Perez simply follow the plan that Bravo Company forged yesterday. Young *decides* he needs to be kept in the loop.

[Teaching Point 58—Soldiers Can Be Made to Stretch]

0830 hours. Road Alpha One. Captain Young's hands-on management will be tested almost immediately. The MP unit has deployed along several kilometers of the route. However, they are now succumbing to what would seem to be food poisoning—seriously depleting their strength and threatening both site and route security. The trucks will be here in 90 minutes, but not if hostile forces get position, or if an improvised explosive device (IED) gets planted. The MP unit leader, Lieutenant Goldberg, has requested reassignment of soldiers to relieve the stricken MPs and shore up route security. Perez passes on this request and recommends that it be followed; FIRST SERGEANT JONES argues that in a tough spot, soldiers can be made to stretch: in this case, the remaining MPs should still be able to do the job, negating the need to pull needed soldiers off the wire emplacement, observation posts, and village militia processing.

(IF Young *decides* to immediately reassign personnel off the wire and onto route security, go to page [Point 58-negative]. OTHERWISE:)

[Teaching Point 58—Positive Decision] Young *decides* first Sgt. Jones is right: the get-it-done ethos becomes the order of the day.

This outline maps out the broad strokes of the story and begins to illustrate some of the interactivity available to the player and the outcomes determined by decisions. One of the tremendous challenges the outline writer faces is illustrating interactivity within a highly linear medium. The outline, composed using Microsoft Word, embedded hyperlinks and bookmarks (standard word processing features) to help readers follow the interactive story flow and simulate some of the interactivity. Thus, we can document possible user selections. For example:

If the user selects X (or has X points or X inventory), <u>click here</u>.

If the user selects Y (or has Y points or Y inventory), <u>click here</u>.

OTHER TOOLS FOR OUTLINING

We're certainly not restricted to using Word or other off-the-shelf word processing software for brainstorming and outlining.

Microsoft PowerPoint (and any other similar presentation software) obviously works as a good top-down outlining tool, which can demonstrate simple interactivity through the use of animation, clickable links, and hotspots on a slide.

However, few software programs are more easily misused than Power-Point. Although excellent for presentations and discussions, the software is not designed for the carrying of detailed content and explanatory material. Few experiences are more painful than suffering through PowerPoint slides crammed with text and overly busy charts and diagrams. While PowerPoint can be a powerful brainstorming and communication tool, don't confuse it with a word processing tool.

More specific outlining and concept building block tools do exist. One such is StoryView, created by Screenplay Systems. (For more information, go to http://www.screenplay.com/products/storyview/index.html.) While primarily designed for the creation of linear script outlines, StoryView can help with linking disparate pieces of content and seeing how they can relate together. StoryView's construction metaphor is a timeline, where users can title and outline scenes, transitions, decision points, interstitial material, and other kinds of content. StoryView can then export to either Rich Text Format (usable by almost any word processing, scripting, or presentation package) or Movie Magic Screenwriter files (of which, more will be said later).

Screenplay Systems also makes Dramatica, again, very specifically designed for the creation of films and television shows, which can be very useful in designing narrative stories hewing very carefully to the 3-act structure described earlier in this book. Dramatica walks you through the building of narrative and character throughlines, testing the logic, dynamics, and richness of each. For beginner story writers and simulation designers, this tool can definitely aid in structuring narrative. (See http://www.dramatica.com for more information.) Dramatica can also export to Rich Text Format or Movie Magic Screenwriter.

Still another outlining software tool is called Writers' Blocks. To some degree, Writers' Blocks is an electronic substitute for the traditional method of building scenes and scene linkage via index cards, allowing you to keep very detailed tracking of how characters interrelate to each other, how often you reuse locations, and many of the rhythms of narrative flow that add up to a good story. The software program has since evolved into a tool for writing scripts as well as outlining them. (See http://www.writersblocks.com for more information.)

Keep your eye out for other outlining tools emerging from the Open Source world of software development (http://sourceforge.net is a good resource). It's a bit of historical trivia that dedicated outlining software tools proliferated in the very early days of personal computing, prior to Microsoft's dominance of the software industry. Since professional writers were some of the earliest adopters of personal computers, this should come as little surprise. Microsoft Word's basic outlining features were good enough to largely eliminate this category of soft-

ware, but there is hope for its gradual reemergence, which will help all of us creating content.

In truth, none of these software tools are perfect solutions for the outlining of dynamic interactive content. But used astutely, the tool we select should greatly aid us in conceptualizing an interactive story narrative suitable for creating a more robust simulation environment.

CONCEPT DOCUMENTS AND DESIGN DOCUMENTS

Outlines are frequently used to create two types of documents used for the design of interactive products and services: concept documents and design documents.

As you might guess, concept documents are developed first. Typical concept documents for a training simulation contain most or all of the following:

- An overview of the project
- Discussion of the user base (see Chapter Eighteen, Evaluation and Testing, for ideas on how to develop this.)
- Pedagogy and user goals in the comprehension and deployment of this pedagogy
- A narrative synopsis: a user's "critical path" or "sweet path" should be mapped out, along with key narrative events and turning points
- An overview of the interactivity (how much input and what type will the user have?)
- Discussion of the delivery platforms (See our discussion in later chapters on the pros and cons of various platforms.)
- Overview of technology, tools, and media used to build and deliver the project
- Overview of the evaluation and assessment tools to be used

Outlines that you have developed may be incorporated into the concept document, or you may find that the concept document itself will be your primary outlining and brainstorming document.

The concept document may support and map out (in broad strokes) the building of a prototype (a "proof of concept"), or it may be the document that helps secure the go-ahead for the full-scale project. A few tips about the concept document are worth mentioning.

1. In their evolution, concept documents have a tendency to become dry recitations of facts and bullet points. In fact, concept documents should be highly readable. Don't forget that the concept document is more than

a set of instructions: it's a motivational tool for project builders, funders, and others.

2. You can sometimes lose the forest for the trees in these documents—but don't! Too much detail may unfairly box in the project too early. Keep thinking "Big Picture," so the concept document can promote innovative solutions and problem solving.

3. Narrative, interactivity, and technology should all be discussed with an eye toward how they advance the pedagogy.

4. The biggest challenge in the concept document is to give a real flavor of the project, both from the user's perspective and the development perspective.

Let's assume the concept document, after circulation and revision, has been successful. The project or proof of concept have a green light, and development will commence! At this point, it's likely you'll wish to move to a design document, which will function as the bible for your project, and details some or all of the following. Some of this has been first mapped out in the design document, but now we're going to want the forest *and* the trees:

- An overview, now in much greater detail
- A more detailed discussion of the user base
- The story narrative: a very detailed treatment of the story flow through chapters or levels, which will include the character bibles for all major characters, major and minor plot points, climaxes and conclusions
- Detailed mapping out of all interactivity and gameplay. If there are levels, how will they work, and how will the user move between them? What will the interface look like and how will it operate? What kinds of user input will be available? Will this be a single-user or multiple-user experience? (This last point would initially be broached in the overview, of course.)
- Level environments and characters (user and nonplayers) within them
- User interactivity and story relevance. (How does user interactivity advance the story? How does the story create opportunities and motivation for interactivity?)
- Detailed discussion of the delivery platform(s)
- Detailed discussion of technology, tools, and media used to build and deliver the project
- Detailed mapping out of the evaluation and assessment tools to be used
- Discussion of proof of concept or prototype, if necessary

Concurrent with or subsequent to the writing of the design document, you should be ready to move from the outline stage to the writing of a full narrative script. This includes, as much as possible, high-level scripting of interactivity,

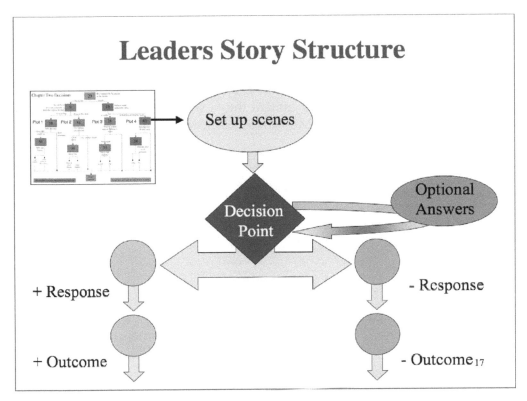

Figure 19.1 An example of a diagram from the *Leaders* Design Document, which illustrates the organization of each story molecule in the simulation.

gameplay, etc. The script may be separated into a story script and gameplay script, if that seems more appropriate for the project.

AUTHORING THE SCRIPT

While it's possible to write a script using Word or other off-the-shelf word processing software, here's where you are likely to want to transition to more dedicated scriptwriting software.

In the world of narrative media, Final Draft (and its sister program, Final Draft AV, both found at http://www.finaldraft.com) has emerged as the most popular software tool for the writing of scripts. The program includes a variety of templates for writing specific kinds of scripts. The template you select should depend on what script format will best serve your project.

Final Draft's television and film scripting templates might be most appropriate when substantial original production of scenes (visuals and audio) are to be created (as is the case with any film or television show). Such a template was

used in the *Leaders* project, where all content, scenes, and interactivity were built from the ground up, and the goal was to really create an interactive movie.

One special template offered by Final Draft is the interactive television template, first developed for Goldpocket Interactive (http://www.goldpocket.com), a producer of interactive TV content. This template will allow the writer to specifically embed interactive cues and content into a script. This interactive content can then be exported into an XML format that can be read and processed by

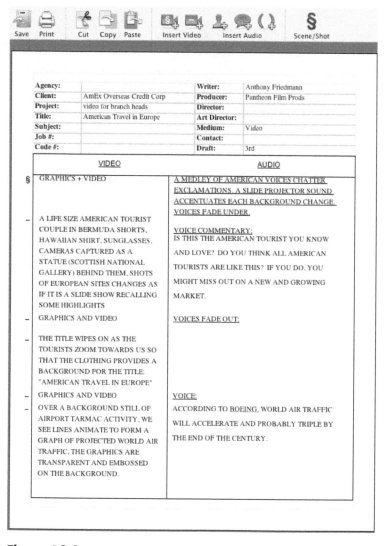

Figure 19.2 An example of a traditional dual-column A/V formatted script as composed in Final Draft A/V. Reproduced by permission of Final Draft Inc. Script sample reprinted with permission from *Writing for Visual Media* by Anthony Friedmann and published by Focal Press.

authoring/production software such as ContentProducer, Avid Media Composer, and others. For certain projects incorporating user polls, Q&As, leader boards, and other simple interactive functionality, this may be a good template to experiment with.

Final Draft AV enables the writer to use the industry-standard audio/visual scripting format, which separates out video and audio content into a two-column format. This format might be particularly appropriate for building story-driven simulations using primarily discrete media assets, many of which may pre-date the project or be created independently of the project (archival video and audio, photographs, charts, diagrams, Websites, blogs, etc.). Figure 19.2 illustrates a typical A/V formatted script.

Movie Magic Screenwriter (http://www.screenplay.com) is the other dedicated screenwriting software program predominately used by professionals. It too will offer templates for traditional, linear scripts intended for original production; fully customizable formats to create dual-column A/V scripts; and a surprisingly robust template for creating interactive content. (See Figure 19.3 for an example.)

Figure 19.3 Movie Magic Screenwriter (in the process of editing a sample interactive script). Used with permission from Write Brothers, Inc.

The software actually includes a run-time engine for testing your interactivity: the writer can step through paths and outcomes, and can package the script and run-time engine so other project principals can walk through some of the interactivity. This has been a surprisingly underrated tool, but worth exploring if you are scripting interactive narrative.

SUMMARY

One of the first steps in building a story-driven simulation environment will be authoring a concept document or design document outlining the project. Various software tools exist to help author these documents. These documents should lead to the authoring of a script that will serve as a bible for the remaining project production. Different software, more specifically dedicated to scriptwriting, will help you complete a script that realizes the narrative content of your simulation and helps map out the production steps to come.

20

Selecting Media and Platform: An Overview

There are two different methods for creating simulated experiences.

1. Boil the experience down to the essence of the behaviors to be learned, and only simulate the tools needed to carry out those behaviors.
2. Build a model of the entire virtual world and let the simulation take place within it.

The first method strips away the environment so that it only provides the information tools needed to carry out the behavior. Chapter Twenty-Two goes into great detail about how and why these simulations are built. The keys to much of their success lie in the role that the computer has begun to play in so many operations. In the military, for example, command centers are loaded with computers, which present much of the picture of the battlefield to decision makers who are far removed from it. The simulation then can be delivered on any desktop and, if the information is presented clearly and dramatically enough, the simulation can be extremely effective.

The US Navy has conducted simulations in which ship computer systems are linked together and fed information about a hypothetical naval crisis. Because the computer systems are closed, the simulation can use standard tools to portray the problem, and standard communication systems to respond to it. The systems can further be programmed to show the outcome of the response just as it would be reported through conventional methods. The sailors are on board ship anyway and if the systems can be dedicated to the simulation, it can work amazingly well. But it can work just as well if computers running the same kinds of presentation are set up in adjacent rooms in a training center. What has become clear is that participants in simulations like these focus so intently on their computer screens that they feel completely immersed in the experience and they block out the outside world anyway.

Approach number one, then, is to create a computer system that makes people feel like they are using all the data and communication streams needed to make crisis decisions without necessarily being present in a realistic representation of the environment. And this clearly works well for environments where use of a computer for data collection, collaboration, and communication is central to the effort. But what about those worlds where that is not the case? For example, what about simulating decision making on the battlefield? Or in a manufacturing facility, or on an offshore oil rig?

Can you build an environment in which the participants feel like they are actually on the battlefield? That is, in fact, a very different kind of simulation than that discussed in approach number 1. In this approach the participants see the battlefield, can talk to virtual soldiers who approach them on the battlefield, and only occasionally use tools that are simulations of parts of a broader communication network.

In some sense, this is the opposite kind of simulation than was described in approach number 1 where the environment was torn away and only the information tools remained. This is a system that attempts not only to build the information tools present in the real world, it seeks to construct a navigable 3D model of the entire world.

Why would it be necessary to build a 3D model of the real world rather than simply build a computer system that provides the same kind of information tools a soldier would normally use in the real world? The answer is, "When the information flow is not the same, the sources of information are different and the means of communication are different as well."

Creating a virtual command center where 3D virtual models of soldiers sit at 3D models of virtual computers and receive data and talk about it, seems like adding a layer of simulation that gets in the way.

Creating a virtual battlefield with 3D models of the encampment and the terrain, with talking representations of the other soldiers who can address you and answer your questions, where you can navigate and see the battlefield results of your decisions, where you can experience the consequences of your performance throughout the simulation, this is a simulation of a different sort. Such a simulation sets out to recreate face-to-face communications as the primary means of intercourse. It swings toward learning situations where the environment itself, and navigation within it, play major roles. It not only represents *time* but also *place*—and the dramatic first-hand experiences or consequences derived from the combination. When the learning objectives call for practice and testing within such an environment, the 3D virtual environment is indeed the way to go, and fortunately more tools are becoming available to help designers and producers create such worlds.

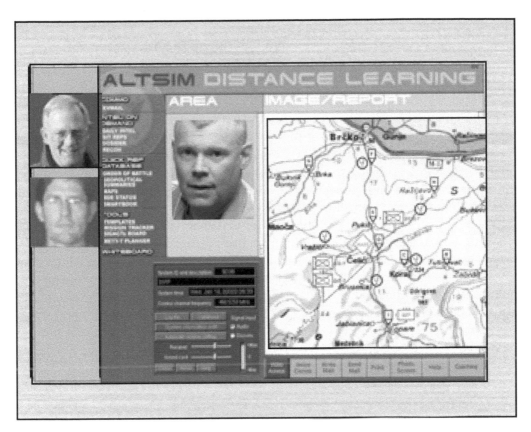

Figure 20.1 ALTSIM—multimedia simulation of a computer based communication system.

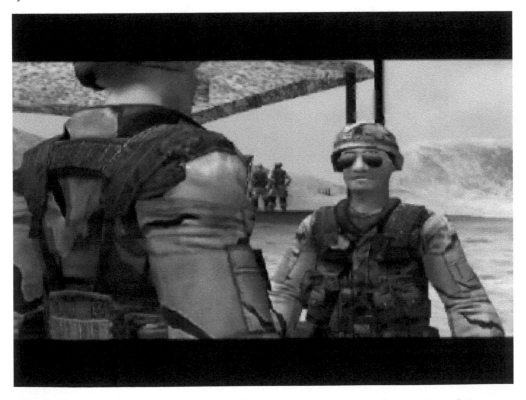

Figure 20.2 *Leaders*—a 3D virtual world representing an entire mission site and its personnel.

SELECTING YOUR MEDIA

With the above "Big Picture" guidelines in mind, selecting your media is a bit like choosing your weapon in a first-person shooter (FPS) game. At different times in the game, different weapons are going to constitute the right choice, and others will wind up being the proverbial sledgehammer-trying-to-swat-the-fly: inappropriate from the standpoint of effectiveness and from the standpoint of time and energy (the "currency" of FPS games).

The selection of media should be derived from a complex matrix of considerations. We should look at media from both its bandwidth costs and its economic costs. We should look at its malleability (i.e., how easily can we change it?) as well as its "temperature" (i.e., the relative hotness or coolness of the media, using the classic Marshall McLuhan scale). In addition, we need to evaluate the effectiveness of the media carrying our specific pedagogy, story, and interactive content.

Such a matrix might look like this:

Table 20.1.

Media	Bandwidth	Financial Cost	Malleability	Temperature
Text	Low	Low	High	Low
Graphics	Variable	Medium	Medium	Medium-High
Audio	Medium	Medium	Medium	Medium
Video	High	High	Low	High
Real-Time 3D	High	High	High	High

Let's drill down to a more detailed look at these media types.

Text

Inexpensive to create, while requiring very little bandwidth for delivery. (Text can be transmitted via telephony text messaging, e-mail, instant messaging, data broadcasting, fax, or in a "ticker" at the bottom of a television screen.) Text is also easy to manipulate, expand, revise, etc. This clearly includes webpage delivery, embedded word processing documents, and optimized-for-screen Acrobat PDF files (assuming textual content only). The drawback to text is the "coolness" of the medium: as a simulation tool, text is usually nonimmersive and keeps the user at a distance, appealing very little to emotion and instinct. However, the successful text adventure games of the early 1980s argue that text can be very immersive and even emotional, but requires tremendous skill in its creation to achieve this.

Graphics

More financially costly than text, effective graphics will entail either good illustration or photographic resources. Delivery will also entail greater bandwidth, particularly as the size of the graphic increases. (Thumbnail graphics accomplish very little by themselves, whereas full-screen and high-color graphics will have more impact on the user.) Thanks to Photoshop, Illustrator, and other image manipulation tools, we can make many changes to our graphics and as the saying goes, a picture can be worth a thousand words (the emotive and immersive power of a great photo or illustration is something we're all familiar with).

Audio

While clearly more expensive than text to create, audio can be created or captured without tremendous cost, as the price of a good microphone (along with audio-recording software) won't break the bank. Audio can also be created using text-to-speech tools (e.g., Dragon Software or Final Draft's script-to-speech feature). Thanks to compressed audio formats like MP3, bandwidth demands have decreased, enabling real-time delivery of audio (as opposed to the stuttering audio of earlier CD-ROMs and dial-up Internet delivery). Audio can also be manipulated fairly easily using Pro Tools or other audio software. Audio can be very immersive, and can at least be warm if not "hot" in terms of its media "temperature." In the days of radio drama, audio alone could be amazingly effective (think of Orson Welle's radio broadcast of *The War of the Worlds* that created a national hysteria), but this requires particularly good storytelling and writing skills. (We'll discuss some strategies toward effective use of audio in Chapter Twenty-Five.)

Video

The high cost of video is pretty obvious: to produce professional-looking, full motion video, you have to spend real money. The endeavor becomes much more collaborative and personnel-intensive than the creation of text, graphics, or audio. Don't be fooled by so-called "reality TV," for substantial pre-production and substantial time have been required to create this product. Video delivery requires significant bandwidth: we've all seen postage-stamp video streamed onto the Web and we know its effectiveness is less than desirable. Delivering reliable full-motion, full-screen video requires a very fat Internet pipe (e.g., a T1 connection) or locally supplied video (via DVD). Another downside to video is the fact that it's difficult to manipulate once captured: if you're interested in changing the video, you'll probably have to go out and reshoot it. However, video is a "hot" medium. Ever been in an airport bar and noticed how everyone's eyes go to the TV? Well-produced video is almost hypnotic in its power: immersive

and often highly emotional and absorbing for the user. However, video's effective re-use, in an interactive setting, may be minimal. After a couple of times watching the same video clip, a user will probably tire of it (think how different this is from a powerful photo or illustration, which we might view dozens of times, only to have its immersiveness and emotional aura increase for us).

Real-Time 3D Computer-Generated Animation

This is what we know from the world of contemporary videogames. Creating good RT3D is costly. Its bandwidth demands are variable, depending on the rendering engine, terrain quality, number of characters, and other issues; often, the bandwidth needs are considerable. RT3D can be manipulated and edited more easily than video: new terrains can be dropped in, sprites can be added and subtracted, mapping levels can be changed relatively easily. And as we might guess (if we know any teenagers addicted to videogames), it's a "hot" medium: hugely immersive and capable of engaging us on a visceral level.

Delivering instructional content through one medium alone may quickly become tedious, even if that medium is a RT3D video game. But by judicious use of several media, we can calibrate and control the type of experience we wish to simulate, and can retain and enhance the interest of the user in our simulation. In the next several chapters, we'll look at how well different delivery platforms handle different media types. We'll also examine some of the other challenges presented by each delivery platform. Selecting the right delivery platform for our pedagogy, story, interactivity, and media is a critical step in our development path—one we want to get correct the first time around.

SUMMARY

It is possible to teach sophisticated decision-making skills by stripping away representations of the environment and focusing on information systems that are vital to those skills. However, certain kinds of experiences require that the simulation represent the entire environment, including the terrain and the people who are present. These simulations address different kinds of situations and build different kinds of communication skills. This reckoning should be our first test for which media are most appropriate for our simulation.

Media should be evaluated for their costs, temperature, malleability, and ability to further the training objectives of our simulation. No single media type will accomplish everything we need, so we'll look at how combinations of media function on different delivery platforms. The wrong platform will delay and conceivably derail our project, so the correct decision on platform is crucial.

21

Immersive Desktop Experiences

A primary rule of learning simulation design is that the simulation should focus on the behavior to be learned and give adequate feedback to the participants as they progress through the simulation experience. While that should seem obvious, there is a real danger in creating simulations that spend enormous amounts of time, energy, and money faithfully replicating parts of the environment that have no bearing on the learning experience at all.

Often, faithful replication of irrelevant parts of the environment actually detracts from learning, because the learners focus on the details of the environment and as a result ignore the specific behaviors that they are attempting to master.

For example, military simulations that focus on an exact reconstruction of a command center or of part of a vehicle often add elements to the simulation that get in the way of learning. Trying to make gauges and knobs and control levers look exactly like those in the latest version of something may make participants ask, "Why is that control just slightly different than the one I'm used to? Why has it changed? Are the newer models better, and if so why?"

This is truly inappropriate when the behavior to be learned has very little to do with the operation of controls and more with the reading, interpreting, and understanding of the messages being delivered by the information system.

In training for high-performance skills, Human-Machine Systems engineer Alex Kirlik commented on a distracting effect of the anti-aircraft warfare coordinator station (AAWC) at a naval training center and noted: "The field study thus revealed that the need for the trainee to attend continuously to the console manipulation activities severely compromised his or her ability to attend and benefit from the tactical decision-making and team coordination experiences that were the stated focus of training" (Kirlik et al., *Making Decisions Under Stress*).

Focusing on the behavior to be learned rather than the exact appearance of the environment itself will help prevent this kind of mistake. For this reason the abstract elements that go into skills like crisis decision making seem ideally

suited for computer based simulations, in which many of the decision elements would normally be delivered by a computer.

But what happens when the environment that is being simulated has elements that are necessary to the skill being taught, but that cannot possibly be built into the physical environment?

Hopefully, the answer is in the media.

If you think of the physical environment as just another medium that presents information to the participants, then a physical object in the real world can be simulated by a cleverly designed piece of media that will do the same thing.

SQUEEZING THE ENVIRONMENT INTO THE COMPUTER

In the Advanced Leadership Training Simulation (ALTSIM), we faced the problem of trying to replicate the experience of being a member of a team within a Tactical Operations Center, but with participants who were geographically separate and operating in environments that looked and sounded nothing like a real TOC.

Our answer was to try and build as much of the experience as possible into the computer, letting the computer actually play the role of some of the physical elements in the TOC environment.

For example, the Significant Activities Board (SigActs Board) is a huge white board that hangs in most TOCs. On it, each battle captain provides a list of the most important events that happen on his or her shift. The events list forms a kind of background for the decisions that have to be made during the day.

In a distributed learning situation you lose the great value of having one big board looming over everyone as they go about their daily business. And you take away the valuable behavior and group dynamic that comes with having that board there to provoke discussion and arrange information. Nevertheless, the SigActs Board can be replicated on the computer screen. But the interface must provide easy access to it, so that every member of the virtual team can keep an eye on it as events unfold, and one member of the team can have the primary responsibility of keeping it up to date.

The design task, then, is to provide the proper user interface design so that the SigActs Board maintains its prominent position and role in the virtual environment and does not just fade away from lack of use or presence.

In an environment like a TOC, as important as the presence of the SigActs Board may be, the need for audio participation is far more important. In fact it could be argued that one of the key decision-making skills to be learned in crisis decision making is the ability to communicate verbally. For that reason, direct voice communication between the participants was considered critical to the design of ALTSIM. Participants had to be able to talk to each other across the world in order to simulate the enclosed group decision-making process of

the TOC. We went a step further and employed Webcams so that the participants could see each other face to face as they rolled through the decision-making process. Again, in a TOC, they would normally be together and would see each other.

While we felt that direct voice communications was a major factor in group decision making, an equally important factor was the distribution of various kinds of information to the working members of the staff.

In a real TOC, there is often a television set up in the corner of the room showing the latest CNN or other news broadcast. At the same time, direct radio communications are fed into the loudspeaker system so that there is constant radio chatter. There is a barrage of e-mail flowing into the different computer workstations as well as a vast network of information available for deep research.

We took the daring and dangerous step of trying to integrate all these disparate elements into a single interface that we hypothesized as a future military information network designed especially for participants in a TOC. The danger came from the fact that building such a system might make the participants dependent on its structure and actually weaken their skills. The upside of the approach was that such a system could allow participants to focus more clearly on the elements of decision making, while we had greater control of the variables, including the amount of distractions in the environment. We attempted, in fact, to focus on the actual behavior that the simulation was supposed to teach.

We gave the ALTSIM system a simulated news network that played on the computer screen. We piped audio through the computer as though it were the streaming chatter of a TOC. We customized the flow of information so that specific information would go to people in specific roles and we maximized the use of media so that each element of information was presented by the medium that was most suited to it. E-mail reports often had video or still attachments to make a specific point about the current situation. When the Battle Captain called for aerial surveillance, streaming video fed back selected shots of the appropriate area. If he or she asked to speak to a commander in the field, we often delivered picture phone access to the individual.

Traditional e-mail delivered updates and reports on events as they evolved, and when things got urgent, radio messages from the battlefield came in loud and clear. The system not only contained the latest maps, but they were interactive and updatable, so that the assigned member of the team could modify the central display that was seen on everyone's computer. Urgent Messaging allowed an officer, at the Battle Captain's request, to send messages to the simulated actors everywhere in the simulation: higher-ups, adversaries, and allies alike. Needless to say, this input prompted the interactive responses of the system, and feedback again was often in the form of mixed media delivered according to two rules: (1) what was the most typical way that the response would normally be delivered, and (2) what was the most clear-cut and compelling way to make the information stick.

Interestingly, the same method that provided such strong relevant message delivery to the participants also enabled us to deliver strong distractions so that irrelevant or contradictory data, if we chose to employ it, could be presented with the same strength as the most critical information.

The entire system was geared to give the instructor the most powerful tools possible to present all manner of information in response to participant action or inaction.

The intent was to create the most highly fluid, and yet most highly controlled crisis decision-making learning environment possible. Figure 21.1 illustrates the media mix that was used to create the virtual TOC on the ALTSIM computers.

In the end, the carefully chosen mix of media allowed us to focus on the actual decision-making elements required by our learning objectives and deliver them exclusively through a computer-based, distance-learning network.

ALTSIM was created for the US Army, but simulations on topics from stock trading to disaster relief to urban traffic management scenarios could be created using LANs or WANs. Video assets can provide on-the-scene representations of newscasts, audio assets can replicate first responder communiqués, and Flash animations or macro-programmed spreadsheets can replicate real-time data updates.

ALTSIM Command Center Architecture

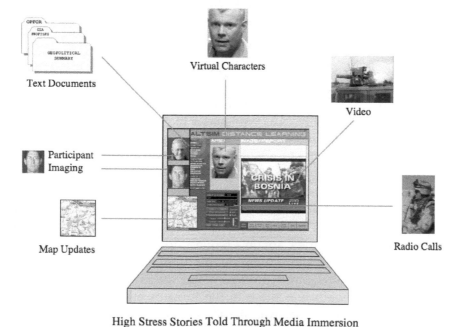

High Stress Stories Told Through Media Immersion

Figure 21.1 ALTSIM interface screen showing the contributing media elements.

Clearly, low-cost technologies like intranet instant messaging and push-to-talk radio/cellphone technology can also be deployed to achieve an immersive desktop experience.

Further advantages to delivery on a LAN or WAN include (1) the data security the contained environment should offer, and (2) the relatively homogenous software and hardware environment that should be available. As we'll see in our next chapter on Internet delivery, these issues must be considered before media and platform are locked down.

SUMMARY

When building simulation experiences, worrying about the bells and whistles that go into the surrounding environment is a waste of time and money. Because of this, using computer systems to simulate critical behaviors can work for a variety of skills. However, there are elements in the physical environment that bear on the behaviors to be learned, and finding ways to integrate them into a computer-based system is a challenging but important task.

Matching the medium to the message allows designers to deliver critical information in the most effective way possible. It also allows for the controlled introduction of complexity and noise into the environment and can enable and reinforce effective communication as a means of collaborative problem solving.

ALTSIM was unique in that it did not attempt to recreate the TOC environment it was simulating. Instead, it sought to build a new, streamlined, decision-making system that enabled participants in distant parts of the world to work together to hone their skills. The intent was to focus on the presentation of the facts essential to understanding the situation and the communication process that was needed to execute the final decision. The same system allowed an instructor fine control of the balance of relevant and irrelevant data, and the ability to inject conflicting information that might add challenge to the task.

22

The Internet

The Internet is the true universal distribution platform of our time. Using it, we can deliver our simulation to any user anywhere, without worrying about whether the user has the right disk, the right hardware, the right operating system, or whether the user can connect to an intranet, extranet, or area network. As long as the user has an Internet-enabled connection, we can reach him or her. While that used to mean the user needed a desktop PC or Mac, we can now count on reaching any user with access to a notebook computer, a handheld PC, a cellphone, an Xbox 360, a Windows MediaCenter, or an Internet Protocol television set.

However, the *type* of content that can be delivered may be constrained by the speed of Internet delivery, dependent on the available bandwidth a user may have access to. A brief overview of which media is most appropriate for each type of connection is presentedbelow.

DIAL-UP

Text e-mails, very light instant messaging, and very small office application files (short documents and spreadsheets, possibly some thumbnail graphics, but no PowerPoint slideshows, PDF files, partial or full-screen JPEGs, audio, or video) are the only media that will facilitate a useful simulation in this environment. Nothing is less immersive than waiting . . . and waiting . . . for downloads. A user is unlikely to consider, absorb, and put into play pedagogical content that frustrates just in its delivery.

Does dial-up bandwidth doom any sort of simulation? Not necessarily. We can imagine a story-driven simulation that works almost purely via e-mails and instant messaging; think of this as the 21st-century equivalent of the epistolary novel of long ago. The simulation must work as an asynchronous experience; perhaps a management, personnel, or other business communication simulation that replicates a communications situation handled strictly by e-mail, between a

167

home office and remote office. Highly dramatic writing with appropriate cliff-hanger endings to each interaction can, in fact, make this a truly compelling experience.

BEYOND DIAL-UP, BUT NOT QUITE DSL

As a sidecar or alternate to Internet dial-up delivery, we should not discount cell-phones and PDAs as completely valid receivers of content. As will be discussed in Chapter 23, these handheld devices are both ubiquitous and intimate, making them very logical platforms for certain kinds of media and content.

For example, cellular text messaging may be a useful adjunct or even a primary medium for asynchronous content. Multimedia messaging is now widely available, allowing for small graphics to also be used. Webpages customized for handheld PC and cellphone browsers, using text, still and animated graphics, and even small Flash movies, can carry content. GPRS-connected phones already provide dial-up speed, and newer 1xRTT-connected and EvDO-connected cellphones begin to approach low-end DSL speeds. These higher-speed networks are rapidly being deployed by carriers like Verizon and Sprint, and by 2007–2008, near-DSL speeds will be quite common with cellphones.

Bandwidth is not the only factor in Internet delivery, however. We also need to look at screen size and ease-of-input. Though cellphones and PDAs can now handle standard e-mail content, lightweight application files, small audio files, and Websurfing, the relative awkwardness of both input and output, as they relate to the delivery of an immersive simulation, should be weighed. Left-right-up-down navigation will work pretty well; alphanumeric input of any duration won't. Outputting small graphics and simple animations will be tolerable; outputting lengthy, stuttering postage-stamp sized video isn't. Bottom line: just because we *can* use this platform doesn't mean we should. Again, a frustrated user will gain little from such a simulation. On the other hand, delivering dramatic text-based interactivity as described in our discussion of dial up Internet content could be extremely engaging when presented on cell phones and PDAs.

DSL AND CABLE

We can now expand our list of media to include complex HTML e-mail, Web content (HTML and Active Server pages, Web application, Flash animations, etc.), PDFs, PowerPoint presentations, JPEG and TIFF graphics, and streaming audio.

Streaming video is deliverable but not wholly reliable, and its value must be weighed against its relatively degraded nature. In general, we can usually only sustain a 320 × 240 video window without beginning to incur substantial frame dropout, and even at this size, pixelation and frame lag are common prob-

lems. At this bandwidth, video is best served at a stepped-down rate of 15 frames per second (television delivers just under 30 frames per second), making it a less than optimum experience.

True, real-time, CG 3D can't hope to be delivered at this bandwidth. Nor can the rich graphical environments one might see in a popular massively multiplayer online game like an *Everquest* or a *Worlds of Warcraft*.

But, but . . . I've seen them!, you say.

Reality check: while it's true that a *Doom* or an *Everquest* are played via the Internet, the reality is that the bulk of the graphical environment is available via CD-ROM or separately downloaded files made resident on a user's local hard drive. For example, *Kuma Wars* (http://www.kumawars.com), a real-time, 3D ground combat game played wholly online, nevertheless must first deposit its engine, terrains, texture maps, characters, and other graphical elements in a separate and lengthy download (in fact, it is using the *Half-Life* game engine). And, as of this writing, this game distributor may well offer the state-of-the-art in this particular game niche.

Internet downloads and local installations invariably create user support issues. We have to deal with firewalls, administrator permissions, pop-up and spam blockers, anti-virus shields, operating systems, and compatibility issues. So we must begin to consider the cost of this kind of media delivery via the Internet, as opposed to CD-ROM or DVD-ROM distribution.

Often, corporate and institutional networks block any kind of saved file download or file installation onto a local hard drive, thus completely preventing this sort of hybrid solution to delivering rich graphical content. This becomes yet another factor to consider.

Assuming we can park our rich graphical content on a user's local drive, interactive real-time 3D over the Internet still offers challenges. If very quick actions and reactions are required, the user may encounter data transmission latency issues. The user responds in a timely way in the simulation environment, but data latency, spread across the system, slows down the response.

In first-person-shooter games, this means that a user can fire a weapon at an enemy with deadly aim and timing, only to discover that the bullet or flame (which, by the rules of the game's physics, should have struck the enemy), slowed down by Internet traffic, didn't arrive when it should. Or, the enemy fired upon may have already moved on; although on the user's system, he was still in location X (rather than Y).

While most simulations may not require this kind of split-second timing, the problem could become an issue and must be taken into account when considering delivery options.

Another type of 3D environment, the blockier X3D (the modern version of VRML) environment sometimes used in real estate walkthroughs and architectural renderings, can be delivered more effectively at this bandwidth; and for simulations not requiring exacting verisimilitude, may be a highly desirable

environment (one emphasizing spatial relationships or basic activities, for example, a simulation training bank tellers).

If we're willing to incorporate more cartoony, 2D environments, one markup language to explore is TVML (see http://www.nhk.or.jp/strl/tvml/english/mini/index.html). This new language and player literally allows you to write a telescript indicating dialogue, camera movements, and character behavior, and have it converted to an animated movie, using predefined CG characters, sets, and props. Think of it as Flintstones anime machinama. Although the animations won't allow for interactivity, this media type may be appropriate for certain projects, due to its low bandwidth demands.

In general, streaming audio becomes pretty reliable at this bandwidth, and as Chapter Twenty-Five will describe, a great deal can be achieved through the use of audio in simulations. We can imagine political and economic simulations being served very well in this environment, for example, a game that simulates some aspect of financial market trading, or data mining in a global surveillance/anti-terrorist operation.

T1/T3

Assuming the T1 connection is not shared by more than a couple of users, streaming video should now become wholly reliable and robust. True, real-time 3D CG becomes closer to a reality (especially so on the T3 line, which is more than 50 times faster than a typical DSL connection). With this kind of bandwidth, nearly all of our content constraints have evaporated. But how many users can be reached on virtually unshared T1 or T3 connections? This is a small user base indeed, and if you're creating a simulation for this club, consider yourself lucky.

One caveat is that our concerns regarding file downloads and file installations remain, so we are restricted to maintaining a live Internet connection, and transactions outside of a connected session can't be counted on (our data payload may never have been launched). For some simulations, this could be an issue.

INTERNET2

Often mistakenly considered as the next-generation Internet, Internet2 is actually a private Internet-like network, created by a consortium of universities along with corporate and government partners. Built on a much higher-speed backbone than the Internet itself, we might consider Internet2 as the ultimate wide-area network. Simulations have, of course, been developed for this network, and its ultra high-speed bandwidth solves most of the problems discussed in this chapter.

SECURITY ON THE INTERNET

For some projects of a sensitive, confidential, or government-classified nature, secure delivery of content and media over the Internet is going to be a major factor in determining whether the Internet is the appropriate delivery platform. Though our content will probably fail the Karl Rove "double super secret background" test, and although concerns about Internet security can sometimes escalate to the level of conspiratorial paranoia, the fact is that all Internet data runs some risk of being monitored and captured.

It is all but impossible to secure user client platforms, particularly if users have the option of accessing the simulation from multiple access points (headquarters, remote offices, home, hotels, etc.). Users accessing the simulation via WiFi pose an even greater security threat, as WiFi is notoriously porous when it comes to data snooping (the same goes with any content delivered via cellphone).

Even if the simulation is conducted and available solely on IT-monitored, in-house workstations behind a firewall, Internet security studies have shown a high prevalence of corporate systems being breached. Not only can simulation content, uploads, downloads, and keystroke activity be captured, but the simulation—if delivered via the Internet—may open the door to other Trojan Horse activity.

These security risks need to be weighed against the advantages and flexibility that Internet delivery promises. One approach may be the establishment and use of an SVPN (secured virtual private network), which uses cryptographic protocols and enhanced authentication to better protect sensitive data. While the SVPN diminishes the chances for data snooping, it doesn't perfectly guarantee confidentiality.

Obviously, the more restrictions a simulation places on access (e.g., excluding offsite and WiFi access), the greater the security protection. But does this begin to deflect the prime value of Internet delivery? Every simulation is different, and so the answer is neither clear cut nor obvious. But if Internet delivery appears attractive, then the importance of secure delivery of content should be weighed, and strategies toward achieving it should be considered.

AUTHORING FOR THE WEB: SYSTEM DIFFERENCES AND SCALABILITY

One of the primary attractions of Internet delivery is that it appears to bypass issues of the user client platform (e.g., Mac? PC? Linux? Solaris?, etc.) and client software. However, this is not entirely true.

For example: font differences in application documents (Word, Excel, PowerPoint, etc.), as rendered by different operating systems, pose the risk of

confusing users. Bullet points become question marks, quotation marks become alphabetic characters with umlauts, etc.—at best, the mistranslations of these characters is merely annoying, and at worst, may render useless the pedagogical or procedural content.

This may argue for delivery of any transmitted document in the simulation to be standardized on Adobe's Portable Document Format (PDF), which will render identical content (both onscreen and in print) on all platforms.

This doesn't solve the mistranslations that occur in HTML e-mail or in the differences of webpages being rendered by Internet Explorer, Firefox, or Safari, which can be substantial enough to misplace content, bungle page layout, and in general, frustrate and confuse users.

Another issue is the residency of software on a user system: Is the Flash Player, the Acrobat Reader, the QuickTime plug-in, or other software available when called? Can the simulation route the user to the appropriate download site if the software is missing? Does the user have permission to download the necessary software, and how are exceptions handled?

Required additional user hardware is yet another problem. Will the simulation require user printouts or user scanning or a digital camera (so users can upload photos)? Will a Bluetooth or WiFi connection be needed (so a user can connect with other systems or other users)? Will a very large desktop monitor be necessary, or can users get by with a laptop screen or even a handheld screen (PDA, cellphone, etc.)?

Clearly, in designing and authoring story-driven content, we'll need to factor in how much our simulation can scale to the client system. We may have a rapid WiFi/WiMax connection (giving us the greenlight on streaming video, streaming audio, full screen and larger graphics, etc.), but if the client system is a handheld device, all of these media elements may be wasted, or, at least, too seriously degraded to propel our pedagogical content. If delivery is meant for handhelds, we may want to author for lower bandwidth media, emphasizing e-mails, smaller graphics, small document files, etc. A vast terrain map or long-running video will be less effective on a small screen.

As we've seen, bandwidth and security are not the only issues to consider when choosing the Internet as a primary delivery platform. As always, proof of concept, and substantial testing of the project as it's built, will help to avoid many of the pitfalls mentioned above.

WEB ANALYTICS (BACK-END DATA COLLECTING)

Set up properly, Internet distribution makes possible a wealth of user data to harvest, via logfile analysis, page tagging, network traffic sniffing, and various hybrid methods. Web log analysis software such as AWStats and Click Tracks

can coax hidden behavioral patterns out of seemingly unrelated data sets; and whether you use a commercial or open source package, or whether your organization assembles its own proprietary logfile analyzer, the analysis of user activity and input is an absolute must.

JavaScript webpage tagging can deepen and refine the data collected, and may only run into problems if delivery is occurring on browsers where JavaScript is disabled or nonfunctional (most likely on cellphones, though some organizations have crippled browser JavaScript for security and IT support reasons), or if Internet distribution is completely bypassing the browser.

Web analytics has become one of the most important and complex tasks involved with Internet distribution, and planning for this task should commence early in the development of an Internet-distributed simulation.

MAINTENANCE

Internet-distributed simulations require ongoing maintenance: everything from servers to routers, from data transmissions to data collections, along with the inevitable security concerns. Where we can more or less walk away from a simulation delivered from a local disk or a local area network, with little concern for system maintenance, the Internet distributed simulation will require ongoing monitoring. Without planning and budgeting for this, our simulation may quickly founder upon the rocks, shipwrecked.

A BRIEF CASE STUDY—*LEADERS*

Leaders suggests another way to use Internet distribution for simulations. In this project, Internet delivery was an interim development stage. To test decision points, and more importantly, to gather data that would help develop the natural language interface, a "choose your own adventure" version of *Leaders* was developed, using simple HTML to outline the setups, scenes, and interactivity for a user. (See Chapter Four for more detailed discussion of this phase of *Leaders*.)

Due to the low-bandwidth nature of this interim version, client platforms were of practically no concern. Data collection, all keyboard input, was relatively simple. And the online version had to be maintained for only a few days.

In this case, the media and gameplay were all appropriate for the distribution platform. When these pieces all fit together, the odds for a successful simulation greatly increase.

SUMMARY

The Internet is a highly tempting delivery platform, due to its ubiquity. However, available bandwidth will constrain media selection and content delivery, and the uncertainties about user bandwidth, privileges, software and hardware, along with Internet security, data harvesting, and ongoing maintenance—all need to be taken into account before a decision is made about the desirability of Internet delivery.

23

Interactive Video and Interactive Television

INTERACTIVE VIDEO

Interactive video is a term that has been around a long time. Since the development of the laser disc in the early 1980s, corporate training centers have combined computer menuing systems with random access laser discs to provide video responses to data entered into computer systems either by individual participants or by representatives of those participants.

In the Final Flurry exercise, the instructors played the latter role. Their computer systems allowed them to send data and digitized video clips directly to participants' laptop computers, but it also provided control of laser disc players that presented video segments on a large television screen at the front of the room.

Daily updates of the state of the world were stored on the laser discs and the instructors could present these updates through a simple menu selection. Because there were various paths through the media, the instructors were also prompted to select those updates that matched the probable outcomes of the decisions that the participants made.

Similarly, the instructors could select comments from the National Security Advisor that matched the participants' decisions and recommendations and use them to give assignments that would shape the rest of the day's work.

The instructor could also assemble the president's daily state-of-the-union address from a set of video responses that would match the recommendations by the participants. In this application, the laser disc actually strung together the series of video clips of the president as though they were a single speech. Changes in camera angles during the production made the presentation of the event seem like a single seamless discourse.

Finally, a variety of outcome scenarios had been prepared to accommodate the range of recommendations that could be chosen by the participants. The

instructors could select and present those outcomes that were most appropriate on the large screen at the front of the room. They did this by accessing the outcome sequences through the computer menuing and laser disc system.

The use of interactive video in Final Flurry was unique in that it depended so heavily on the instructor as "the man in the loop." The instructor acted as the system AI and decided which prerecorded media elements were most effective.

To a large degree the *Leaders* project represents the ultimate updating of what was done in Final Flurry. Video content, which can easily be stored on a DVD these days, was instead part of the 3D simulation environment. But the animated responses to user actions were complete scenes that were stored in their totality and called up from the digital database. Participants did not present documents to instructors who then interpreted the documents and made the media selection based on human judgment (as they did in Final Flurry). Instead individual participants typed responses into their own computers, where a natural language processor decided what their words meant and accordingly allowed the media selection to be done by the computer system.

While this totally automated system seems to be a far cry from the Final Flurry laser disc-based interactive video system, in reality, the underlying instructional design, logic, and branching structure is exactly the same. So in fact, laser discs should be thought of as stepping stones to the more advanced technologies used in presenting interactive video today. In the same way, all these systems contain the same pitfalls relating to rigid content that made us seek the development of more flexible synthetic characters as described in Chapter Fourteen. While access to prerecorded or pre-rendered video content is powerful and of a very high quality, the trade off is lack of flexibility, which means that the video presentation may not respond perfectly to all the details of the input that the participants provide.

INTERACTIVE TELEVISION

In the commercial sphere, interactive television (now often called "enhanced television"), or iTV, has been ballyhooed since the 1980s. However, in anything other than tiny but controlled tests, commercial iTV only began real deployment with the emergence of digital interactive technologies in the late 1990s with both the maturation of the World Wide Web and the gradual deployment of modern set top boxes (STBs) and digital video recorders (DVRs). iTV use in the United States is only beginning to accelerate in growth; its penetration remains substantially less than the usage of iPods, DVDs, and broadband Internet. In England and other countries, iTV is far more prevalent.

Traditional television offers a broadcast (whether over-the-air, satellite, or cable) featuring one-way communication, the classic definition of "push" media. Loosely defined, iTV converts this broadcast to two-way communication: a

viewer can interact with content. The broadcaster can then shape content based on that interaction, and the interactive dialogue between viewer and broadcaster commences.

iTV is being delivered via two methods: two-screen interactivity and one-screen interactivity.

iTV: Two-Screen Applications

To date, a majority of commercial iTV applications in the United States have been deployed using two-screen interactivity. Most typically, this has meant the simultaneous use of TV console and personal computer (desktop, laptop, handheld). More recently, these applications have also combined the use of TV console and cellphone.

Two-screen interactivity arose because the TV set has remained a "dumb" console for most users. The TV remains a one-way broadcaster of content, even though the broadcast is now delivered by cable or satellite system. Thus, all two-way interactivity occurs on the second screen. While this is undoubtedly (to use a time-honored engineering term) kludgy, it also reflects usage patterns of a substantial portion of the population: people are already accustomed to using their computer or cellphone simultaneously with a TV. Why not harness this usage pattern and lash both screens together?

The two-way content may be either synchronous or asynchronous to the broadcast, delivered via the Internet (see Chapter Twenty-Two for further notes on delivery of Internet content). Content synchronous to broadcast is likely to be more dynamic for the user/viewer. For example, a development in the TV broadcast will trigger content on the second screen, perhaps a poll, a quiz question, a factoid, an image, or streaming media. Synchronous content will require that the user continually focus on the broadcast screen, effectively merging the two screens into one feedback loop.

While the cellphone may seem like a less effective second screen (due to screen size, communication bandwidth, etc.), its diminutive size may be countered by the relative intimacy of the device, which means many users are actually more comfortable and likely to use it. With screen resolutions, bandwidth, and capabilities continually improving, the cellphone becomes an ever-more viable platform for shared or total content delivery. (See Chapter Twenty for detailed discussion on bandwidth and how cellphones stack up.)

iTV: One-Screen Applications

Set-top boxes, in real-world settings, have finally become robust enough to enable true two-way interactivity on the single screen of the TV console. Applications vary, everything from user control of camera shots (Wimbledon viewers in the UK, for example, can choose which game to watch and which angles they

like) to user input selecting content (additional graphics, charts, text); voting in polls; taking quizzes; determining branching story direction; and much more.

Interactive content may appear as a separate window on the screen or as a transparent overlay on the main screen. The bandwidth available for upstream (i.e., user transmission) use remains miniscule compared to the bandwidth on the downstream (the TV broadcast), but will continue to improve in the years ahead.

TiVo, and similar DVR devices, offer another methodology toward one-screen applications, as content can be downloaded in the background prior to the actual simulation experience, and can then be triggered throughout a broadcast, creating the illusion of two-way interactivity (user interactivity is likely to be with the DVR-device only, selecting to view video stream one vs. video stream two, for example).

In the long run, it seems likely that one-screen applications will overtake two-screen applications. For now, however, second-screen devices generally offer more archival storage (good for tracking user history and performance), output options (printer, scanner, email, Internet, etc.), and portability (a user can bring his laptop to another location and display or output data collected during an iTV experience). In addition, usability and psychological issues could argue for the continued use of second screens (perhaps particularly cellphones) in some simulations. The two-screen experience may also better simulate certain actual environments.

iTV vs. Internet Delivery

Why choose iTV as a simulation delivery platform? To begin with, the TV console is still the best delivery system for full-motion, live action video. If video clips comprise a substantial portion of your simulation's media assets, then this platform might be worth a look. However, iTV is a broadcast medium intended for wide delivery and numerous users. Building a one-screen iTV system is expensive and demanding, and probably only makes sense when plans exist for a number of simulations to be delivered to numerous, dispersed users over a period of months or years. Creating a two-screen iTV system is more feasible, but still requires considerable skills should synchronicity with broadcast events be desirable.

As one-screen iTV becomes more pervasive (via STBs, DVRs, and newly developed Internet Protocol Television [IPTV]), it will become increasingly possible for government or private sector entities to lease a "virtual channel," which will essentially use the Video On Demand (VOD) features that TV distribution companies (phone, cable, satellite) will have in place.

IPTV, in particular, offers the potential for anyone to become a broadcaster, as the TV becomes just another Web-enabled node. This technology makes "narrowcasting" (highly targeted broadcasting) to intracompany sites more practi-

cal. (See http://www.iptvnews.net for more information on IPTV.) In addition, new middleware services like Brightcove (http://www.brightcove.com) will more easily enable the production and delivery of iTV narrowcasting.

These developments should make iTV delivery no more complicated than Internet delivery for training simulations. But this area remains the "bleeding edge" of technology, and probably argues for a longer development timeline on any simulation project.

Story-Driven iTV

Given the emerging commercial uses of iTV in the United States, it may appear that the platform will carry little story content and is only meant for user trans-actions and game show applications. In fact, the opposite is true. Even if the interactivity only involves quizzes, polls, factoids, and other primarily textual material, this content can be used to deepen and enhance the video content, often providing a hook or arc that will pull together disparate videos into a truly involving narrative.

If users have the capability to begin to select and direct camera action, they will begin building their own story narrative, and this ad-hoc narrative can then help to carry pedagogical and training content. Further video content can be "awarded" to users who answer questions, make selections, or fill out profiles. Showtime's episodic drama *The L Word* has experimented with this approach under the umbrella of the American Film Institute's Digital Content Lab. We are truly at the dawn of learning how to tell interactive stories, but the use of full motion video content offers rich possibilities for immersive and engaging narratives.

VIDEO PRODUCTION

Video is generally regarded as the most expensive of all media to produce. And though the creation of 3D virtual worlds with the accompanying need for quality assurance and difficult revisions may be giving it a run for its money, video is still something that needs to be approached with a healthy budget and a healthy respect for its complexity.

That being said, there are many things that can be done to exercise cost control and to get the most out of your video production investment. Let's take a look at the various styles of media used in simulations and discuss the pros and cons of each.

Full-scale production is surely the most expensive and most difficult to pull off. Creating a complete new mini-movie on any topic is generally very difficult. We noted in earlier chapters that *Leaders* was based on a very successful film that ICT produced called *Power Hungry*. The film had a sophisticated script,

well-trained actors, many extra players, music, sound effects, an expansive location, authentic sets, props, and a good deal of high-priced editing. The key characters are complex and require good performances from the actors. Certainly the film was extremely well received by the Army participants who viewed it. But the key to its success was its believability that was far easier to achieve in Hollywood, with experienced writers, directors, and experienced actors all around.

Today's sophisticated audiences are accustomed to prime time television commercials and $200 million action movies. They are immediately turned off by amateurish productions. If you've set your heart on a Classic Hollywood-style production, beware. It will be very hard to achieve. If you must go this way make sure you have a good script with believable dialogue. Hire someone who knows the demands of directing. Get someone who knows about lighting and won't allow ugly shadows to distract from your production. Get the best actors you can find, make sure they know their lines, and rehearse them over and over again. Choose inexpensive "real" locations over limbo sets with limited props and borrowed furniture. Shoot outside whenever you can to simplify the lighting requirements. Use tight close-ups of characters to eliminate the need for detailed backgrounds. Hire an experienced editor or learn a good, well-rounded editing program like Final Cut Pro yourself. And good luck.

If you can't afford the classic Hollywood style or don't have enough experienced colleagues, go to a production format that is still acceptable but doesn't require the polish of Hollywood. Try the hand-held style of many of today's independent films, or go for the gritty news format kind of show, which because of its immediacy is allowed to be far less polished.

In the Final Flurry and ALTSIM projects, the Paramount Pictures team produced video content modeled after news broadcasts. This lent itself to the military situations that made up the main content of the simulations and allowed us to hire people with news experience. Newscasting, while still requiring a certain polish, uses a simpler kind of presentation. Newscasters are trained to be unemotional and as such are not required to exhibit the intonations of character that would make their performance less believable.

Also, news sets are fairly simple and as such are easier to replicate. Sometimes internal, corporate TV production groups have news sets of their own. Sometimes the local TV station will make their news sets available for local production.

Stock footage is always more believable than any attempt to restage an important event. Local and national news companies often sell their stock footage on a limited use basis and they give discounts for training or educational uses of the material.

It is sometimes difficult to achieve a real, believable green-screen effect, in which the actor/narrator is keyed (superimposed) over the stock footage background, but if you have an editor who is skilled at rendering such effects, and you have the time, it is definitely worth a try. You can have your newscaster

Figure 23.1 Jackie Bambery, a professional newscaster keyed in front of a Washington DC location for the Final Flurry Exercise.

standing in front of the White House, just key him or her over some footage of the White House. And make sure there is a little movement in the scene (a fluttering flag, an occasional car driving by). Today's sophisticated audiences know to look for that.

Producing video segments featuring actors portraying characters in an interview, public announcement, or press conference brings up some of the issues presented when discussing classic Hollywood-style productions. But then these are usually easier to achieve than dramatic scenes involving dialogue. Get the best actor you can. If you can afford an over-the-lens teleprompter, use it. It will make the actors delivery much more believable because the actor will be looking directly into the camera. Sit the actor in a comfortable position. Go for the finest lighting possible.

Because press conferences and interviews are often staged in impromptu settings, the backgrounds do not have to be as realistic as in a classic Hollywood set. Use a state or national logo, a map, the flag of the relevant country, or a classic painting that fits with the character being portrayed.

Again, keep the shots tight. In ALTSIM we rented a military Humvee so that we could show our Lieutenant in the field. But in the end, all the shots were

so tight that we never saw the Humvee, and the rental money was wasted. Generally speaking tight shots of a good actor are always more believable than elaborate long shots that attempt to portray more of the scene.

Keep the actor's lines as concise as possible so the speech or announcement does not drone on and lose the audience. Make sure that you think of and shoot every single possible statement and remark you could ever need. If you later think of one interactive response or one conditional statement that needs to be added you will probably never match the lighting and the sound quality of the statement again, and you will probably have to rerecord the entire set of statements all over.

Use voice over narration whenever possible. Well-directed actors reading lines off-camera are easier to control and more accurate. But if there is any chance at all that dialogue *might* be delivered on-camera, shoot all of it on-camera, then all the audio will match. If you can't find that elusive stock footage shot, you may be able to cut to the newscaster.

Use diagrams, titles, and maps as full screen graphics. It is easier to create a good-looking graphic than it is to light an actor and get the lines perfect. The presence of the graphic will upgrade the entire video presentation. And, since graphics are basic elements of many newscasts and press conferences, they will add an element of authenticity to the proceedings. If graphics are good, animation is better if it looks like those in newscasts and announcements.

Finally, video clips that are examples of a specific situation are especially effective if used on their own. In *Leaders* we needed to show video captured by a UAV (unmanned aerial vehicle); we were able to acquire that kind of footage from the military and deliver it as a desktop video clip. We needed a shot of a hard rain. One of the authors walked out his front door one March afternoon, pointed his camera over the tops of the trees, and took the shot. Shots of fires, riots, weather conditions, auto accidents, etc. can be purchased from your local news station, or even captured with your own camera. Turn these shots into desktop video clips where the quality is supposed to be low anyway or attach them to e-mails and you've added another media element to your presentation.

SUMMARY

Interactive Video began as the control of random access laser disc video by computer multimedia systems. In Final Flurry, it was the instructor who interpreted the decisions of the participants in the classroom and chose the appropriate video clips to play on the large TV system in the front of the room.

Current forms of interactive video include clip selection by AI systems built into the individual computers of simulation participants, as in the *Leaders* project. These days, video elements can be stored on DVDs or in libraries of digital video files resident on the computer itself.

iTV is beginning to emerge as a rich and exciting platform for the building and delivery of a simulation that relies primarily on video content. iTV is truly a broadcast medium, and at this time, is probably out of the reach of most government and private sector entities. However, as Video on Demand, virtual channels. and Internet Protocol Television are made readily available by TV delivery systems (cable, phone, satellite), iTV will become a logical platform for delivery of certain simulations.

Video production for any of these approaches should be governed by a healthy respect for the cost and complexity of the production. Classic Hollywood styles are extremely difficult to imitate and will often be judged amateurish. Independent film styles or news formats are much easier to achieve, especially since many news sources will sell their footage and professional newscasters are everywhere.

Real-Time 3D Virtual Worlds

When pedagogical content (and the gameplay that will help roll it out) calls for significant user avatar spatial navigation and interaction, in a realistic looking environment, then a real-time 3D-rendered (RT3D) environment is probably the platform of choice. RT3D demands a high degree of computing and graphical processing power and significant bandwidth. Consequently, this platform is largely inappropriate for delivery on handheld devices (screens are too small and navigation tends to be clunky), and online or network-only delivery isn't a feasible option, even on a robust desktop PC system with a broadband connection. Terrains, texture maps, characters, objects, and animations will need to be resident on a local client drive. This content must either be distributed on a disk or via file download and installation.

Building RT3D environments is costly and labor intensive. Giant software companies such as Electronic Arts and Microsoft take years and spend millions of dollars building videogames in these environments. Unless the backers of your simulation have extremely deep pockets, it may seem impossible to use this platform, as right as it may seem for your project.

Leaders was an experiment in building this sort of environment relatively cheaply, using off-the-shelf software, and relatively rapidly. The results are encouraging enough to suggest that other simulations can be built in similar fashion. Some of the key aspects of creating for this platform are the creation of assets, the building of terrains and levels, the creation of characters and character animations, and the placement of these elements (and the triggers, actions, and interactivity associated with them) within an RT3D engine.

WHICH PLATFORM: PERSONAL COMPUTER OR GAME CONSOLE?

Although the emerging new generation of game consoles (Playstation 3, Xbox 360, Nintendo Wii) will further blur the line between PCs and game consoles,

185

Figure 24.1 The Leaders RT3D environment and characters.

the reality is that game consoles have up to now not been a logical platform for the development of training simulations. Typically, console software development kits (SDKs) have only been made available to large, proven commercial developers, but as we went to press, Microsoft was making available a low-cost SDK for the Xbox 360. PCs, of course, offer numerous commercial and open-source SDKs and are vastly more prevalent in the workplace.

Windows remains the operating system of choice, again thanks to the wide availability of necessary software tools. Choosing Mac or Linux operating systems may overly restrict the deployment of a simulation and may choke the workflow if it turns out that a particular software tool is not available for the operating system.

VISUAL ASSET CREATION

For an RT3D environment to come to life, virtual terrains, sets, and props must first be built. The terrain will need texture mapping to begin to bring it to life, simulating the color, surface and depth that we observe in real-life terrains. It may need flora, rocks, and other natural elements to achieve more realism. Sets will need to be placed on the terrain (or else molded out of the terrain), so that a level that characters can navigate can be constructed. Sets are likely to be buildings, walls, enclosures, ruins, foundations, and so on. Adding further realism and simulation value will be props such as weapons, vehicles, first-aid kits, brief-

cases, furniture, appliances, and other objects that a user will view or interact with. All sets and objects need to be 3D models.

This may sound a lot like moviemaking, and to a large degree, it is: movies were really the first simulation environments. This observation is an important one which we'll revisit later. Naturally, our movie-like simulation will need characters. Characters need to be designed, modeled, and rendered in three dimensions, and then incorporated into character animations (a character running, waving his arms, standing, sitting, walking, crawling, falling, etc.).

As this brief discussion suggests, skilled artists who can work in this environment are a must. Terrain building, texture mapping, character modeling, and character animations are all separate and distinct skills. Some artists may be able to combine these skills, but artists will tend to have stronger and weaker skill sets in these areas.

Experienced professional 3D artists are in high demand and earn high salaries. Game companies spend lavishly to recruit the best. If your best available artist has mastered drawing "stick men" but not much else, you may begin to feel that this platform is out of your reach.

Leaders experimented with using trade school art students, hiring them as project interns, with generally positive results. This approach may work for you, but still requires a seasoned team leader with tremendous knowledge of 3D computer graphics who can supervise work flow, quality control, and asset management.

Artists are only as good as the script they have to work with; their job is to realize the vision, but not create the vision from scratch. The greater the clarity of vision in the simulation itself, the more likely that effective 3D graphics can be created to support the vision.

Creating that vision can usually only be realized through dedicated graphics software, and commercial tools in this class are usually expensive. Maya and 3D Studio Max are two popular commercial modeling packages. However, Open Source alternatives are emerging; ImageMagick is one such package. Software suites known as middleware may handle other aspects of asset creation such as level design, tree rendering, particle simulation, and more. Publishers like VirTools offer these suites. (A later section in the chapter discusses the emergence of Open Source simulation toolkits.) Because labor is generally a much higher cost than the software itself, the determination for which software to use should rest with the artist team. However, familiarity with Open Source alternatives may be one factor in artist recruitment.

AUDIO ASSET CREATION

Audio assets (dialogue, environmental sound effects, program cues, music), their value to your project, and the myriad choices you face, are such an

important (and usually underrated) aspect of the overall simulation that this book has reserved an entire chapter for their discussion (Chapter Twenty-five).

THE GAME ENGINE

All the visual and audio assets you create are meaningless without their eventual deployment via the game engine. The game engine is the core component of a game or simulation environment, marshalling all the assets and managing their availability, rendering, and behavior. Game engines usually also provide game AI, collision detection, camera placement, lighting, shadowing and shading, game physics, heads-up displays, and other features. As the phrase suggests, no 3D game will operate without a 3D game engine.

Game engines are generally licensed. The license fee may be very high, or in the case of Open Source game engines, may be cost-free. *Leaders* used the Unreal Tournament game engine. Other game engines include Quake III, Doom 3, RenderWare (used in *Grand Theft Auto*), Torque, Gamebryo, and Open Source Crystal Space.

All these engines are considered first-person shooter (FPS) game engines; however, most FPS engines will enable either first-person or third-person point-of-views (POVs) and user experiences. The choice on which POV to choose is critical, and should serve both the pedagogical content and the immersiveness of your simulation.

While it may seem obvious to use the first-person POV (after all, isn't that what we experience?), the third-person POV may be a better fit for some projects. You may wish to engineer a more movie-like experience (think about the Tomb Raider game series), where we have the freedom to jump to nonuser "cut scenes" if we need to. Interestingly, this may achieve an even greater feeling of immersiveness.

The third-person POV was the choice ultimately made for *Leaders*. Partly, the choice was made because the project's approval group, not typically game players themselves, would find the third-person POV more attractive and understandable. In addition, there was an argument that greater simulation "situational awareness" would be achieved via the third-person POV. This POV was achieved in two ways: interactive scenes employed an over-the-shoulder camera angle (arguably creating a second-person POV, where "you" are the user avatar), while cut scenes played in the objective third-person POV that we're familiar with in film and television (the user could see "himself" walking with subordinates or studying the horizon).

The third-person POV may also be attractive if the goal is to achieve a certain distancing from the experience, so the user can be more objective about events and outcomes. While sacrificing some immersiveness, this approach may be appropriate to certain pedagogical and training goals.

SCRIPTING THE GAME LEVELS

The game engine will require the use of a level editor in order to begin scripting the events, actions, behaviors, and outcomes of the levels of the simulation. One of the attractions of the Unreal Tournament game engine (for *Leaders*) was the inclusion of UnrealEd, the official level editor for the engine. Most commercially available engines package an editor as part of the licensing for their engine, and Open Source engines also have available editors. Technical support for level editors is spotty, at best, so the level designers you hire are likely to confront some learning curve in the use of the editor (unless they've had substantial previous experience with it).

DIRECTING THE RT3D SIMULATION

Placing the camera for the events, actions, and outcomes and directing how these elements will play out are two of the most crucial elements of designing a RT3D simulation. We would never imagine a movie that didn't have a director. With a RT3D environment we have virtual sets, virtual actors, and a virtual camera. However, there is no virtual director. Your project will need a flesh-and-blood one.

In the film world, it's the director who enforces a consistent, coherent vision that informs every element of the final product. In a simulation, scenes and sequences need to be blocked (that is, the position of actors and set pieces need to be determined); the speed of character movement and navigation needs to be figured out; character behaviors need refining; level color palettes need coordination; and the artistic style of sets, terrains, and characters needs to be selected. In fact, this is just a small selection of the creative decisions that need to be made, and in the midst of production, the decisions seem nearly endless.

While it may be possible to learn directing on-the-job, this is really flying by the seat of your pants. Collaborative or committee directing may also seem doable, but is likely to achieve a muddled or incoherent vision in the finished project.

But if you decide to recruit a professional director, should he or she come from the television/film/commercial world (i.e., the world of live action) or from animation/videogames? The perfect choice would be a director with experience in both realms; but if a choice needs to be made, the director with animation and videogame experience is likely to be preferable.

Finding this director won't be easy. The Directors Guild of America (http://www.dga.com) is the professional organization for film and television directors, and they offer an ultra low-budget contract for small-scale projects; however, videogame directors rarely belong to this guild. If you're on a tight budget, then you may need to recruit from a respected media arts or digital arts

educational program and hope you can find a student or recent alum with substantial experience. But this is a hiring decision to be made very carefully, because it will determine much of the success of your simulation.

PROOF OF CONCEPT

No game company attempts a new RT3D game environment without first producing a "proof of concept": building a partial level to test out the visual look and feel, user interface, interactivity and gameplay, and internal production workflow. New discoveries about your goals and their realization in the simulation are inevitable; creative decisions will need refinement; and problems regarding workflow, mechanics, asset integration, gameplay, and content delivery are always bound to arise. The more these can be determined at the proof-of-concept stage, the more smoothly actual production will go.

BETA TESTING

Testing of the nearly finished simulation needs to be built into the production timeline. Debugging and content and interface modifications will be necessary throughout production, and become even more critical as production nears completion.

Samplings of the user population should be used for beta testing. The production team itself is usually too subjective and project invested to provide useful feedback and testing. Obviously, testing should be done as quietly and confidentially as possible; advance word that a product is buggy or ponderous is likely to spread quickly, coloring its impact and acceptance upon eventual release. You may need your users to sign nondisclosure agreements to maintain confidentiality and protect the reputation of your simulation before its official unveiling.

AMORTIZING COST

Typically, game companies find that version 2 and version 3 of their games are actually more successful than the original version, as workflow and technology issues are worked out, advancements become more incremental, and even greater concentration on content becomes possible. The high costs of an RT3D simulation can be better amortized by planning for successive upgrades, versions, or simulations. If the simulation is meant to be a "one off," even greater scrutiny should be given to its return on investment. However, if successive simulations seem likely and desirable, it becomes easier to justify the initial costs of producing an RT3D simulation.

VEHICULAR 3D SPACE

Although FPS game engines have most often been used to create ground-based environments, several game engines are fully capable of integrating vehicular models, behaviors, and actions. These include Torque, Halo, and Unreal Tournament 2004. This means that a simulation can easily include a user avatar navigating both on foot and on wheels, increasing verisimilitude for certain training environments.

NON PHOTO-REALISTIC 3D

If a simpler, blockier, cartoony 3D environment is acceptable for your simulation, then one approach may be the purchasing of Sims2 games, and building "mods" and skins to customize the world and create the content. Sizable compromises must be made in this effort. The Sims2 game engine (which is not available for separate licensing) is not designed for lengthy audio dialogue and extensions to incorporate video, application documents, and other materials. Sims2 characters are behaviorally driven, but any sort of language-driven interface is out of the question. Nevertheless, Sims2 mods might succeed as environments for certain "soft skill" simulations, where the evaluation of emotional states and their application and modifications lie at the core of the simulation. (Note that Sims2 usage remains governed by its publisher's end user license agreement, as well as any EULA attached to a downloaded mod.)

As mentioned in an earlier chapter, X3D has become the successor to the VRML file format, and engines and authoring kits exist that can work with the X3D format. Although the results will not rival the lush 3D realism of Quake 3 or Unreal Tournament, simpler 3D environments and objects including terrains, sets, props, and vehicles are easily renderable, and the bandwidth necessary for delivery is substantially less than for the Quake/Unreal worlds (making delivery via the Internet a more realizable proposition). Vizx3D (http://www.vizx3d.com) is one authoring kit and engine for X3D, and for smaller, modular 3D simulations, may be worth the exploration. Media asset creation is largely the same, but the simpler 3D environment will probably allow for less sophistication in art assets (lowering the cost of development).

An integrated simulation tool kit, which includes a 3D engine, is now being marketed by Breakaway Federal (http://www.breakawayfederal.com). Called MOSBY, the kit is "lite" both in developer demands and cost. Designed primarily for military simulations, MOSBY boasts that it can recreate both advanced morale logic and chain-of-command logic within its tactical and operational simulations.

In the months ahead, we can expect to see more 3D-lite game engines and development suites emerge, making real-time 3D simulations increasingly cost-effective and produceable within tight budget constraints.

Figure 24.2 A screenshot from VizX3D, a real-time 3D authoring tool. Used with permission of Media Machines.

SINGLE-PLAYER AND MULTIPLAYER ENVIRONMENTS

Most of the FPS engines we've mentioned handle single-player interaction and multiplayer interaction. Media demands remain almost identical: the major challenge in multiplayer simulations is designing pedagogy, narrative, and interactivity that all work together when multiple users are given autonomy within the environment. Will the presence of multiple users end up undercutting, contradicting, or overcomplicating pedagogical content? Multiplayer experiences may argue for a man-in-the-loop approach, with an instructor present in the virtual environment to further shape the training and keep the experience on track.

Game developers frequently build a single-user version of their game first, and then move to multiplayer deployment. However, in the realm of training simulations, it's hard to imagine the mere bolting-on of a multiplayer component as being successful. The move from a single- to multiplayer environment is so transformative to the experience that it needs to be planned for from the begin-

ning. Once again, pedagogy should drive the decision to make the experience multiplayer, and although nothing may be "sexier" than a multiplayer environment, its use should aid the transfer of pedagogy rather than impede it.

SUMMARY

A real-time 3D environment may well be the most complex and treacherous type of simulation to undertake. However, if your simulation requires substantial user navigation and interaction in a realistic environment, this platform is likely to come closest to realizing your pedagogical and training goals. Though game companies typically spend millions of dollars to develop and produce games in this environment, the use of Open Source and commercially off-the-shelf software, trade school interns, and recent media arts graduates may substantially reduce budgets and keep the project in the six- or even five-figure range. Proof of concept on the front end of development and beta testing at the back end of development must be included to enhance the chances for a successful simulation. Production will demand a broad range of talents, most of them likely to be contractual in nature, rather than in-house. Due to the expense of RT3D sim production, it may be easier to justify its costs with plans to spawn successive simulations using the same engine and workflow, and re-using assets, interface, and gameplay design. However, "3D-lite" game engines and development kits are becoming more available, making 3D simulation development more accessible all the time. Multiplayer experiences may be very tempting to explore, but pedagogical content should be the driver of this decision, rather than the desire for a "sexier" simulation.

25

Audio

Audio is probably the most underrated and undervalued media asset, yet its functionality, malleability, and power are enormous. Theatrical films ignored sound for three decades, and although most of this was because of technological limitations, the fact is that sound design and sound delivery have been catching up ever since the advent of talkies. While Cinemascope, 3D, and other visual breakthroughs were being delivered in the 1950s, Dolby sound and the THX format came about a quarter century later.

Similarly, until relatively recently, television sound was delivered out of a tinny monaural speaker, long after color broadcasts, chroma-keying, and other visual techniques had matured.

And because computers could initially only deliver sound beeps, and later became equipped with speakers that must have been castoffs from cheap AM radios of the 1960s, sound was an all but ignored component of videogames. Once again, audio has been playing catch-up.

Paying attention to audio design, audio recording and capture, and audio delivery will yield major dividends in any simulation project. The creative use of audio can vastly enhance both the immersiveness and the pedagogical breadth and depth of a project, and can often disguise a constrained production budget and limited production resources. Audio can even salvage segments or entire projects that have fallen short of their goals.

Let's take a look at different types of audio, and how we can better enhance a simulation environment through their shrewd design and production. These audio types include onscreen nonplayer character (NPC) and user dialogue, off-screen NPC and user dialogue, voiced narration and instruction, sound effects, and music. (Dialogue, as used here, denotes any speech from a character, as it is defined in screenwriting and playwriting. Consequently, an NPC or user soliloquy is still considered dialogue.)

ONSCREEN NPC DIALOGUE

People rarely pay much attention to silent security video monitors stationed in department stores, supermarkets, and so on. However, if audio was suddenly made available on these monitors, and if the monitors began eavesdropping on conversations, passers-by would soon become riveted to the TVs. You've seen this behavior in action if you've ever shopped for a television set at an electronics store: characters talking onscreen are difficult to ignore, and shoppers have a difficult time pulling their attention away from the demo sets. Similarly, if you're hosting a party, you'd better make sure the TV is off: strangely, once the sound is turned up and onscreen characters are talking, the TV has an almost hypnotic effect, even when flesh-and-blood people are also in the room!

The power of onscreen characters, actually speaking, is undeniable. The fact that they talk makes them more believable, pulling us deeper into the simulation. Onscreen characters accompanied by popup dialogue balloons (a la comic books) or text windows containing dialogue remind us of the artificiality of the simulation experience, combating the goals we have in applying story elements to simulation.

However, synchronizing (i.e., "syncing") voiced character dialogue to character lip movement is difficult and expensive to achieve (whether with live-action actors or animated/virtual actors). If we've decided to include character dialogue, do we need to sync it to lip movement?

If we are using live-action onscreen actors, the answer is yes. Most of us have seen a badly dubbed foreign film, where dialogue is clearly out-of-sync with lip movement. We know how distancing this is: the immersive movie experience takes a back seat to our constant awareness of the dubbing, and often, even dramatic scenes become comic in the rendering.

However, we seem to be far more forgiving of out-of-sync dialogue when it comes from the mouth of a virtual actor. Nobody expects Homer Simpson's lips to exactly conform to his dialogue. The same goes with characters from *Grand Theft Auto*. Some of this has to do with how closely our virtual actors come to looking like human actors; some of it has to do with the size of the screen. One of the objections that some viewers had to *The Polar Express* and to *Final Fantasy: The Movie* was the very slight disconnect between lip movement and dialogue. But the virtual actors cast as NPCs in *Leaders*, though they were three-dimensional and clearly human, didn't aim to exactly replicate live-action figures. As a consequence, relatively primitive lip movement sufficed for delivery of character dialogue.

Tools to achieve character lip sync keep improving. For example, Di-O-Matic's Voice-O-Matic (http://www.di-o-matic.com/products/Plugins/VoiceOMatic) is a 3Ds max plug-in that automates lip sync to 3D models. While the lip syncing isn't perfect, it's pretty good. As lip syncing tools continue to develop, the problems with good character lip sync diminish.

Key Frame Test **Sample Every 0.1 Second**

Figure 25.1 Presentation of some of the experimentation with automated lip sync that was carried out as part of the *Leaders* project. Various automated methods of syncing were tried including random mouth movements, which seemed to work quite well.

Internet delivery of your simulation may complicate the lip sync decision, since users of commercially available DSL may experience latency issues and some lag time in dialogue cueing. Clearly, a proof of concept should precede a final go-ahead in this situation. Similarly, dialogue cueing may be more problematic on a less than robust local area network, particularly if the LAN is on duty in other capacities.

One of the "cheats" that can be used to deliver nonsync onscreen NPC dialogue is the technique of "degraded video." Back in the 1990s, when audio and video storage and bandwidth were still at a premium, the massive (and highly successful) videogames *Wing Commander III* and *Wing Commander IV* used precisely this technique to deliver many hundreds of lines of dialogue. The game's central conceit turned the player into a space fighter pilot, flying with a wingman. It was believable that, even far in the future, delivering high-grade video between fighter ships approaching the speed of light would be impossible. Thus, postage-stamped video, highly granulated and stepped down in frame rate, conveyed a close-up of a wingman (or a mothership communications officer) who would frequently talk to you. None of the dialogue was lip synced, but the player never knew the difference.

This technique has to "play" believably, of course. But many situations suggest the use of "degraded video" to deliver the presence of a NPC. For example, the NPC could be speaking via a satellite-uplinked videophone (as seen on CNN) or via videoconferencing (where the frame rate is stepped down and the video window is reduced). The NPC could be speaking in a darkened room or via streaming video onto a handheld device. The NPC could be a mechanic working underneath a car or a patient bandaged up because he or she has just

had cosmetic facial surgery (very believable in a simulation about cosmetic surgery or bedside manners!).

Some simulations (such as the *Wing Commander* series) will lend themselves to the degraded-video technique; others will allow for only a very spare use of the cheat. But look for opportunities to exploit this technique: in varying the overall look of the simulation, you'll enhance the immersiveness of the project. (In the real world, we're used to contending with different, and not always optimal, visual conditions.)

In sum, there is less excuse than ever for NPC characters' speech to be presented through text in a simulation. Users expect to hear audio when NPC dialogue is being included, and nonaudio substitutions will reduce the immersion of the experience.

PRERECORDED *VS.* REAL-TIME SYNTHETIC NPC DIALOGUE

One decision to make is whether to rely on prerecorded comments, responses, questions, and monologues for your NPCs, or whether to attempt delivery of more truly synthetic, AI-driven and assembled speech, based on a library of phrases, phonemes, etc. (See Chapter Sixteen for discussion of on-the-fly narrative construction.)

Clearly, prerecording all NPC dialogue will restrict the flexibility, repeatability, and illusion of spontaneity with the dialogue. This can be somewhat ameliorated with randomization of NPC responses. For example, three or four content-identical pieces of dialogue can be rotated in and out, either on a purely randomized or a sequenced basis (e.g., selection 1 is played the first time, selection 2 the second, etc.), or some combination of the two.

However, this approach will increase the scripting, budgeting, casting, production, asset management, and postproduction of audio dialogue. Consequently, we have to weigh the costs of repetition and lack of content customization against development and production costs. In addition, the game engine will have to parse an ever larger library of audio media assets, which can impact performance.

However, creating truly synthetic dialogue may exact even higher costs. We must either develop an expansive phrase library (that can recombine into almost countless dialogue snippets), or a complete phoneme library. We must also have in place a robust assembly AI, along with a state-of-the-art speech engine capable of seamlessly swapping phrases in and out or blending phonemes on-the-fly, based on a vast vocabulary library. Most of us have experienced some form of synthetic speech, usually on the telephone, and we know that this speech doesn't sound "human." The human voice is almost infinitely nuanced, and we haven't achieved anywhere near this level of sophistication in creating synthetic speech yet.

Consequently, while prerecorded dialogue blocks may defeat immersiveness due to repetition or slight inappropriateness, even state-of-the-art synthetic speech will remind us of the mechanics beneath its use. At this moment, neither approach is fully satisfactory. It's a fact, however, that prerecording all NPC dialogue is currently the more economic and efficient choice for most projects, though it's not 100% ideal.

USES OF ONSCREEN NPC DIALOGUE

The uses of onscreen NPC dialogue are many and varied, of course. An NPC can directly address the user, offering backstory, situational exposition, instructions, agendas, plans, choices, and other informational, pedagogical, and testing information. NPCs can also engage in their own dialogues with each other, accomplishing any of the above.

The typical talking-heads scene will involve two NPCs in conversation (perhaps with the user avatar as listener or participant, perhaps as a "movie scene" that cheats point-of-view since the user is not officially "present"). However, we can vary this as much as we want, borrowing from cinematic language.

For example: multiple, simultaneous NPC conversations can quickly immerse us in a world. Robert Altman has used this technique many times in early scenes of his films, as a moving camera eavesdrops on numerous, independent conversations (whether on a studio lot, at a sumptuous dinner table, or elsewhere). Skillfully done, this can quickly convey the rules of the world, the current conflicts, and the central participants in a story-driven simulation. Somewhat paradoxically, the semi-omniscient camera feels "real" to us. All of us have had the experience of moving through a movie theater, ballroom, or sports stadium, hearing snatches of conversation (which we'd often love to hear more of).

Onscreen, this technique feels authentic because it gives us the "feel" of a larger space and larger environment that spills out from the rectangular boundaries of the screen.

The art of NPC dialogue is having it sound natural, rather than didactic and pedagogical. Again, television shows and films are the best examples of this: dialogue is always carrying expository material, character backstory, and other information; but at its best, the dialogue seems driven purely by character agendas and actions and reactions.

NPC dialogue might also be used in the form of a guide or mentor or guardian angel character who enters the screen when the user asks for help (or whose input clearly indicates confusion or regression). To some degree, this may diminish the immersiveness and realism of the simulation, but set up cleverly, this technique may not feel particularly intrusive. Obviously, the angel in *It's a*

Wonderful Life is a believable character within the context of the fantasy. On the other hand, Clippy, the help avatar in recent versions of Microsoft Office, is an example of a "spirit guide" who breaks the immersive nature of the environment. Rather than an elegant and seamlessly integrated feature, Clippy feelscrude and out of place.

Our mentor character might be a background observer to many or all key actions in our simulation, or could be someone "on call" whenever needed (who also "happens" to be available when the user gets in trouble). A supervisor character can also be a mentor. For example, in the *Wing Commander* series, the ship's captain would devise missions and advise the user avatar, while in THQ's *Destroy All Humans*, the aliens' leader teaches the user avatar how to destroy homo sapiens.

Whether the mentor is an NPC or a live instructor, the pros and cons of each approach is the subject of other chapters in this book.

ONSCREEN USER DIALOGUE

But what of user dialogue (i.e., user responses, user questions, user exclamations, etc.) delivered via a headset or from a keyboard (with text then translated to speech) that could then be delivered by an onscreen user avatar and understood and responded to by NPCs?

As previously discussed, the decision made in *Leaders* was to avoid (for now) any use of audio in rendering user dialogue. The Natural Language Interface had enough difficulty parsing text input from a keyboard. Attempting a real-time translation of text input into digitized speech that would become an active part of the immersive experience was impossible. (The slowness of keyboard input is reason enough to avoid the effort.) Attempting to translate spoken language into textual data that could then be parsed was equally beyond the capabilities of the technology.

One can imagine a simulation that might succeed with the natural language recognition system looking to recognize one or two keywords in user-delivered dialogue—but this seems to suggest very simplistic content and responses. (You may have encountered natural language recognition systems used by the phone company or state motor vehicles department that attempt to understand your speech, which works reasonably well providing you don't stray past a vocabulary of five or six words.)

Though text-to-speech and speech-to-text translation engines continue to improve, the fact is that the error rate in these translations probably still prohibits robust use of user-voiced responses and questions within the realm of a pedagogically based, story-driven simulation employing NPCs. However, this element has tremendous potential for the future. (See http://www.oddcast.com for demonstration of a text-to-speech engine with animated 2D avatars. The results are surprisingly effective.)

For now, we can probably incorporate user-voiced dialogue only when our simulation characters are primarily other users, rather than NPCs. Indeed, this device is already used in team combat games, where remotely located players can issue orders, confirm objectives, offer information, and taunt enemies and other team players, using their headsets. The human brain will essentially attach a given user's dialogue (heard on the headset) to the appropriate avatar, even though that avatar has made little or no lip movement.

Providing the dialogue doesn't need parsing by a text engine or language recognition engine, it can add tremendous realism and immersiveness to an experience. However, without some guidance and monitoring from an instructor or facilitator, this user-created dialogue can deflect or even combat the pedagogical material ostensibly being delivered.

As noted elsewhere, users will always test the limits of an immersive experience. In *Leaders*, non sequitur responses and unfocused responses would trigger an "I don't understand" response, and continued off-topic, non sequitur responses would soon trigger a guiding hand that would get the conversation back on track. If most or all dialogue is user created, we can easily imagine conversations devolving into verbal flame wars or taunt fests, with the intended pedagogical content taking a backseat to short-term user entertainment.

In addition, with no textual parsing and logging of this onscreen dialogue, the material becomes useless for evaluation of a user's knowledge, learning curve, strengths, weaknesses, and tendencies. Its sole value, then, becomes the added user involvement it brings, and must be weighed against the cost of the processing needed to deliver this style of audio.

Clearly, one of the users of our simulation might actually be the instructor or facilitator: the man in the loop. While a live instructor embedded into a simulation might be able to keep dialogue on track and focused on pedagogical content, issues regarding delivery of his or her dialogue remain the same. Does the instructor speak into a mike and have the system digitize the speech? Or is text-to-speech used?

OFFSCREEN NPC AND USER DIALOGUE

It's easy to overlook opportunities to use offscreen character dialogue, yet this type of audio can add tremendous texture and richness to our simulation. NPCs can talk to the user by phone, intercom, or iPod.

Indeed, if the conceit is constructed correctly, the NPC could still be speaking to us via video, providing they remain offscreen. Perhaps the stationery camera is aimed at a piece of technology, or a disaster site, or something else more important than the speaker. Or, perhaps the video is being shot by the speaker, who remains behind the camera: a first-person vlog (video blog).

Another potential conceit is recorded archival material, e.g., interviews, testimony, meeting minutes, dictation, instructions, and raw audio capture. Any of these may work as a credible story element that will enrich the simulation, and indeed, intriguing characters may be built primarily out of this kind of audio material.

If we have crowd scenes, we can also begin to overlay dialogue snippets, blurring the line between onscreen and offscreen dialogue (depending on where the real or virtual camera is, we would likely be unable to identify who spoke what and when, and whether the speaking character is even onscreen at that moment).

Not surprisingly, we can also use offscreen user (and instructor) speech. Many of the devices suggested above will work for both NPCs and users. But while the offscreen dialogue delivery solves the worries about syncing speech to lips, the other issues discussed earlier remain.

Speech that is merely translated from text, or digitized from spoken audio, is likely to have little pedagogical value (although it can add realism). And the difficulties of real-time natural language processing, in order to extract meta-data that provides input and evaluative material, are nearly as daunting. If we can disguise the inherent lag time of creating digitized speech from typed text (which is more possible when the speaking character is offscreen), this type of audio now becomes more realizable and practical, but it requires an extremely fast typist capable of consistently terse and incisive replies.

VOICED NARRATION

From the beginning of sound in the movies, spoken narration has been a standard audio tool. Certainly, we can use narration in our simulation. However, narration is likely to function as a distancing device, reminding the user of the authoring of the simulation, rather than immersing the user directly in the simulation. Narration might be most useful in introducing a simulation, and perhaps in closing out the simulation. Think of this as a transitional device, moving us from the "real world" to the simulation world, and then back again.

Obviously, narration might also be used to segment chapters or levels in our simulation, and narration can be used to point out issues, problems, solutions, and alternatives. But the more an omniscient sort of narrator is used, the more artificial our simulation will seem. In real life, narrators imposing order and meaning do not exist. Before using the device of a narrator, ask yourself if the information can be conveyed through action, events, and agenda-driven characters confronting obstacles. These elements are more likely to ensure an immersive, story-driven simulation.

SOUND EFFECTS

The addition of sound effects to a project may seem like a luxury, something that can easily be jettisoned for reasons of budget or time. Avoid the temptation.

Sound effects are some of the best and cheapest elements for achieving added immersion in a simulation. They are easily authored or secured, and most game engines or audio-processing engines are capable of managing an effects library and delivering the scripted effect.

In *Leaders*, simple effects like footsteps, trucks moving, shovels hitting dirt, crickets chirping, and background landscape ambience all contributed to the immersive environment. Right now, as this is being written, one can hear the background whir of a refrigerator coolant motor; a slight digital tick-tock from a nearby clock; the barely ambient hum of a television; and the soft sound of a car moving on the street outside. We're surrounded by sounds all the time: their presence is a grounding in reality.

Whether you need to have leaves rustling, a gurney creaking, first-aid kits rattling, coffee pouring, a television broadcasting a football game, or a garbage disposal grinding, pay attention to the background sounds that seem to be a logical part of your simulation space. If dialogue is being delivered by phone, don't be afraid to distort the sound occasionally (just as we experience cellphone dropouts and warblings).

Sound effects libraries are easily purchased or licensed, and effective sound effects usage will enhance the realism of your simulation, and perhaps even mask (or divert attention from) other shortcomings.

MUSIC

We might expect music to be an intrusive, artificial element in our simulation. Certain simulations, of course, may demand ambient music: for example, a radio or CD player might be playing in a space or in the background of a telephone call. But most of the time, music will not be a strictly realistic element within the simulation environment.

Nevertheless, soundtrack music may often help to set the tone and help with a user's transition into the simulation space. Inevitably, a simulation is asking users to suspend their disbelief and surrender to as deep a level of immersion as possible. Because of our understanding of the audio grammar of film and television, soundtrack music may indeed make the simulation more believable.

Hip-hop music might settle the user into an urban environment; a Native American flute might better suggest the wide-open spaces of the Southwest; a quiet guitar might transition the user from the climax of a previous level or chapter into a contemplative mental space for the next chapter or level or evaluation.

In *Leaders*, introductory Middle Eastern ethnic music immediately helped the users understand that they were in Afghanistan, far away from home. Different snippets helped close out chapters and begin new ones, while reminding the users where they were.

Music libraries are easily purchased or licensed, and a number of rhythm- or music-authoring programs for the nonmusician are available, if you'd like to create your own background tracks. While not every simulation project will call for music, the use of music should never be summarily dismissed. If its use might have the effect of augmenting user immersion, it should be given strong consideration.

SUMMARY

Audio is probably the single most underrated media element. Its use as dialogue, effects, and ambient background will enrich any simulation, and can easily be the most cost-effective production you can undertake. Audio can deliver significant pedagogical content (particularly via dialogue), while encouraging users to spend more time with a simulation and immerse themselves more fully in the space. Many decisions have to be made on what types of audio to use in a project: How will they support the pedagogy and the simulation, and at what cost? Will true synthetic speech be used, or prerecorded analog speech? Will users be able to contribute their own audio? And how deep and complex will the use of effects be (i.e., how dense an environment do I need to achieve)? Effective audio deployment is bound to contribute to the success of a simulation.

26

Simulation Integration

As we've seen in the first half of this book, and also in Chapter Twenty-Four, the assembly of story-driven RT3D simulations is very complex. Once learning objectives have been arrived at and story and gameplay have been conceptualized, the work only begins.

Terrains need designing. Sets and props need creating, and characters need to be built and animated. Levels need construction, and all story and interactive events need placement and triggering. Cameras, lighting, and shadowing need to be in place. Resource, inventory, and player history data need managing.

As a consequence, significant programming and procedural language skills are needed to move from the asset creation stage (script, art, etc.) to a fully working level of a RT3D environment. Although commercial game development suites and middleware provide tools attempting to integrate some of this workflow, much of the level building comes down to "hand coding," necessarily slowing down development time and implementation.

However, work has begun to create a more integrated design environment meant to be used by nonprogrammers. One such project, Narratoria, began during the development of *Leaders*, and is now a licensable technology from USC's Office of Technology and Licensing (www.usc.edu/otl), where it is already being used to author follow-up simulation story worlds.

One of Narratoria's inventors, USC senior research programmer Martin van Velsen, notes that other efforts to streamline authoring in 3D environments exists, "removing the programmer out of the production pipeline" but "ironically, [these] efforts take the burden of code development and place it instead on the artist"—clearly, an imperfect solution. In contrast, "Narratoria replaces the limited tools currently available with authoring tools that allow fine-grained control over virtual worlds. . . . Instant feedback allows real-time editing of what is effectively the finished product. In essence, we've combined the editing and shooting of a film, where there is no longer any difference between the raw materials and the final product."

Van Velsen argues that most traditional game and simulation authoring uses a "bottom-up" paradigm, laboriously building up animations, processes, behaviors, interactions, levels, and final project. However, he sees the traditional Hollywood production model as pursuing a "top-down" paradigm, and has designed Narratoria to do the same, looking at the different authoring activities (scripting, animating, level building, etc.) as different language sets that can be tied together and translated between.

The approach is one of "decomposition." If learning and story objectives and outcomes can be decomposed (i.e., deconstructed), along with all the elements, assets, and types of interactivity used to deliver these (levels, sets, props, characters, behaviors, camera movements, timelines, etc.), then it should be possible for this granularized data to be reassembled and built up as needed.

Narratoria accomplishes this through the processing of XML metadata attached to the assets it works with. These assets will typically call or trigger prescripted activities such as lighting, camera movements, resource and inventory evaluations, collision detection, and natural language processing. Scene and sequence (i.e., story and gameplay) scripts will designate the ordering of events, entrances and exits of characters, and so on.

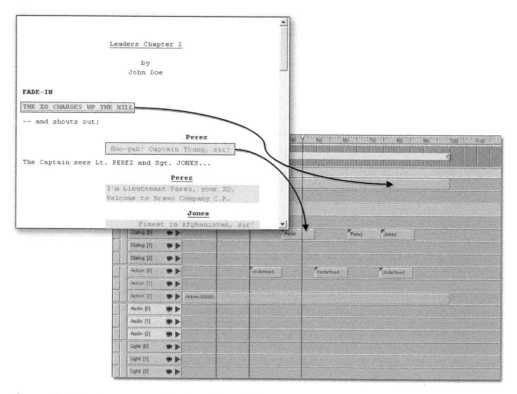

Figure 26.1 A conceptualization of how Narratoria translates screenplay metadata to an event timeline. Image reproduced with permission of Martin Van Velsen.

The actual authoring of these events take place in Narratoria's menu-driven, drag-and-drop environments (actually, a set of plug-in modules to handle individual tasks like asset management, character animation, camera controls, scriptwriting, natural language processing, etc.), so that artists, content designers, and even training leaders can directly and collaboratively build some or all of a level.

Once usable terrains, characters, and objects have been placed in the Narratoria system, any collaborator can immediately see how a level will look and feel by requesting a visualization using the chosen game engine for the project. (Currently, Narratoria works with the Unreal, Gamebryo, and TVML game engines, with other engines expected to be added.)

Let's take a look at an example. The simulation authoring might begin with a very detailed screenplay containing extensive XML metadata to represent scenes and interactivity (Figure 26.1). The metadata would obviously include the scene's characters, props, timeline, location, and set, and could suggest basic character blocking, available navigation, the mood of characters (perhaps a variable dependent on previous interactions), emotional flags on dialogue, and when and what type of interactivity will be available (perhaps a user avatar can talk to an nonplayer character to seek out information, or perhaps a user will need to locate a piece of equipment in a confined space, or perhaps an NPC requires a decision from the user avatar).

The script sequence itself could be directly authored in Narratoria (using the plug-in module designed for reading and handling scripts), or authored in another tool (e.g., Final Draft) and then imported into the proper plug-in module.

The sequence's XML data could then call up previously input camera and lighting routines that will read location, character blocking, and character mood, and set up the right cameras and lights in the appropriate terrain or set, all at the correct placement within a level.

Character bibles (discussed in Chapter Twelve) which have very specifically defined character behaviors (e.g., this character, when depressed, shuffles his feet listlessly) will then drive AI so that character animation within the scene becomes fully realized (the character won't just move from point A to point B, but will shuffle between the two points, with his head held down).

Integrating with other sequences and keeping track of all the variables, Narratoria will determine whether a piece of equipment is currently available (e.g., character A took away equipment X earlier in the level; therefore, character B will be unable to find equipment X, and be unable to complete the task), or whether NPCs will be forthcoming in offering information (e.g., the NPC has previously been rewarded by the user avatar, so will quickly offer necessary information if asked the right question by user).

If all of the sequence's XML data has been detailed enough, Narratoria should be able to build, shoot, and edit a first cut of the sequence automatically, visualizing it within the game engine itself. The author can then fine-tune this

portion of the level (e.g., adding more background characters to a scene, or adding another variable that will improve on the desired learning objective), either within the confines of Narratoria or working more directly with the game engine and its editing tools.

Narratoria can work with multiple instances of the game engine simultaneously, so that it becomes possible to test camera controls and moves within one visualization, while testing the placement of props, character movement related to them, and collision detection issues, in another. All this can occur where artists and writers are working with interfaces and language familiar to them, rather than having them master a particular editor for a particular game engine (which they might never use again).

Work on a similar authoring tool has been undertaken by the Liquid Narrative Group at North Carolina State. Although their tool isn't yet licensable (at the time of this writing), it also attempts to integrate and automate the creation and production workflow in building a 3D simulation story world.

Part of this automation is the development and refinement of cinematic camera control intelligence, resulting in a discrete system that can map out all the necessary camera angles, moves, and selections for an interactive sequence. Arnav Jhala, doctoral candidate at North Carolina State, worked on the *Leaders* project and continues his pioneering work in this area for the Liquid Narrative Group.

As Jhala and co-author Michael Young write in a recent paper: "In narrative-oriented virtual worlds, the camera is a communicative tool that conveys not just the occurrence of events, but also affective parameters like the mood of the scene, relationships that entities within the world have with other entities and the pace/tempo of the progression of the underlying narrative." If rules for composition and transition of shots can be defined and granularized, it should be possible to automate camerawork based on the timeline, events, and emotional content of a scene. As Jhala and Young put it:

> Information about the story is used to generate a planning problem for the discourse planner; the goals of this problem are communicative, that is, they involve the user coming to know the underlying story events and details and are achieved by communicative actions (in our case, actions performed by the camera). A library of . . . cinematic schemas is utilized by the discourse planner to generate sequences of camera directives for specific types of action sequences (like conversations and chase sequences). (From *A Discourse Planning Approach to Cinematic Camera Control for Narratives in Virtual Environments* by Jhala and Young; see bibliography for full citation).

Having generated these camera directives, the system has one other task. We can easily imagine the system defining a camera tracking move that ignores

the geometry and physics of the environment, i.e., where the camera may crash into a wall, trying to capture a specific move. A "geometric constraint solver" will need to evaluate the scene's physical constraints and determine necessary shot substitutions before the game engine attempts to render the scene.

Not surprisingly, while a full implementation of this kind of automated camera system won't eliminate the need for a director (as discussed in Chapter Twenty-four), it could eliminate days or even weeks of laborious level design, concentrating manpower on the thornier issues of how a sequence plays and its relationship to learning objectives and user experience.

SUMMARY

The difficulties of building RT3D simulations has brought forth the development of a new generation of software suites, which promise to make authoring easier for nongame programmers. USC is now licensing the results of its venture, Narratoria, into this arena; and for anyone embarking on an RT3D simulation, the use of this suite should be given consideration. North Carolina State's Liquid Narrative Group is working on a similar suite, and an eye should also be kept on their research. By integrating the disparate tasks of simulation building, more focus can ultimately be given to the pedagogical and story content, as well as to evaluation of user comprehension and progress.

PART SEVEN

STORY STRUCTURES FOR COMMERCIAL GAMES

27

Back Story and Free Play

The *Grand Theft Auto* (*GTA*) videogame trilogy (*Liberty City, Vice City, San Andreas*) is arguably the most successful commercial game franchise in history. It has also gained notoriety for its "hidden" sexual content (unlocked via a videogame "mod") and for its nonjudgmental (or amoral) allowance for criminal behavior.

GTA also happens to define one of the most successful storygame models yet developed in the commercial realm. A brief look at some of its techniques and mechanics may inform your approach to a simulation, particularly if you're looking at using the RT3D platform.

GTA is often known as a "sandbox" game. As the tag suggests, players have full freedom to explore the virtual urban environment, for as long as they'd like—an illustration of the pleasures of exploration and navigation, as discussed in Chapter Seventeen on gameplay. If *GTA* was set in an unpopulated, empty terrain, of course, these pleasures would quickly evaporate. But *GTA* is stuffed with characters, sets, and objects to interact with, and interactivity is nearly always available.

Unauthorized acquisition of vehicles (it *is* called *Grand Theft Auto*, after all) is at the heart of the interactivity. But one simple illustration of the richness of the world is the panoply of radio stations a player can listen to once behind the wheel of a car. The radio station music and chatter further immerses the player in the daily life of *Vice City* or *San Andreas*, and enhances the pleasure of basic navigation, so that even when there is a specific, story-driven task, the execution becomes an exercise in play.

GTA's story is doled out via a combination of cut scenes and missions or quests (combinations of hide-and-seek, solve-the-puzzle, and kill-the-enemy). Ideally, the characters and plot encourage the player to undertake the missions and "learn" the world. The player is amply rewarded (usually with virtual financial remuneration) for successful completion of the missions, and betters himself or herself in a demonstrable way (via the *GTA* virtual economy).

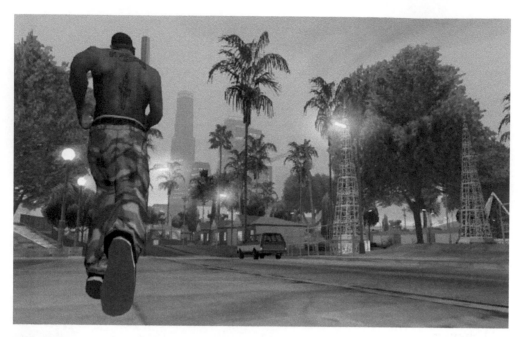

Figure 27.1 *Grand Theft Auto San Andreas.* Used with permission of Rock Star Games, Inc.

At the same time, players are not forced to complete quests in a certain order; they're allowed enough free will within the game to determine their goals and needs. This encourages players to spend hours of time within the environment, gleaning everything they can from it.

We're not suggesting that your simulation include automobile theft and the underbelly of urban existence, but that you think out your world with the thoroughness that *GTA* has. The little touches do matter. And the more you can encourage your user to explore your world, the more your pedagogical content should be imparted.

Interestingly, *GTA* moved from a purer simulation environment to a much more balanced storygame environment, and consequently became the best-selling game in history. Should there be some question as to the value of story content in a simulation game, the example of *Grand Theft Auto* speaks for itself.

SAN ANDREAS: BACKSTORY, MAIN STORY, AND FREE PLAY

In *San Andreas*, the player avatar, CJ Johnson, grew up in Los Santos (*GTA*'s fictional version of 1990s Los Angeles) and in his teens became a member of the Grove Street Families (GSF, *GTA*'s fictional version of the Bloods, a notorious Los Angeles street gang). The GSF, headed by Ryder, Big Smoke, and CJ's older brother Sweet, were anti-heroin and anti-cocaine. A series of events lead to the

death of CJ's younger brother Carl, and because Sweet held CJ responsible for the death, CJ fled the city.

Five years later, the murder of his mother forces CJ to return to Los Santos. He finds the GSF in disarray, having splintered into several gangs and heading toward the drug trade, despite older brother Sweet's best efforts to stay clear of it. These developments force CJ to stick around and help. He soon discovers that Ryder and Big Smoke are in league with corrupt cops and a rival gang. The rival gang ambushes Sweet, setting up Sweet's arrest and incarceration. Corrupt officer Tenpenny kidnaps CJ, who is extorted into carrying out the crooked cop's dirty work.

In the course of these missions, CJ gains new allies, gets involved with Asian gangs, and manages to kill Ryder, the first of the betrayers. One of CJ's new friends is a government agent who eventually helps in freeing CJ's brother, Sweet. Tenpenny, meanwhile, is arrested and tried for his crimes, even as CJ and Sweet are reunited. However, Tenpenny's trial acquittal triggers massive riots in Los Santos. During the chaos, CJ confronts the traitor Smoke and kills him. Tenpenny reappears and nearly kills CJ, while escaping with all of Smoke's cash. Sweet and CJ pursue Tenpenny through the riot-torn streets, and finally achieve a day of reckoning with their nemesis. CJ and Sweet's entire family are reunited as the story ends.

Though the story is extremely linear, every experience of it will tend to feel fresh because of the remarkable freedom that the player has to operate within the world at all times. However, a few narrative devices such as ticking clocks, along with the player's desire to know "what happens next," will tend to keep most players on track in carrying out missions and prodding the story along.

The story compels players to master the pedagogical content (the intent and execution of each mission), while feeling they are part of a very real world with meaning and emotion. Players don't feel burdened by the pedagogy; instead, they feel liberated by the amount of control they have in this world.

VICE CITY: BACKSTORY, MAIN STORY, AND FREE PLAY

In *Vice City* (*GTA*'s fictional version of 1980s Miami), the player avatar, Tommy Vercetti, has recently been released from prison, due to his previous work for the Forelli organized crime family. Attempting to reestablish himself with the family, Tommy is sent to Vice City by Sonny Forelli to oversee an important drug deal.

In the inciting incident of the story, masked gunmen steal the drugs and money and kill almost everyone involved in the deal. Tommy barely escapes with his life. Now, Tommy has one overriding mission: get back the drugs and money and exact vengeance for the ripoff. If he fails, he's just as likely to have Sonny coming after him.

To discover the truth behind the ripoff, Tommy must rise up through the criminal ranks, accumulating wealth and real estate, eventually becoming the city's crime kingpin. Once again, Tommy has the freedom to roam the story space and pursue his own agendas, independent of the story's throughline. However, the desire to know "what happens next" generally propels most users to return to the storyline, but at their own pace, rather than a predetermined story pace.

The story space has self-correcting mechanisms to keep players close to the storyline. For example, too much random stealing of vehicles will trigger intense interest from the local police, and eventually the FBI and the National Guard. At a certain point, the user who has "goofed off" too much will certainly die. The odds for user success increases the more the user works toward mastering the game's pedagogy—the motivation for that is contained in the storyline's addictiveness.

THE SIMS: NOTHING BUT SANDBOX

The Sims videogame franchise (which has gone through several iterations and numerous add-ons over the years) has been referred to by its creator, Wil Wright, as a digital dollhouse. The game is completely open-ended, with no goals, objectives, or finish line for the user. This approach may seem like anathema for a pedagogical simulation where specific objectives and endgames are desirable. But since this game may arguably be the best-selling videogame of all time, there are lessons—both illuminating and cautionary—worth noting in its DNA.

The Sims amply illustrates that interactive environments need not be fantastic, noir-ish or scifi-ish to achieve long-term immersive play. Ordinary settings and objects can be immensely absorbing and worth interacting with, when users have nearly total freedom to do so. Although *The Sims* has no built-in narrative, users are almost instantly compelled to begin creating their own storylines out of the sandbox, through their selection and customization of characters and their behavioral interaction with these characters.

Free play is further directed by the "ticking clock" of Sims character lives; as the characters will advance from young adult to adult to elder life stages, the user is under some obligation to help the Sim satisfy his wants and needs.

The Sims uses some of the most advanced character AI yet seen in a commercial videogame environment. Characters have a high degree of autonomy, and may even ignore specific instructions the user gives them, when the instructions clash with current character agendas. Additionally, users can only control their own customized Sims: "visiting" Sims (nonplayer characters) will be fully autonomous, and may interact with the user's own Sims either positively or negatively.

The Sims itself can, potentially, be used as a simulation environment through the deployment of user mods, which may either disable or expand various game

behaviors. The right combination of mods can create a highly customized and specialized world that could focus on very specific workplace or educational endeavors.

One specific drawback, of course, is *The Sims* nonlingual environment. Sims speak "Simlish," a fictional language that is based more on intonation than sophisticated sentence dynamics and construction. Any sort of natural language interface or real-life immersion is, in essence, out of the question. Interaction is purely behaviorally based, rather than drawn from textual or logical pedagogical material. Whether this can deliver sufficient pedagogical content and advancement is highly debatable.

In addition, *The Sims Online* is instructive in terms of massively multiple user behavior in a free play, nondirected environment (some may point to it as a case study of "mob" psychographics). There has been general agreement that the community has degenerated into anti-social behavior (prostitution, extortion, etc.). While a single user will usually carve out a satisfying Sims experience, the presence of numerous, simultaneous users in a completely nondirected environment seems to encourage more extreme selections and interactions. The failure of *The Sims Online* demonstrates that a strong, moderating presence, the man in the loop, becomes more necessary as multi-user autonomy increases.

SUMMARY

A look at some of the most successful videogames in history is useful for seeing ways that backstory and free play are integrated into games. *Grand Theft Auto*'s unique combination of these elements has made it a favorite environment for millions of game players, and creates a particularly rich environment. The extreme in nondirected environments, *The Sims*, offers both positive and negative lessons in how users interact within the virtual world.

Stories in State-of-the-Art Serious Games

Because serious games are developed for a private clientele, rather than the commercial arena, any survey of how story narratives are being used in this field will necessarily be spotty. The Paramount/ICT/Army simulations highlighted in this book, are all, of course, serious games, and are worthy examples of how story is used in this area.

Several military simulations, *America's Army, Full Spectrum Warrior, Real War,* and *Close Combat,* have been converted from in-house training games to successful commercial games. *Close Combat,* for example, hops from engagement to engagement within its series: the Battle of the Bulge; Utah Beach; Beirut, Lebanon during the Marine occupation. All these games are tactical exercises, emphasizing squad-based combat and stealth maneuvers. Story narrative is fairly minimal, although characters do exist and missions do advance progress.

Many serious games hue pretty tightly to tactical simulations, eschewing story, such as:

- *Incident Commander* teaches incident management for terrorist attacks, Columbine-like school shootings, and natural disasters like Hurricane Katrina.
- *Pulse* teaches lifesaving techniques to emergency medical personnel.
- *Interactive Trauma Trainer* is a decision-based surgical training tool.

While story narrative remains fairly minimal in these projects, another Serious Game, *World Hunger: Food Force,* takes a more ambitious approach. A game about world hunger from the United Nations World Food Programme, the story revolves around a political crisis in the Indian Ocean, which triggers food shortages for millions of people. The WFP sends in a new team to step up the program's presence, and via management of planes, ships, and trucks, the user races the clock to get food supplies delivered on time.

Other serious games using real stories include:

- *Insider*, developed for PricewaterhouseCoopers, teaches new auditors to understand derivatives on corporate balance sheets. Set in the future, users join the finance team of intergalactic mining company Gyronortex, where they are required to master the basics of hedging, swaps and options.
- *Objection!*, a game using animated 2D characters, teaches young lawyers in courtroom tactics with a series of civil and criminal trial scenarios.
- *Darwin: Survival of the Fittest*, another animated 2D character game, teaches stock options trading to new hires at a stock trading firm. A scenario involving a new trader trying to move up in the organization unfolds.
- *Catechumen* is a *Half-Life* mod where the user assumes the role of a persecuted Christian in ancient Rome. The Christian warrior-in-training is armed by an angel, with both physical and spiritual weapons, and must battle gladiators, lions, and centurions, in order to survive and help the nascent movement to prosper.

As serious games begin to take full advantage of state-of-the-art game technology (moving from 2D to 3D environments, from turn-based to real-time interactivity), story-driven simulations seem to become more necessary. This probably has much to do with the greater immersion that state-of-the-art media offers. When the pedagogical simulation is only slightly removed from old pen-and-paper training, we don't expect much story narrative. When the simulation looks like a movie or contemporary videogame, we do.

SUMMARY

Serious games have begun to use more story elements to advance the training objectives of the simulation. As serious games become even more immersive, user demands for story are likely to increase, just as they have for entertainment videogames.

29

Stories in State-of-the-Art Commercial Games

If there was ever a doubt about the importance of story in gameplay environments, that was solidly put to rest with the emergence of the *Tomb Raider* series. Although the accessible and entertaining gameplay had much to do with the success of the series, there is no doubt that Lara Croft's Indiana Jones-like adventures placed the series head and shoulders above its competitors.

Even the Tony Hawk skateboarding series, a classic example of "pure" game, has moved increasingly in a story-based direction. Story elements inevitably draw in players who won't normally feel compelled to explore pure gameplay. Consequently, story-driven games can reach an even wider range of players.

Two first-person shooter series hailed for their rich storylines are *Halo* and *Half-Life*.

HALO

The *Halo* series centers on the user/character Master Chief, who must battle forces of The Covenant (dedicated to destroying humanity), along with a parasitic alien race known as The Flood. Here, cut scenes are used to advance story. The game also has a significant amount of backstory, regarding Master Chief, The Covenant, and The Flood.

Master Chief, the hero/user avatar of the *Halo* games, spent an idyllic early childhood until he was kidnapped as part of a military training project because of his "perfect genetic match" with the project's desired profile. Raised in sort of an *Ender's Game* environment, Master Chief is cybernetically augmented and sent on a series of military training missions. He forges deep friendships with some of his cybernetically augmented comrades, who were also kidnapped from their childhood homes. Finally, he begins to combat the aliens of The Covenant.

Halo 2 reveals more about The Covenant and The Flood, and continues to evolve the *Halo* mythology. Although *Halo* has been hailed for its gameplay and graphics, its Orson Scott Card meets Robert Heinlein storyline is part of the reason for its success. The world is well thought out, with pathos and paranoia part of its emotional pull.

HALF-LIFE

The *Half-Life* series centers around user avatar/character Gordon Freeman, a research scientist who is part of a team that unwittingly opens up a portal to an alien world, releasing a plethora of deadly creatures that Freeman must combat just to survive. In the second iteration, set some years later, another alien race known as the Combine has conquered Earth. Freeman joins up with the resistance and investigates all that has happened, and also wins some battles against the alien forces.

 Half-Life is written by science fiction writer Marc Laidlaw; the backstory is rich, and the story is full of intriguing characters and ambiguities. Interestingly, Freeman (the user character) never speaks, and *all* action is seen solely through his eyes, a remarkable adherence to a first-person point of view.

MEDAL OF HONOR

The *Medal of Honor* series is in the single-player game genre dedicated to historical combat, specifically revolving around famous World War II battles. As the series has evolved, a coherent storyline has become increasingly important. In the most recent iteration (at the time of this writing), the story centers on OSS operative Lt. William Holt, who is sent on a secret mission by President Franklin Roosevelt. Mission success unfurls further layers of the story, as Holt eventually uncovers Nazi work on a prototype atom bomb and must eliminate the Nazi scientist racing to deploy the bomb.

 Significantly, legendary screenwriter John (*Apocalypse Now*) Milius wrote the story for this iteration, yet another indicator of how important story has become to classic game genres.

METAL GEAR SOLID

The *Metal Gear Solid* (MGS) series, a classic in the single-player stealth action genre, has long boasted some of the most complex storylines and cinematic approaches in gaming. *MGS*1, set in an alternate history 1995, has the user searching for a weapon of mass destruction, only to discover that the leader of his special forces unit is actually the mastermind behind a rogue state planning

to use weapons of mass destruction. *MGS2* is generally considered to have the most complicated plot in the series, and again has the user trying to shut down a WMD and rogue forces attempting to use it. Cut scenes and user avatar dialogue were added to *MGS2* to better advance the sometimes convoluted plot twists. *MGS3* is something of a prequel, narrating events in a slightly alternate 1964 which will reveal the genesis of the special forces boss who later becomes the double-crossing rogue mastermind mentioned above. Cut scenes are used even more extensively.

SPLINTER CELL

Tom Clancy's *Splinter Cell* series is another example from the stealth action genre, and as we might expect from Tom Clancy, is very strong in its application of story. This game allows for single players, cooperative players, and combatant or tournament play (indeed, the game is based on the Unreal engine).

The story revolves around user character Sam Fisher, a black-ops secret agent working for the National Security Agency. In the latest iteration, *Chaos Theory*, Fisher must pursue the Masse algorithms, the WMDs of information theory. This is a classic example of the story device called the McGuffin, an object of desire (like the Maltese Falcon) that eventually becomes irrelevant, but drives all the action of the story.

Chaos Theory is a good example of author-imposed plot twists within the confines of the story; despite the user's gaming skill, Fisher will actually fail in stopping the algorithms' release. Fisher must later make the moral decision about whether to kill an old friend, and finds out that supposed allies are actually on the other side.

GUITAR HERO

Perhaps the finest commercial example of the use of object simulation, *Guitar Hero* provides a simulated guitar that allows participants to play along with popular rock tracks by watching a video of streaming notes that move forward along paths representing the strings of the guitar. Hit the notes on the right strings as they go flying by and you are an integrated member of a rock band. (In actuality *Guitar Hero* follows in the footsteps of a well-known musical notation method called tablature.) Play the piece over and over until you get it right and you are not only playing a game, you are playing music at the same time.

Interestingly enough, *Guitar Hero* does employ some story elements, presented as newspaper reports of your success as a rock star moving up from humble beginnings to superstar status. The story surrounds you with cheering groupies and fans and encourages you to move forward through the game, rather than rest on your laurels at the easiest levels. It is a very limited use of

story and the story element is noninteractive, but it suggests that even in the most visceral of games, story elements do provide a benefit.—It is also a reminder that story narrative can be achieved through creative use of limited media assets.

STORY AND GAME COMPLEMENT EACH OTHER

Despite the wide-spread belief (especially from nongamers) that users can truly alter the narrative lines of games, the reality is that the user can intervene very little in the actual story. Users may bring out more of the backstory and the deeper textures of the story by their skills and explorations, but an antagonist cannot suddenly be converted into an ally, unless the game designer has embedded this possibility into the story world. The user cannot suddenly determine that another quest is more important than the story's primary quest.

This suggests that users, even hard-core gamers, are actually quite willing to tolerate the constraints of a story world with a well-defined narrative line. The tradeoff this involves is seen as a positive one. Story values will impart greater meaning and higher stakes to gameplay, and users will surrender some of their cherished control in order to play a game that matters.

For designers of simulations who wish to incorporate meaningful stories, this is good news: the attempt to create infinitely flexible and malleable storylines, guided solely by the user, may be a misstep.

MULTIPLAYER GAMES

Arguably, strong storylines benefit single-user games the most. As we look at multiplayer and massively multi-player games, we find that the need for a strong storyline can often diminish. However, this varies depending on what type of multiplayer experience is deployed. For competitive, one-on-one gameplay, story is often unnecessary, except for the post-hoc narratives combatants create for themselves. Examples of this include basketball, football, and racing games.

This is generally also the case for multicombatant (or tournament) play such as that found in *Doom* or *Unreal*. These are really the virtual equivalent of playing paintball, where combatants need only a team and some geography to give them ample motivation for completing gameplay and defeating the opponent side.

However, when we begin to look at games relying on cooperative gameplay, for example, Tom Clancy's Rainbow Six series, we see a strong narrative line reemerging. Again, users have more reason to enjoy and exploit cooperation when missions are invested with meaning and emotional stakes are high. (The enemy kills a trusted ally, or massacres women and children, or threatens a city with weapons of mass destruction.)

Massively multiplayer games, which combine cooperative with combatant play, often oscillate between a strong storyline and a relatively weak storyline. Unrelated quests and resource economies unconnected to larger story elements create an increasingly entropic state in a massively multiplayer environment; but inevitably, users chafe against a very strong story hand, seduced by the freedoms the massively multiplayer online game (MMOG) offers. This tension has still not been satisfactorily resolved, possibly contributing to the relatively slow growth in MMOG subscription rates.

MMOGs offer an additional challenge in the open-endedness of their games: closure and conclusion are not goals of the experience. This is similar to the experience that daytime soap opera viewers have. Interestingly, these viewers experience tremendous immersion in the soap opera experience, despite the lack of closure in the narrative arc, which is usually a desired goal in story-telling. However, mini-story arcs do exist within the soap opera experience, providing a sense of progression and transformation necessary for a satisfying story experience. When MMOGs achieve similar mini-story arcs, users find their immersion in the MMOG increases, as they build a sense of history and back-story, which helps propel them forward and makes them want to stay with the game.

ALTERNATE REALITY GAMES

Alternate reality games (ARGs) have recently come to prominence, and from the beginning, have been intensely story driven. ARGs will use multiple websites, faxes, live telephone calls, e-mails, newspaper ads or clippings, and real world events to advance story and initiate gameplay. In addition, users may have to physically show up at a location or event to interact with the alternate reality. Arguably, this expands the "verb set" of user input, adding new possibilities for deeper, more nuanced stories. ARGs attempt to blur the line between in-game and out-of-game experiences. Successfully executed, this creates the potential for even greater immersion into a simulation experience. Titles to date include *The Beast*, *I Love Bees*, *Street Wars*, and *Last Draw Poker*.

Interestingly, the gameplay in ARGs is usually more cerebral than that of MMOGs (involving puzzle solving, code breaking, and Internet research), more collaborative, and at the same time, often more low-tech and yet more personally involving for a user.

While most contemporary videogames aim for movie-like immersion to convey story, ARGs create a different kind of immersion, something more akin to live theater crossed with fiction reading. The gameplay is much more asynchronous and turn based, with far less emphasis on real-time experiences. However, knocking down the wall between "game" and "reality" may make the experience even *more* real-time, since the game never ends. (David Fincher's 1997

film, *The Game*, illustrates an ARG taken to extremes, years before the ARG concept arose.) With the passage of time (the experience of which is probably the most immersive factor of our lives) typically built into ARGs, the line between simulation and reality blurs further.

ARG storylines tend to postulate vast hidden conspiracies, the gradual revelation of which encourages users to research, share information, collaborate on strategies, and get out of their seats to further pursue the goals of the game. Clearly, "conspiracy" stories can be refitted to understanding global systems (economic, environmental, political). The ARG story/gameplay model offers a different way of looking at simulations, where delivery is more appropriately based on networked and Internet resources (discussed in Chapters Twenty-one and—Twenty-two) and where the simulation might last for weeks and months, rather than a few hours or days.

The recent ARG, *Last Call Poker* (www.lastcallpoker.com), works with a different sort of story premise, substituting mystery, history, and a touch of the supernatural for the usual conspiracy stories, suggesting that ARGs have only begun to explore the types of stories that might work within the ARG framework.

The siren song of ARGs is: "This is not a game." Naturally, this is a feeling we'd like to inculcate in the middle of a training simulation, that the environment, emotions, and stakes have become so real that the notion of "game" has been left behind.

SUMMARY

Commercial games are worth examining for their various approaches to integrating story into game environments. The primacy of story partially depends on the pedagogical goals we have, and the type of interactivity we think will advance those goals. Single-player and cooperative multiplayer environments seem to be particularly friendly to strong storyline content. For simulations that are primarily tournament or combatant experiences, strong storylines may be less necessary, although a different kind of story, the *post-hoc* story (where the gameplay creates a narrative line for players), should be expected and used. Alternate reality games suggest a new way of thinking about story-driven simulations, drawing inspiration from theater and print fiction, as well as from movies and videogames.

PART EIGHT

THE FUTURE OF STORY-DRIVEN GAMES

30

The Future: The Role of Story

IMMERSIVE DISTANCE LEARNING EXPERIENCES

Higher education has been in a "steady state" phase for at least a generation, with few new institutions, public or private, opening for business. Distance learning, however, is growing by leaps and bounds, thanks in part to the widespread deployment and availability of digital technologies and delivery systems.

Environments like *Virtual Harlem*, a 3D recreation of 1920–1930s Harlem, intended to educate students about the Harlem Renaissance, are being delivered to remote classrooms. This book has made the case that these environments and experiences will be enriched further when story components, and even full-blown story narratives, are added to multimedia and 3D distance learning experiences. While we can build navigable 3D environments with increasing ease, these environments become little more than "open house" or diorama experiences without a compelling throughline and personal stakes that will motivate users to fully explore and gain knowledge about the space.

The same is true for distance learning experiences that rely more on delivery of e-mails, documents, instant messaging, websites, slideshows, and audio and video snippets. The disparateness of these separate media cry out for some unifying force, a spine or throughline that will create a shared imaginative world, hiding some of the seams of this mélange of data delivery. Alternate reality games suggest one methodology for importing story into these experiences: the stories can even provoke more active user interactions, either with other users or with real-world environments. By knitting together the virtual and the physical worlds, a greater sense of immersiveness will be achieved.

As distance learning experiences become more pervasive at all levels of education and training, the addition of story spaces and story narratives will be some of the primary elements differentiating a perfunctory product from a superior product.

Figure 30.1 *Virtual Harlem* allows students to walk through the streets of Harlem in the 1920–1930s and learn more about the context of the literature they are studying. Reproduced with permission from Bryan W. Carter.

ONLINE COLLABORATIVE GAMES AND SIMULATIONS

As we've discussed in Chapter Twenty-nine, story narratives and story worlds seem to work very well in collaborative environments. The story world can create a safe environment, adding both meaning and desire to users thrown together and being asked to work with one another to achieve common objectives.

Creating a shared narrative framework helps users who are otherwise strangers come together. Think about fandom for a particular sports team. Successful fandom is generated because the sports team creates a shared narrative: they may be a scrappy, underdog team mirroring the scrappy, underdog narrative of a city like Pittsburgh; or a sleek, glamorous team mirroring the sleek, glamorous narrative of a city like Los Angeles or New York. In turn, this shared narrative helps fans connect with each other and give more of themselves to the "alternate reality" created (e.g., fans will paint themselves outrageously and

otherwise "act out" without fear of social retribution; indeed, fandom behavior is encouraged by other fans).

The shared story world also encourages users to learn from each other, accelerating the rolling out of pedagogy and its mastery. Left to their own devices, with no shared narrative, people have a more difficult time connecting and collaborating. We see this behavior all the time, in elevators, in a line at the post office, or in the workplace (in our first days on a new job). However, under the umbrella of a story experience, the usual social barriers that stand between people dissipate. Users are more willing to collaborate with fellow users and to tutor newcomers.

Most job functions and workplace environments require collaboration and team building. As jobs get more complex and as labor costs for hands-on training continue to rise, training in these areas is likely to lean more heavily on simulations to smooth the entry of new employees and upgrade the skills of veterans. Both small- and large-scale stories will aid in the delivery of pedagogy in these contexts.

STORY-DRIVEN MASSIVELY MULTIPLAYER ONLINE GAMES

In the commercial arena, MMOGs have combined collaborative and combative gameplay, and as we've observed in Chapter Twenty-Nine, the importance of story in MMOGs has sometimes varied, not because it's unimportant (just the opposite) but because it's been hard to calibrate in a satisfying way for all players.

However, as cinematic (i.e., Hollywood) stories have increasingly suffused with videogames, serving to further expand the audience, so too can we expect commercial MMOGs to lean more on larger, continuing stories, in a bid to expand the user base.

The serious games community is now looking to deploy MMOG environments. As we've discussed, the inclusion of story narrative speeds the delivery of pedagogy and creates greater immersion for an environment. Development on MMOGs for the medical profession, first responders, and the legal profession is already underway. These MMOGs will create story worlds with very specific goals and conflicts, and perhaps, with a greater degree of closure than commercial MMOGs ever attempt (because it is against their economic interests to do so).

LOCATION-BASED FULL-SENSORY SIMULATIONS (VIRTUAL REALITY)

Location-based story-driven simulations already exist; for the most part, they're theme park rides (most of us have experienced at least one). If we think about a

ride like Indiana Jones or Pirates of the Caribbean at Disneyland, we realize that these are classic full-sensory, virtual reality simulation environments rich in story narrative.

The Indiana Jones ride relies hugely on the backstory of the films; the classic Pirates of the Caribbean ride creates a complete story arc, as the audience is plunged downward into a virtual pirate-land-of-the-dead. The narrative then flashes back to the lives and typical times of the pirates, as they defeat an enemy force, pillage a seaside town, and enjoy their spoils. It's not surprising that the theme park ride was rich enough in content to serve as the springboard for a blockbuster film franchise.

Significantly, these theme park rides have been passive, movie-like experiences until recently. One of Disney's most popular current attractions, Buzz Lightyear's Astro Blasters adventure, adds a first-person shooter component to the ride, while relying on the *Toy Story* films for backstory.

Location-based environments are hugely expensive, of course; it's no coincidence that huge media giants like Disney and GE/Universal are primary players in this arena. Most pedagogical entities don't have the budgets or facilities to begin designing serious games or training simulations with this kind of size and scope. It's much cheaper to build a virtual 3D environment on a display screen.

That said, there is clearly tremendous power in the experience of a full-scale physical, sensory simulation; theme parks make huge revenues for a reason. Location-based environments may be the last frontier for pedagogically driven simulations. Already, the US Army has been building full-sensory, story-driven environments for soldier training. Leading American universities are experimenting with similar environments.

Although simple, full-sensory simulations like paintball can be compelling for user-participants, full-sensory simulations containing educational experiences will need much more context and narrative to motivate and guide users. Story development and execution will be a crucial component in the successful deployment of location-based, full-sensory simulations.

KEEPING TRACK OF THE EVOLUTION

Numerous organizations, conferences, and Websites now exist to track some of the progress and proliferation of serious games.

- Games for Health, www.gamesforhealth.org
- Games for Change, www.gamesforchange.org
- Serious Games Initiative, www.seriousgames.org
- Social Impact Games, www.socialimpactgames.com
- The Education Arcade, www.educationarcade.org

SUMMARY

As the novelty of immersive distance learning, collaborative simulations, and massively multiplayer games wears off, users will increasingly demand good stories in the serious games and simulations they participate in. Given the ubiquity of media, the good story is what will draw greater interest and involvement. We see this in television (the reason *American Idol* and *Survivor* are popular is because of the storylines they contrive), in sports (the Lakers were the most popular NBA team for years because of the Kobe-Shaq melodrama), and in videogames (*Halo, Half-Life*, etc.). Simulation designers and training developers must not overlook the quality of the story in the pedagogical worlds they create.

Conclusion

This book has attempted to stress the importance of storytelling in the creation of serious games and simulations, while still recognizing principles of good gameplay and effective pedagogy. We have surveyed media and platform selection, and offered some tips on production and asset usage. Of course, numerous books and websites explore these topics in greater detail and specificity.

Our primary effort has been to use the specific examples from our own experiences in the trenches, to identify strategies for marrying story narrative to learning objectives in order to bring greater authenticity and excitement to the world of serious games and simulations.

Just as the motion picture at the dawn of the 20th century invited educators to take advantage of the new medium, so too should Serious Games and immersive simulation environments invite 21st-century educators to answer the growing pedagogical needs of our diverse global society.

The US Army, with its tremendous training requirements, has once again paved the way in developing technology that can also serve the principles of the private sector and other government agencies. We hope that sharing our experiences with developing military simulations and serious games can benefit those developing such training material for crisis decision making, cultural awareness and understanding, and interpersonal management and teambuilding. The Army's collaboration with Hollywood and the academic community has brought a new dimension to tasks that once were only learned through the use of workbooks and lectures.

If stories teach us how to live, then combining them with our strongest instructional technologies can lead to greater global understanding and the ability to confront the challenges we know face us in the decades ahead.

Bibliography

Calica, Ben. "I Second That Emotion, or...Playing Games with People's Feelings." *Gamasutra*. 24 July 1998. http://www.gamasutra.com/features/game_design/rules/19980724.htm.

Campbell, John. "Adventure Developers." *Adventure Developers*. 10 Apr. 2006. http://www.adventuredevelopers.com/featuredetail.php?action=view&featureid =25&showpage=1.

Driscoll, James E., and Joan H. Johnston. "Stress Exposure Training." *Making Decisions Under Stress*. Ed. Janis Cannon-Bowers and Eduardo Salas. Washington, DC: American Psychological Association, 1998. 191–217.

Frame, Adela and Lussier, James W., eds. *66 Stories of Battle Command*. Ft. Leavenworth, KS: U.S. Army Command and General Staff College Press, 2000.

Gordon, Andrew S. *Authoring Branching Storylines for Training Applications*. Proceedings of the Sixth International Conference of the Learning Sciences. Santa Monica, CA, 2004.

Gordon, Andrew S., and Nicholas V. Iuppa. *Experience Management Using Storyline Adaptation Strategies*. Technology for Interactive Digital Storytelling and Entertainment (TIDSE) Conference Proceedings, Zentrum Fur Graphische Datenverarbeitung E. V. Darmstadt, Germany, 2003.

Gordon, Andrew S., Mike van Lent, Martin Van Velsen, M. Carpenter, and Arnav Jhala. *Branching Storylines in Virtual Reality Environments Fore Leadership Development*. Proceedings of the Sixteenth Innovative Applications of Artificial Intelligence Conference. Menlo Park, CA: IAAI Press, 2004.

Hill, Randy, Jay Douglas, Andrew S. Gordon, F. Pighin, and Martin Van Velsen. *Guided Conversations About Leadership: Mentoring with Movies and Interactive Characters*. Proceedings of the Fifteenth Innovative Applications of Artifical Intelligence Conference. Menlo Park, CA: IAAI Press, 2003.

Iuppa, Nicholas V., Gershon Weltman, and Andrew S. Gordon. *Bringing Hollywood Storytelling Techniques to Branching Storylines for Training Applications*. Narrative and Interactive Learning Environments Proceedings. Edinburgh, Scotland, 2004.

Jhala, Arnav, and Michael Young. *A Discourse Planning Approach to Cinematic Camera Control for Narratives in Virtual Environments*. Proceedings of the National Conference of the American Association for Artificial Intelligence. Pittsburgh, PA, 2005.

Johnson, Bill. *A Story is a Promise: Good Things to Know Before You Write That Screenplay, Novel, or Play*. Blue Heron Publishing, 2000.

Kirlik, Alex, Arthur D. Fisk, Neff Walker, and Ling Rothrock. "Feedback and Practice." *Making Decisions Under Stress*. Ed. Janis Cannon-Bowers and Eduardo Salas. Washington, DC: American Psychological Association, 1998. 91–113.

Lippman, John. "As Hollywood Casts About for a War Role, Virtual Reality is Star." *Wall Street Journal* 9, Nov. 2001, sec. A: 1+.

Longyear, Barry. *Science Fiction Writer's Workshop—I: An Introduction to Fiction Mechanics.* Philadelphia, PA: Owlswick Press, 1980.

Magerko, B. *Story Representation and Interactive Drama.* Proceedings of the 1st Artificial Intelligence and Interactive Digital Entertainment Conference. Marina Del Rey, CA, 2005.

Magerko, B. and Laird, J.E. *Mediating the Tension Between Plot and Interaction.* AAAI Workshop Series: Challenges in Game Artificial Intelligence. San Jose, CA, 2004. 108–112.

McKee, Robert. *Story: Substance, Structure, Style and the Principles of Screenwriting.* Regan Books, 1997.

Murray, Janet. *Hamlet on the Holodeck.* Free Press, 1997.

Stephenson, Neal. *The Diamond Age.* Spectra, 1995.

Sternberg, Robert, et al. *Practical Intelligence in Everyday Life.* Cambridge University Press, 2000.

Subject Index

Page numbers followed by *f* indicate figures.